Chicana and Chicano

Art

THE MEXICAN AMERICAN EXPERIENCE

Adela de la Torre, EDITOR

Other books in the series:

Chicana and Chicano Art

Art

ProtestArte

Carlos Francisco Jackson

The University of Arizona Press Tucson

The University of Arizona Press
© 2009 The Arizona Board of Regents

Library of Congress Cataloging-in-Publication Data
Jackson, Carlos Francisco, 1978–
Chicana and Chicano art : ProtestArte / Carlos
Francisco Jackson.
p. cm. — (The Mexican American experience)
Includes bibliographical references and index.
ISBN 978-0-8165-2647-5 (pbk. : alk. paper)
1. Mexican American art. 2. Social movements in art.
3. Chicano movement. I.Title. II. Title: ProtestArte.
N6538.M4J25 2009
704'.0368'72073—dc22 2008031518

Publication of this book is made possible in part by the proceeds of a permanent
endowment created with the assistance of a Challenge Grant from the National
Endowment for the Humanities, a federal agency.

Manufactured in the United States of America on acid-free, archival-quality
paper containing a minimum of 30% post-consumer waste and processed chlorine
free.

14 13 12 11 6 5 4

This book is dedicated to Mary Ortega Jackson, Santiago Jackson, and Abigail Jane Rubenstein

■ CONTENTS

ILLUSTRATIONS

■ ACKNOWLEDGMENTS

I would like to thank all the artists and their families who are represented in this book. I am grateful for their support of this project and willingness to be included in the collection of images. I would also like to thank them for their commitment to creating artwork that represents a new future and clearer understanding of our diverse communities. There is little financial reward in producing artwork that challenges the dominant culture nor in being represented in books published by nonprofit presses: I am grateful for and inspired by their work.

I would also like to thank Adela de la Torre for offering me the opportunity to develop this book. I am grateful for her support, encouragement, and guidance. I am also grateful for the support of my colleagues in the Chicana and Chicano Studies Program at the University of California, Davis: Angie Chabram-Dernersesian, Yvette Flores, Sergio de la Mora, Miroslava Chávez-García, Lorena García, Refugio Rochin, Kevin Johnson, Celina Rodríguez, and Alma Martínez. I appreciate them for welcoming me into the program as a colleague and for their support of my work on this book and in developing Taller Arte del Nuevo Amanecer (TANA). I would especially like to thank Malaquias Montoya and Lezlie Salkowitz-Montoya for their friendship, guidance, encouragement, and support. They have provided me a home away from home for which I will be eternally grateful. Words cannot justly express the gratitude, love, and appreciation I have for them. I would also like to thank all my TANA *colegas* in Woodland, California, especially the friendship and support of Francisco Rodríguez and Artemio Pimentel. While my work for TANA was separate from the writing of this book, they both certainly inspired and informed each other.

Generous funding and support for the development of this book was provided by Jessie Ann Owens, Dean of the Division of Humanities, Arts, and Cultural Studies in the College of Letters and Science, and by the Publication Assistance Fund from the Vice Chancellor for Research at UC Davis.

This book would not have been completed without the guidance of acquiring editors at the University of Arizona Press Patti Hartmann and Kristen Buckles. Thank you especially to Kirsteen Anderson for her careful eye in editing this manuscript.

Chicana and Chicano Art

Introduction

hicana and Chicano Art: ProtestArte discusses how **Chicano** and **Chicana** visual art has represented the Chicano community and served as a reflector and creator of Chicano culture. This volume of the Mexican American Experience series addresses the role art has played in the development of the Chicano movement. Any attempt to provide a comprehensive overview of Chicano/a art would be a massive undertaking, beyond the scope of this series, so this book is merely a survey. It gives anyone interested in learning about Chicano art an introductory overview of its influences, its activity and relationship to the Chicano movement, its organization as an art movement, its historical legacy, and its current trends. In addition to providing discussion questions and information to encourage dialogue and debate amongst colleagues and classmates, it provides a detailed and extensive bibliography, suggested readings, and recommended Web sites to encourage further research and investigation into particular topics and themes of interest to young scholars, students, and the general public. Books and exhibition catalogues have been published that attempt to be comprehensive in their representation of the **Chicano art movement** and the artists involved. Many books, articles, and exhibition catalogues have highlighted specific demographic, social, and political aspects of Chicano/a artistic representation. A selection of these are listed at the end of each chapter.

This introduction introduces the Chicano movement and its motivations in order to lay a foundation for understanding the artists who helped visually represent a new Chicano culture and identity. A historical summary is essential because this book focuses on artists with a direct relationship to the Chicano movement and on those who continue to promote and create **Chicanismo.**

Chicano art deals with the power of ideas. Powerful ideas are always the foundation for great art. They express a vision and understanding of some aspect of the human experience and can affect the consciousness of an entire people. *Chicano/Chicana* has become widely used to describe a **Mexican**

American identity, but this wide use of *Chicano/Chicana* does not fully represent the meaning or the value of the term. Throughout the early part of the twentieth century, *Chicano* began as a derogatory word used both inside and outside the Mexican American community to describe the poor Mexican immigrant living in the United States. Mexican American civil rights activists appropriated the term in the late 1960s to embody a new cultural and political identity for Mexican Americans. As scholar Vicki Ruiz states, these activists "transformed a pejorative barrio term 'Chicano' into a symbol of pride. 'Chicana/o' implies a commitment to social justice and social change" (Ruiz 1998, 98). Ruiz's definition of Chicana/Chicano thus articulates an idea or philosophy rather than a rigid identity.

Chicano has often been presented as an identity that simply represents the Mexican American experience or community. Historian Ignacio García has explicitly described a Chicano or Chicana as "a 'new' Mexican American, one who understood his or her roots and shunned assimilation or integration" (García 1997, 35). As a political or ideological identity, however, *Chicano* came to mean more than simply a race-based identity. To identify a community or its artistic and cultural production as Chicano solely because it is connected to the Mexican American experience is problematic because the Mexican American community in the United States is composed of a complex **mestizaje,** or racial and cultural mixture.

Film scholar Rosa Linda Fregoso, in *The Bronze Screen*, a critique of Chicano cinema and film, eloquently discusses the issue of naming and identification. In her introduction Fregoso addresses the question, does all film produced by Mexican Americans demand inclusion in the label "*Chicano*"?

> Specifying that Chicano represents a category of progressive politics allows us to circumscribe further the specificity of Chicano cinema. If we recognize that Chicano cinema developed within the context of the Chicano Power Movement's struggle of antiracism (equality, self-determination, human rights, and social justice), then its cinema must somehow remain bound by these ideals. However, if we disarticulate the cultural politics from Chicano cinema, then the definition becomes too bland, too all-inclusive, too pluralistic, equating cultural forms engaged in antiracism and empowerment struggles with those informed by fascist, racist, or sexist tendencies. (Fregoso 1993, xix)

What Fregoso is arguing here is that to define Chicano cinema or Chicano art or any form of cultural production strictly on the basis of race is to

incorporate racist tendencies into an ideology that fights against racism. Defining Chicano cultural production instead on the basis of how the activity of art making relates to the ideas of the Chicano movement, "equality, self-determination, human rights, and social justice," offers the potential to transcend the negative ideas that have often perpetuated social inequality and injustice.

The arts are one the best places to find fertile debates and representations of what the Chicano experience has been and continues to be today. "El Plan Espiritual de Aztlán" and *El Plan de Santa Barbara* (discussed later) remain the two most articulate manifestos expressing Chicano as an identity and a new political culture. In this book I see each painting, poster, and mural as a type of manifesto that represents the Chicano or Mexican American experience. Art provides the artist an opportunity to create a vision that has never existed or been articulated. The art that is specifically Chicano/Chicana can provide a vision for the development of a new culture that embraces humanity and equality, or of a truer democracy than has yet to be created through the political process. Through Chicano art we see the experiences of those people most often invisible in society—the poor and dispossessed—highlighted and venerated. We see women breaking down a historically oppressive patriarchal culture, we see farmworkers and service workers celebrated as heroes, and we see examples of family unity and solidarity with international social movements. Chicano art also provides the best representation of the physical and metaphorical experience of living on the border. Because artists enter the studio without rules, they often have opportunities to lead the way in visually representing a society that embraces equality and social justice. This artistic freedom enables them to break down barriers that have yet to be broken down in society, to enter spaces otherwise impenetrable, and to conjure up worlds that cannot be or have yet to be created in reality.

■ History of the Mexican American Experience

The Mexican American experience has a deep and vast history in the United States, particularly in the Southwest. As Chicano culture scholar Tomás Ybarra-Frausto states, "while Chicanos are a native national group, there exist rich, distinctive, and complex regional Chicano artistic traditions . . . tejanos, arizonenses, nuevomexicanos, and californios" (Ybarra-Frausto 1994, 125). Each region deserves a particular study of its

development and its relationship to the Chicano movement, a comprehensive geographical history that would be impossible to provide in this introduction. Yet, a brief discussion of the historical Mexican American experience is essential to understanding the origins of many of the themes that have remained important in Chicano art, politics, and culture.

The Spanish expansionist explorations of the fifteenth century led to their "discovery" and the colonization of the North and South American continents, and the subjugation of millions of Native Americans. Advanced civilizations and cultures, the Aztec and Maya primary among them, were decimated by a combination of violent repression and foreign diseases such as smallpox, to which the natives had no immunity. Researchers have debated the population living in central Mexico before the Spanish conquest, but a rough estimate is 25 million. By 1620 the Native American population in Mexico was approximately 730,000 (Mann 2005, 129). Bartolomé de las Casas, Spanish missionary and first Catholic bishop of Chiapas, was the first witness to describe the atrocities committed by the Spanish in the Americas. His book *A Short Account of the Destruction of the Indies* (1552) provides the earliest and most vivid descriptions of the genocide committed by his countrymen against the indigenous people of America. With colonization came Christian missionaries and missions, the Spanish language, and a new race of people, mestizos.

Mestizo is a Spanish term used to describe people of mixed European and Native American ancestry. Anthropologist Martha Menchaca has written a book on the complex racial history of Mexican Americans. Menchaca explains that "most Mexican Americans are predominantly *mestizo* people: after Spain conquered Mexico in 1521, widespread intermixture of Spaniards and Indians occurred" (Menchaca 2001, 19). Menchaca goes beyond the traditional understanding of mestizaje as a mixture of just Indian and Spanish ancestry to include the West African presence in Mexico and the Americas. Mexican Americans have white heritage from "Spain, the Indian from Mexico and the U.S. Southwest, and the Black in West Africa" (19). This complex multiracial past is the consequence of the conquest and colonization of the Americas. Though a tragic genocidal event, the colonization of the Americas by various European nations resulted in a multiracially diverse and culturally rich experience throughout Mexico and the U.S. Southwest. This experience, known as mestizaje, can be imagined as a particular type of border, a border where multiple cultures interact, clash, mix, and negotiate boundaries in the forging of a new identity. The border,

in this case, is symbolic, but the Mexican American experience also has a history of negotiating a real border, the U.S.–Mexican border. The border both as a metaphor for cultural mestizaje and as a geopolitical reality has been a prominent theme among Chicano artists.

Spanish rule of Mexico lasted three hundred years, its territory extending from Chiapas to northern California and parts of Utah and as far east as western Kansas. The Mexican War of Independence was fought from 1810 until Spain's defeat in 1821. Stability for the newly sovereign nation, however, was hindered and tested by threats from foreign nations, particularly the United States. Fifteen years after independence, Mexico was fighting insurrectionist American settlers in the Mexican state of Tejas. Soon thereafter it would be at war with the United States.

During the 1840s, U.S. politicians used the concept of Manifest Destiny to renew a sense of national unity and to create a spiritual mission for the country. The idea symbolized the mission to expand westward and ultimately unify the west and east coasts under the American flag. Manifest Destiny explicitly expressed the belief that the United States had a divine mission to expand and spread *American* democracy—a democracy that, at the time, accepted enslaving African Americans and denying women the right to vote—to what is now the western United States. Scholar Laura Gómez notes in her book *Manifest Destinies* a major misconception that Mexican Americans are a new group consisting primarily of recent immigrants and their children. Gómez points out that Mexican Americans have had a long history in the United States going back before 1848, when more than 115,000 Mexicans became American citizens through U.S. annexation of Mexican territory at the end of the Mexican War. While many in American society continue to refer to Manifest Destiny as a positive marker of a proud period of American expansion, an underlying implication of Manifest Destiny was that the newly independent Mexican nation post 1821 was culturally deficient and in need of "civilization." Gómez cites historian Reginald Horsman to clarify the true meaning of Manifest Destiny. Horsman states that "a sense of racial destiny permeated discussion of American progress and of the future American world destiny. . . . By 1850 the emphasis was on the American Anglo-Saxons as a separate, innately superior people who were destined to bring good government, commercial prosperity, and Christianity to the American continents and to the world. This was a superior race, and inferior races were doomed to subordinate status or extinction" (Gómez 2007, 4). Such was their fervor that many

Americans believed Manifest Destiny had been bestowed upon the Euro-American leaders of the United States by Providence, or even more directly, by God. Using religious zeal as a guise for expansionist policy is the same rationale the Spanish Empire used in justifying its three hundred years of colonizing the Americas.

The Mexican War of 1846–1848 made the border a geopolitical reality for Mexicanos living in what is now the southwestern United States. The 1848 Treaty of Guadalupe Hidalgo gave the triumphant United States more than 50 percent of Mexico's territory. Parts of what are now Texas, Colorado, Arizona, and New Mexico, and the whole of California, Nevada, and Utah were transferred from Mexican to U.S. sovereignty. The provisions in the Treaty of Guadalupe Hidalgo guaranteeing the property and civil rights of Mexicans who chose to remain in the United States as U.S. citizens, and the U.S. government's disregard of these provisions, is central to understanding the Mexican American experience. *Foreigners in Their Native Land: Historical Roots of the Mexican Americans*, edited by David J. Weber, provides source material that illuminates the ways in which the Treaty of Guadalupe Hidalgo went largely unenforced, resulting in numerous injustices, including Anglo usurpation of Mexican land grants and denial to the new Mexican Americans of "all the rights of citizens," in the wording of the treaty. The geographical border established by the signing of the Treaty of Guadalupe Hidalgo (and slightly modified by the Gadsden Purchase) has played an important role in the way Mexican Americans and Chicanos/Chicanas are viewed and how they view their relationship to the United States. Awareness of and sensitivity toward the history of one population divided by a border is key to understanding the way Chicano artists throughout the United States have articulated this experience. Here, the popular Chicano saying becomes clear and apropos: "We didn't cross the border, the border crossed us!"

A New Nation and a New Culture

The Mexican American experience and culture has a long history in the United States, with indigenous roots going back long before Anglo-Protestant culture appeared in the Americas. Nevertheless, the idea that Anglo-Protestant culture is central to America's existence and that Mexican immigrants and Mexican Americans need to assimilate into this culture has been predominant ever since the United States took control of the

U.S. Southwest. In a recent book entitled *Who Are We? The Challenges to America's National Identity* Samuel P. Huntington, a Harvard professor and former chairman of the Harvard Academy for International and Area Studies, claims that in the post 9/11 era the greatest threat to America's existence is the tidal wave of Mexican immigrants who are turning this country into "a bifurcated America, with two languages, Spanish and English, and two cultures, Anglo-Protestant and Hispanic" (Huntington 2004, xvi). His claim is shocking considering it was written at a time when America was deeply entangled in the war in Iraq and recent memory had witnessed three airplanes used as missiles against American citizens. And Mexicans are supposedly the gravest of these threats to American culture? While this is not the appropriate place for a debate on Huntington's book, his argument is important in the context of understanding the history of Mexican American people and their ongoing struggles to be recognized and represented as fully participating U.S. citizens. In Huntington's introduction he makes clear that he is advocating not Anglo-Protestant people but Anglo-Protestant culture. He states that to be an American and to ensure America's future "existence," Hispanic culture must be assimilated and made to embrace Anglo-Protestant culture—not necessarily white in color but white in mindset and values.

As a respected Harvard professor, Huntington is certainly not alone, even in 2004. The beginning of the twenty-first century has seen increased attention amongst scholars and the mainstream media to the growing population of immigrants from Latin America, especially from Mexico. The mainstream media, print media in particular, have tended to portray Mexican and Latin American immigration as an invasion and potential reconquest of the Southwest. This portrayal has struck fear into the hearts of many people who do not understand or belong to the Mexican and Mexican American experience. U.S. dependence on cheap immigrant labor coupled with a xenophobic response to Mexican immigration is far from a new phenomenon. The early twentieth century saw heavy Mexican immigration to the United States owing to an increased demand for labor and the eruption of violence along the border during the Mexican Revolution. The Chinese Exclusion Act of 1882, and its indefinite extension through the Geary Act of 1892, all but eliminated Chinese workers as a source of cheap labor, leading to an open border between the United States and Mexico. Along with the new waves of Mexican immigrants came organized missionary efforts to "Americanize" the foreigners. The Young

Men's Christian Association (YMCA) was one of these missionary organizations. Focusing on the Mexican immigrant communities along the border, its goal was to save these immigrants from the evils of "un-American" ideologies. The organization sought to transform Mexican culture into a form of Anglo-Protestantism. At the same time, the president of the Presbyterian Synod explained Americans' fears in an either/or dichotomy: Mexican immigrants would be either "won to anarchy or to Americanism; to Bolshevism or to Democracy; to Trotsky or to Christ" (Muñoz 1989, 28–29). In other words, white Americans wanted Mexicans to come into the country and work, but only if they were willing to be Protestants and sympathetic to capitalism. The YMCA's activities and objectives are one example of the constant coercion to which the peoples living throughout the Americas and the U.S. Southwest have been subjected—a historical pattern known as **cultural imperialism** or **cultural colonialism.**

The missionary activity along the U.S.–Mexican border during the early twentieth century was part of a period of rapid growth and change for Mexican Americans living in the United States. Benjamin Heber Johnson has written in *Revolution in Texas* about the introduction of the railroad and the transformation of the Southwest into an agricultural economy. Johnson describes how these two movements led to accelerated and systematic disempowerment of Mexican Americans. In regard to Mexican American Texans, Johnson states that "the combination of economic pressure, title challenges, and outright theft led to significant Tejano land loss shortly after the railroad's construction" (Johnson 2003, 34). Rapid increases in property taxes during this period forced many Mexican American families to default on their homes and be reduced "to fieldwork, helping to enrich the very farmers whose arrival had so much to do with their own dispossession" (34). The railroad also brought an influx of European American settlers who legally or illegally took possession of Mexican American–owned lands.

The practices of American missionaries and prejudices of white American settlers subjugated and devalued the history and culture of the Mexican American community. Even public schools facilitated the missionary and assimilative efforts. Although segregation was not imposed on the Mexican American community the way Jim Crow laws were instituted throughout the South, de facto segregation created a system of education that was separate and unequal, with systematically preferential treatment of European American children. Up until the late 1960s, young Mexican

American men and women were placed into vocational education tracks, which often pushed students out of school. Mexican Americans were also placed in classes for students who were mentally retarded or had learning disabilities—a practice often justified by their lack of knowledge of English—another way of channeling them into manual training rather than academic courses. This practice perpetuated the status of Mexican Americans as a source of readily available, cheap labor. Resistance to this cultural imperialism, including Mexican American exclusion from the public education system, was a major issue Chicano activists would address during the 1960s in order to develop and encourage community pride and empowerment. The legacy of this educational inequality is still being fought today, as many educators still have lower expectations for Mexican American students.

■ Mexican Americans and the World War II Era

The era preceding World War II and the boom years immediately following it have been called the Mexican American generation. The cultural Americanization of Mexican Americans took root during this time. Many Mexican American men and women publicly identified with the European part of their mestizaje, denying their indigenous roots and referring to themselves as "Spanish." During the early to mid-twentieth century, it was also common practice for people to anglicize their first names, changing Jorge to George or María to Mary, for example. Although a very subtle example of the ramifications of cultural imperialism, this practice shows a community and culture changing its language and definitions to appear more culturally white Anglo-Protestant, and by implication, more "American." This was a direct result of an educational system where educators denied the students' culture by punishing them for speaking Spanish or speaking English with an accent.

Various Mexican American and **Latino** advocacy organizations in the first half of the twentieth century, such as the League of United Latin American Citizens (LULAC), promoted assimilation, or "Americanization," as a means of gaining greater equality and recognition within the dominant American culture and society. LULAC promoted respect for Mexican Americans' "racial origin," but believed for strategic reasons that in order for Mexican Americans to gain their full rights as citizens, the community would need to accept Anglo-American culture. As

Ignacio M. García states in *Chicanismo: The Forging of a Militant Ethos among Mexican Americans*, "the constant promotion of Americanization, the continual concern with legitimacy, and the overall better economic conditions many of them attained cemented them emotionally and philosophically to mainstream society and away from their Mexicanness" (García 1997, 20). During this period, LULAC and other organizations that promoted this type of Americanization were acting in the best interests of the Mexican American community. Among the Mexican American community, assimilation was not seen as repressive but rather as a means for gaining status in society.

The YMCA continued its missionary activities in the Mexican American community through the 1940s, providing conferences that used sports and recreation to "encourage good citizenship and desirable values among Mexican Youth," that is, to assimilate and Americanize them (Muñoz 1989, 30). In the 1960s, Chicano activists would begin combating the notion that the Mexican American community lacked "desirable values" and was less worthy of being considered American citizens. A loosely organized group of Mexican American youth emerged from the YMCA conferences and began discussing issues of cultural identification, including the historical repression of their community's identity. Félix Gutiérrez, a UCLA student and former YMCA conference participant, began printing a newsletter entitled "The Mexican Voice," which provided a forum for young Mexican Americans to begin asking questions such as why community members denied their cultural history by self-identifying as Spanish, or why people had historically been hesitant to express pride in their history as Mexican Americans (32–33). Student leaders who emerged from these conferences also began addressing issues of poverty and lack of educational opportunities in the Mexican American community. Remedying these disparities would become the central demands of the Chicano movement.

Chicano Scholar Carlos Muñoz describes efforts of the organizers of "The Mexican Voice" as representing the emergence of a Mexican American movement. These organizers would eventually establish an independent organization called the Mexican American Movement. The Mexican American Movement and "The Mexican Voice" are significant because they represent an early effort by youth to establish a new identity that more appropriately represented the experience of being of Mexican origin but living in the United States. Muñoz cites various examples from "The Mexican Voice" of writers challenging the early twentieth-century

phenomenon of Mexican Americans self-identifying as Spanish and thus denying the totality of their culture and history. Muñoz quotes "Mexican Voice" editor Félix Gutiérrez, who in 1943 expressed anger at Mexican Americans denying the totality of their culture and history:

> Rather discouraging has been a trend . . . among both our Americans of Mexican descent and other[s] . . . of calling any accomplished Mexican American . . . or well-to-do above average either in professional or trade circles . . . "Spanish" or "Spanish American." . . . The whole inference is . . . THAT NOTHING GOOD COMES FROM THE MEXICAN GROUP. The inference . . . is that only the talented, law abiding, the part Mexican, the fair complexioned, the professionals and the tradesmen arc "Spanish." (Muñoz 1989, 45)

The identity of "Mexican American" emerged during this period amongst student and community activists who sought to gain full representation in society without having to deny who they were.

World War II veterans also collectively organized around a sense of cultural unity and experience, most notably in their efforts to establish the American GI Forum. Mexican American men and women fought and served in the U.S. armed forces in a higher proportion to their overall population compared to white Americans. They also proportionally earned more medals of honor than any other racial or ethnic group (Acuña 1988, 253). At the beginning of the war almost three million Mexican Americans were living in the United States, and somewhere between 375,00 and 500,000 served, representing only 10 percent of the armed forces but 20 percent of the casualties. Indignation over this disproportionate sacrifice would reemerge in the Mexican American community during the Vietnam War, when the Mexican American community was once again grossly overrepresented amongst draftees and casualties.

Returning Mexican American World War II veterans looked to the GI Bill of Rights, guaranteeing educational, medical, housing, and other basic benefits, for support in reentering American society and improving their lives. Many Mexican American veterans however found themselves systematically denied their rights and veteran's benefits. In response veteran Héctor García, from Corpus Christi, Texas, headed the creation of the GI Forum. Established in 1948, the forum sought to remedy the discrimination and unequal treatment of Mexican American veterans and their families. The GI Forum provides an early example of members of the Mexican

American community unifying and organizing on the basis of culture and race, a precursor to the more radical organizations that would emerge in the 1960s under the banner of the Chicano movement.

Emergence of Chicanismo

Building on the numerous precursors to the Chicano movement in the post–World War II era, four major events in different areas of the Southwest helped unify Mexican American activism in the 1960s: the labor struggles in California's Central Valley and the creation of the National Farm Workers Association, which became the **United Farm Workers of America (UFW)**; the development of the La Raza Unida Party in Crystal City, Texas; the Land Grant Movement in New Mexico; and the Los Angeles High School Blowouts (or Walkouts). The following section briefly discusses these important developments.

Throughout the 1960s a confluence of social, political, and cultural issues and activity created a unique and special period in American history. Diverse communities organized towards creating institutional and societal changes that would promote civil rights and equality for all Americans. For many years African Americans had worked to eradicate the racist and unjust Jim Crow laws in the South, and their rampant poverty and de facto segregation throughout the United States. In 1954, the landmark Supreme Court decision in *Brown v. Board of Education* outlawed "separate but equal" laws throughout America. Although this decision was a spark and a turning point in the civil rights movement, the Supreme Court had no authority to legally enforce its decision.

This lack of accountability created the central motivation of the civil rights movement: to make law enforcement authorities and government institutions abide by the Constitution and the rule of law. One year after *Brown v. Board of Education* struck down segregation, Rosa Parks and Martin Luther King Jr. emerged as civil rights leaders in the 1955 Montgomery Bus Boycott, seeking to end the Jim Crow law requiring blacks to sit in the backs of buses and give up their seats to white citizens. It was citizens themselves who had to fight for enactment of the important Supreme Court decisions protecting the rights of all peoples regardless of race, color, or gender. The example set by black civil rights activists in the 1950s and 1960s led many other marginalized groups to demand justice and equality, Mexican Americans among them.

The nationwide protests against the escalating war in Vietnam was another important factor in the emergence of the Chicano movement. Much like during World War II, higher percentages of Mexican Americans than white Americans were being drafted and dying. American draft laws became a symbol of American injustice and discrimination because they disproportionately targeted the poor and communities of color. The antiwar movement was a cause that encouraged activism across racial lines. Hundreds of thousands of young white college students across the nation protested the war, and not long before his assassination, Martin Luther King Jr. had begun campaigning to end U.S. involvement in Vietnam.

Labor activists César Chávez and Dolores Huerta met as members of the Community Service Organization (CSO), which organized grassroots union and social justice causes in California. César Chávez became general director of the CSO but resigned when the organization refused to focus its efforts on organizing farmworkers (Chávez 1965). Dolores Huerta founded the Agricultural Workers Association and worked with Larry Itlong, a Filipino leader of the Agricultural Workers Organizing Committee (AWOC), an organization composed of Filipino, black, white, and Mexican American farmworkers. In 1962, Chávez and Huerta co-founded the National Farm Workers Association (NFWA). At the time, both activists stated that the NFWA intended to work for at least five years on developing the union and strengthening its member base before taking action, but in 1965 the NFWA was forced to decide whether or not to mobilize. Their decision to move forward would affect and inspire civil rights leaders across the nation (Chicano!).

On September 8, 1965, AWOC began a strike against nine grape growers around Delano in the San Joaquin Valley. AWOC, composed primarily of Filipinos, had recently organized a successful strike to get their workers the same pay as the Mexican bracero (guest worker) farmworkers. The Di Giorgio Corporation, one of the largest grape growers in California, refused AWOC's demands, and Mexican workers from the surrounding area were brought in to break the strike. Five days later, Larry Itlong approached César Chávez and Dolores Huerta, asking that NFWA join the unionizing effort. On September 16, 1965, Mexican Independence Day, NFWA unanimously voted to join the strike. At the time the fledgling organization had $100 in its bank account (Chicano!). AWOC and NFWA eventually united to form the United Farm Workers, a union which would help inspire and ignite the larger Chicano movement.

Lasting five years, the Delano Grape Boycott would capture the hearts of Mexican Americans and civil rights activists throughout the United States. The unionization of the Mexican and Mexican American workers exemplified a civil rights struggle for just wages and safe working conditions for laborers. The grape boycott highlighted the disproportionate number of poor farmworkers who were Mexican, Mexican American, and people of color. The NFWA, César Chávez, and Dolores Huerta also provided some of the Chicano movement's most iconic moments, such as the 340-mile farmworker march from Delano to Sacramento, and Chávez's commitment to nonviolent tactics, fasting and drinking only water for twenty-five days in support of the farmworkers' strike demands (Chicano!). These forms of activism transformed the farmworkers' struggle into a larger struggle for civil rights, equality, and social justice. Chávez, Huerta, and the UFW were able to link the struggle of agricultural workers and laborers with a larger civil rights movement.

César Chávez and Dolores Huerta also pioneered the integration of the arts in support of labor and civil rights struggles. The founding of El Teatro Campesino was a seminal moment in the Chicano art movement. El Teatro Campesino was a theater group whose purpose was to help the UFW organize and unify workers by portraying the abuses perpetrated by the growers the union was fighting. Many times the *actos* (skits) were improvised and performed on the backs of trucks in the fields of the very growers the union was seeking to unionize. El Teatro Campesino would go on to become a Chicano art institution, presenting plays around the world.

La Alianza Federal de Mercedes (The Federal Alliance of Land Grants) was another movement that captured the imagination of Chicano activists. La Alianza was established by Reies López Tijerina, who had studied the Treaty of Guadalupe Hidalgo and recognized that Mexican Americans had been systematically defrauded of the rights it supposedly guaranteed them. He became convinced that national forest land in Tierra Amarilla in northern New Mexico belonged to the Pueblo de San Joaquín de Chama. Tijerina believed this land was an *ejido*, or village communal property, that under Mexican law and the Treaty of Guadalupe Hidalgo belonged to the people of the community. In 1966, Tijerina led a group of 350 people who occupied Tierra Amarilla, proclaiming the ejido rights of the Pueblo de San Joaquín de Chama to 1,400 acres of the Kit Carson National Forest (Acuña 1988, 340). La Alianza's actions led to a confrontation with forest

rangers and a violent takeover of Tierra Amarilla's courthouse, where members of La Alianza were detained.

Although no lands were ever given back to descendents of the original Mexican land-grant holders, Reies López Tijerina and La Alianza pushed the Treaty of Guadalupe Hidalgo into the forefront of Mexican American consciousness. Their armed attempt to regain lands appropriated by white Americans after the U.S. victory in the Mexican War was a powerful and striking statement about the historical legacy of Mexican Americans in the Southwest. Ideas of land, an original homeland, and an occupied Southwest would become major issues addressed by student activists seeking to develop a framework for a new Chicano identity and political direction.

In 1963, Crystal City, Texas, was the site of a dramatic but short-lived shift in the political landscape of the Mexican American community. Crystal City, located in Zavala County, forty-five minutes from the Río Bravo (Rio Grande in U.S. parlance), was historically a prominently Mexican American community. Yet despite its Mexican American majority, Anglo politicians held political control of the city on the state and local levels. The Mexican American community in Crystal City felt poorly represented by politicians who did not share or empathize with their experience. In an effort to attain better representation, a group of five Mexican Americans ran for and were elected to the city council. Cannery workers, represented by the Teamster's Union with support from the Political Association of Spanish-speaking Organizations (PASSO), were the primary leaders of this organizing effort. For the first time since the aftermath of the Mexican War, Mexican Americans held complete political control of the community. These five elected officials became known as Los Cinco. Although they lost power just two years later, their election was a major event in the effort of Chicano activists to gain political autonomy. Crystal City eventually became one of the bases of La Raza Unida Party, an ambitious attempt to establish a national Chicano political party (Chicano! Fighting for Political Power).

As in many communities throughout the Southwest, in Los Angeles de facto segregation plagued communities of color, in turn creating unequal educational resources and opportunities for Mexican American youth. Primarily Mexican American students from California State University, Los Angeles, and from various East Los Angeles high schools, with the support of a few teachers, organized direct action to restructure the educational system that was provided to the Mexican American community. This

activism took the form of a strike that became known as the East Los Angeles Blowouts (or Walkouts). For the first time in U.S. history, Mexican American students protested en masse against the racism plaguing public education and its failure to provide equitable educational opportunities for all students (Muñoz 1989, 65). For a week and a half in 1968, ten thousand Mexican American students walked out of five high schools located in predominantly Mexican American neighborhoods.

Not only was this the first widespread Mexican American student protest, it was also the first time that Mexican American activists began identifying their political engagement as Chicanismo. The Chicano identity had yet to have a complete political ideology attached to it. But the signs and slogans of "Chicano Power" were becoming a powerful articulation of a political identity for Mexican American activists.

■ National Chicano Youth Liberation Conference and Aztlán

In 1965 in Denver, Rodolfo "Corky" Gonzales established the first Mexican American civil rights organization, the **Crusade for Justice.** Four years later, in March 1969, the Crusade for Justice sponsored the National Chicano Youth Liberation Conference, seeking to provide direction and unity to the diverse Mexican American activism of the 1960s. Activists and leaders throughout the Southwest attended the conference. Over the course of a week they discussed the numerous issues affecting their communities. They also sought to define and conceptualize the Mexican American experience, addressing the ways Mexican American culture had been historically repressed by the dominant Anglo-American culture. The discussion at the conference brought to light that cultural colonialism had caused many successful and educated Mexican Americans to distance themselves from the community from which they emerged. It was also the reason Mexican Americans did not feel proud of their history and culture. The common desire of Mexican Americans to be perceived and identified as white or Spanish or simply American was clearly attributed to a repressive American culture that did not value the cultural contributions of the Mexican American community.

The conference attendees outlined a strategy to begin eliminating this cultural colonialism and instead develop an identity that more completely represented the Mexican American experience. Based on this discussion

conference leaders drafted a document called "El Plan Espiritual de Azt-
lán" (The Spiritual Plan of Aztlán). El Plan encouraged civil rights activ-
ists to use cultural nationalism as a tool to unite Mexican Americans across
"religious, political, class, and economic factors" ("El Plan Espiritual de
Aztlán" 1970). Nationalism, in the view of conference leaders and partici-
pants, would encourage unity based upon a common cultural history.

Scholar Martha Menchaca, in *Recovering History, Constructing Race*, de-
scribes how Chicano scholars, particularly the Chicano poet Alurista, envi-
sioned a homeland in the United States for Mexican Americans. Alurista,
who was a conference participant, is often acknowledged as the poet and
scholar who first put forth the idea of **Aztlán** and tied it into the Chicano
civil rights struggle. Aztlán is said to be the original homeland of the
Aztecs, the place whence they began their migration in search of an eagle
perched atop a cactus, devouring a snake (which, legend said, would be the
sign showing them where to build their capital). Generally, Chicanos inter-
preted Aztlán to represent the southwestern states annexed by the United
States after the Mexican War. The idea of Aztlán gave "Mexican Ameri-
cans a source of pride in their indigenous heritage . . . and transform[ed]
that racial heritage into a legacy of pride. It was also Alurista's attempt to
dispute the myth that Mexican Americans were solely a recent immigrant
group in the United States and therefore had not contributed to the growth
of the nation" (Menchaca 2001, 20–21). It is important to note that Aztlán
was an idea first articulated by an artist, a creative vision that helped forge
a spiritual relationship between Mexican Americans and the land where
they now resided.

"El Plan Espiritual de Aztlán" spoke of the Mexican American commu-
nity being "free and sovereign to determine those tasks which are justly
called for by our house, our land, the sweat of our brows, and by our
hearts." El Plan also spoke of "declaring Independence of our Mestizo
nation. . . . We are a nation, we are a Union of free pueblos, We are Aztlán."
Did Chicanos declare literal independence from the United States? Did
Chicanos declare war with this document? Of course not. Rather, they
were declaring their intention to fight for equal access to American democ-
racy, political representation, and higher education. Aztlán was a meta-
phor for Mexican Americans' attempt to reimagine their relationship to
the United States and, in particular, the Southwest.

One month after the National Chicano Youth Liberation Conference
a network of Chicano students, faculty, and staff from universities and

colleges across the Southwest, calling themselves the Chicano Council on Higher Education (CCHE), held a conference at the University of California, Santa Barbara. Embracing the ideas of the Denver Conference, the Santa Barbara attendees sought to develop a strategy that would not only facilitate Mexican American access to higher education but would also develop an academic curriculum that better served the Mexican American and Chicano community. They viewed assuming control over their own education as the means for achieving equity and empowerment.

El Plan de Santa Barbara: A Chicano Plan for Higher Education, the document emerging from the Santa Barbara conference, outlined a structure for Chicano self-determination within higher education. It also took the ideas in "El Plan Espiritual de Aztlán" further by defining *Chicano* as a new identity. It called for Chicano studies programs to teach the culture and history long denied Mexican Americans. Understanding that the leaders of academia would not welcome Chicano studies into the university curriculum, they established that the program must serve and gain its validity from the surrounding Mexican American and Chicano community. Lastly, the Santa Barbara conference advocated that the many diverse Mexican American student groups throughout the Southwest adopt a common student and community organization, one consistent with the visions and strategies outlined at both the Denver and Santa Barbara conferences. Student organizations dropped their old names and collectively became El Movimiento Estudiantil Chicano de Aztlán (Chicano Student Movement of Aztlán, MEChA).

El Plan de Santa Barbara presented *Chicano*, historically a pejorative class-bound epithet, as the root idea of a new identity as a Mexican American who was politically empowered and believed in the goals of the Chicano movement. The movement was a quest for a new identity, a creative process, a continual reimagining and redefining of terms, identities, histories, and symbols. In many ways, this creative reimagining created or allowed for instability. Just a few years after the movement's outset, fissures appeared that proved irreconcilable. Some people saw the radical and nationalist activists as impractical; others saw those groups that sought political change within the system as too mainstream. There were some who benefited from higher education and affirmative action, and those who still remained marginalized and excluded. As the political climate changed—with the end of the Vietnam War, the government's crackdown on radical groups, and enough political concessions achieved for some to

feel their goals had been met—the concept of a politically empowered Chicano became nebulous. Who was allowed to lay claim to that identity? Although two major plans, or manifestos, were drafted at the Denver and Santa Barbara conferences, disagreement continues today over the true meaning of *Chicano/Chicana*.

◼ Approaching Democracy and Approaching Chicanismo

As Mario Vargas Llosa, influential Peruvian novelist and scholar, eloquently states, "It is not culture that unites the Afghani cabbie of New York City, the Jewish Hollywood producer, the Basque shepherd of the Idaho forests, the Korean biologist at Berkeley. . . . It's an open and flexible system, profoundly democratic, which allows all those different ways of being, believing and living to co-exist and have a sense of mutual solidarity without renouncing their cultural uniqueness" (Vargas Llosa 2005, 25–26). What unites all U.S. citizens and gives the United States of America the potential to be a great nation is its civic culture. The term describes the way diverse peoples coexist under a social foundation that secures the rights of everyone regardless of race, ethnicity, country of origin, and gender. The notion of civic culture, of course, has developed and progressed over the course of American history. The emancipation of the slaves, the women's suffrage movement, and the civil rights struggles have all helped push the United States closer to a truly representative democracy. This movement, however, did not occur by itself, and Americans with wealth and political power most often did not lead it. Instead, meaningful change in America has traditionally come from those people struggling for the protections offered by the Constitution, and demanding the rights and privileges afforded the dominant white Anglo, primarily male, elite.

In this book I consider Chicanismo to be the ideology behind the Chicano movement and those people who self-identify as Chicano or Chicana. Those Americans of Mexican descent who do not identify with the Chicano movement or think of themselves as Chicano or Chicana I refer to as Mexican Americans. People whose origin is from countries in Latin America other than Mexico I refer to as Latinos/as. People throughout Latin America have shared a similar colonial experience as Mexicans; many have crossed borders and discovered their own form of mestizaje. As a result, many Latin Americans living in the United States identify with the

Chicano movement and the experience of Chicanismo. Many even iden-
tify as Chicano or Chicana. There are cultural differences across Latino
groups, however, and many Latino/Latina immigrants are middle- or
upper-class political refugees, differences that sometimes create tensions
between them and Mexican Americans and Chicanos/Chicanas. *Hispanic*
is a conservative term derived from *Hispania*, the name the Romans gave to
what is now Spain and Portugal. *Hispanic* emphasizes the Spanish experi-
ence of people of Latin American descent, focusing more on the European
component of mestizaje, while diminishing or disregarding its indigenous
roots. Hispanic as an identifier harks back to the generation of Mexican
Americans who felt it necessary to identify with Europe in order to have
validity as Americans. It is also the official U.S. census designation for
people of Latin descent. Unfortunately, despite the diverse cultures that
make America a vibrant nation, "American" is still widely idealized as
Anglo-Protestant culture. A Mexican American or Chicano or Latino pos-
sessing a long and rich history in the Southwest shouldn't have to deny his
or her culture in order to be embraced or accepted as an American.

Lastly, the definition of Chicanismo as an idea, a way of being, and a
view of history is in constant evolution—a process that continues to this
day. In this survey of the Chicano art movement I promote and encourage
the continued creation of Chicanismo. Forty years ago, Chicano artists
began looking to their communities for inspiration and validity. They
began seeing the arts as tools to further the goals of the Chicano movement.
But forty years is only a blip of time. I write with a sincere belief in the
potential of the creative process to open doors to a better world, one that
isn't reflected in the everyday. Chicano art provides just such a door.

■ Organization of This Book

This book is chronologically organized. Chapter 1 discusses some of the
artistic movements that have influenced Chicano artists. The Mexican
artist José Guadalupe Posada's work as a printer and illustrator profoundly
shaped the ways Chicanos would make art. His accessible, popular imag-
ery and use of mass-produced broadsheets were a unique example of how
art could be socially relevant. The **Mexican mural movement**'s role in the
development of a new Mexican identity in the post–Mexican Revolution
period is vital to understanding the way Chicanos used the arts to articulate

their own new identity and culture. The Works Progress Administration's (WPA) support of the arts during the New Deal era was also vital in the emergence of arts reflecting and representing culture. Lastly, the effort of Mexican and Cuban **talleres** (print workshops) to democratize the arts by combining print with artistic expression helped make posters and prints one of the key media of Chicano artists.

Chapter 2 discusses the role of the visual arts in the Chicano movement. In this chapter I explain the different ways artists who identified with Chicanismo worked to serve the goals of the movement. The poster and the mural are the two primary art forms that initially served Chicano activism. As scholar Alicia Gaspar de Alba states, "Chicano art, then, was about activism, and as such, relied heavily on two forms for its production and dissemination: the mural and the poster" (Gaspar de Alba 2001, 206). Chapter 3 looks deeper into how the prominent issues and themes prevalent in Chicano culture have been and continue to be expressed in various artistic media (paintings, prints, murals, altars, sculptures, and photography). The themes I discuss are nationalism and pre-Columbian culture, labor, family, feminism, gender and sexuality, immigration and the border, imperialism and the antiwar movement, third world liberation struggles, and Chicano popular culture.

In chapter 4 I discuss the importance of art collectives, examining several important collectives and how they organized themselves and viewed their role in the Chicano movement. This review is by no means complete or geographically comprehensive, but I attempt to give a solid understanding of the range of ideas that brought Chicano artists together with a common purpose and mission. Very few Chicano art collectives are still working together, but their contribution to Chicano art is integral. In many ways, their formation, collective work, and eventual disintegration mirror the directions Chicano art has taken over the past forty years.

Chapter 5 charts the development and emergence of Chicano talleres and community art centers. Instead of seeking validation for their work from the mainstream Anglo-dominated art world, many Chicano artists and enthusiasts sought to develop an alternative that would give the Chicano and Mexican American community greater access to the arts. Although many talleres established in the late 1960s and early 1970s are no longer in existence, a few have managed to continue supporting cultural production and to maintain a vibrant position in their community.

To close, chapter 6 discusses recent trends in Chicano art. I begin by highlighting major exhibitions of Chicano art and examining how the history of Chicano art has been presented to the general public. Also discussed are the signs that Chicano art is becoming accepted into mainstream art institutions: the emergence of Chicano archives and art collectors whose support has expanded, or perhaps compromised, the Chicano art movement. I end with a discussion of a pair of articles published in the Chicano journal *Metamorfosis*, debating the direction of Chicano art in the late 1970s and early 1980s. I encourage artists and creative people to see Chicanismo as an idea in process, one that continues to be re-created and redefined. I also emphasize the importance of artists and cultural workers in developing new frameworks for understanding our collective experiences—frameworks that empower and uplift those people who are too often marginalized by dominant American culture.

Due to the structure of the Mexican American Experience series I was unable to reproduce every artwork and image discussed throughout this book, much as I might have liked to. This limitation posed a challenge in discussing various artworks: visual art is most meaningful when it is seen, not described. Almost all of the artworks described in this book are pictured either in various texts and exhibition catalogues, or online at gallery or museum Web sites and at artists' personal Web sites. Online images can usually be located by typing the artist's name and title of the artwork into an Internet search engine. Throughout the text I also cite print sources where specific works are pictured whenever applicable. Here I list several main texts that contain good reproductions of many of the artworks described throughout this book.

Reproductions of artworks discussed in chapter 1 ("Artistic Influences on the Chicano Art Movement") can be found in the following books:

Jose Clemente Orozco in the United States, 1927–1934, by Dawn Ades et al.
Mexico and Modern Printmaking: A Revolution in the Graphic Arts, 1920–1950, by John Ittmann
Art and Revolution in Latin America, 1910–1990, by David Craven
Diego Rivera: The Detroit Industry Murals, by Linda Banks Downs
Mexican Muralists: Orozco, Rivera, Siqueiros, by Desmond Rochfort

Reproductions of most artworks discussed throughout chapters 2–6 can be found in the following several texts and exhibition catalogues:

Chicana Art: The Politics of Spiritual and Aesthetic Altarities, by Laura E. Pérez

Painting the Towns: Murals of California, by Robin J. Dunitz and James Prigoff

Signs from the Heart: California Chicano Murals, by Eva Sperling Cockcroft and Holly Barnet-Sánchez

Chicano Visions: American Painters on the Verge, by Cheech Marin

Just Another Poster? Chicano Graphic Arts in California, by Chon A. Noriega

Latin American Posters: Public Aesthetics and Mass Politics, by Russ Davidson

Contemporary Chicana and Chicano Art: Artists, Works, Culture, and Education (2 vols.), by Gary D. Keller et al.

Bear in mind that this book is far from comprehensive. *Chicana and Chicano Art* serves only as an introduction to the vast cultural production of Mexican American and Chicano artists since the emergence of the Chicano movement. My intention in this overview is to provide an understanding of the structure and unique characteristics of the Chicano art movement. Chicano visual production is an important field that needs greater research, study, and publications to highlight the important contributions of Chicano art to the greater American landscape and experience.

■ Discussion Questions

1. Discuss colonialism's role in the development of mestizaje.

2. Discuss how the Mexican American generation during the World War II era approached getting ahead and becoming accepted as Americans through assimilation. Why did Chicano activists find the assimilation approach problematic?

3. Discuss the evolution of the term *Chicano/Chicana*. Why was its adoption as a political identity significant?

4. Discuss Chicanismo and its characteristics. How did the Chicano movement and activists develop a new political consciousness for the Mexican American community? Discuss the meaning of self-determination. What did self-determination mean to Chicano activists?

5. Discuss *Aztlán* as a metaphor. How did the idea of Aztlán empower activists and community members during the Chicano movement?

▪ Suggested Readings

Acuña, Rodolfo. *Occupied America: A History of Chicanos*. 3rd ed. New York: Harper-Collins, 1988.

Chicano! History of the Mexican American Civil Rights Movement. Video. Los Angeles: NLCC Educational Media, 1996.

de la Torre, Adela, and Beatríz M. Pesquera, eds. *Building with Our Hands: New Directions in Chicana Studies*. Berkeley: University of California Press, 1993.

Fregoso, Rosa Linda. *meXicana Encounters: The Making of Social Identities on the Borderlands*. Berkeley: University of California Press, 2003.

García, Ignacio M. *Chicanismo: The Forging of a Militant Ethos among Mexican Americans*. Tucson: University of Arizona Press, 1997.

Goldman, Shifra M., and Tomás Ybarra-Frausto. *Arte Chicano: A Comprehensive Annotated Bibliography of Chicano Art, 1965–1981*. Berkeley: Chicano Studies Library Publications Unit, University of California, 1985.

Haney López, Ian F. *Racism on Trial: The Chicano Fight for Justice*. Cambridge, MA: Harvard University Press, 2003.

Huntington, Samuel P. *Who Are We?: The Challenges to America's National Identity*. New York: Simon and Schuster, 2004.

Menchaca, Martha. *Recovering History, Constructing Race: The Indian, Black, and White Roots of Mexican Americans*. Austin: University of Texas Press, 2001.

Muñoz, Carlos Jr. *Youth, Identity, Power: The Chicano Movement*. New York: Verso, 1989.

Oropeza, Lorena. *¡Raza Sí! ¡Guerra No! Chicano Protest and Patriotism during the Viet Nam War Era*. Berkeley: University of California Press, 2005.

Ruiz, Vicki L. *From out of the Shadows: Mexican Women in Twentieth Century America*. New York: Oxford University Press, 1998.

Vargas Llosa, Mario. "Extemporaneities: Sleeping with the Enemy." *Salmagundi* [Skidmore College] nos. 148–49 (2005): 23-35.

Artistic Influences on the Chicano Art Movement

In this chapter I present a select sample of the artistic movements and artwork that influenced artists during and after the Chicano movement. Chicano and Chicana art was the visual representation of the political and cultural aspirations of the Mexican American civil rights movement. The mural and poster were two primary art forms adopted by Chicano artists because of their unique capability to reach audiences outside of traditional art venues such as galleries and museums. As scholar Alicia Gaspar de Alba states, "Chicano art . . . was about activism" (Gaspar de Alba 2001, 206). These two quintessentially Chicano art forms have direct ties to the Mexican mural movement that emerged after the Mexican Revolution and from the printmaking and graphic arts produced in Mexico by José Guadalupe Posada and the Taller de Gráfica Popular (Popular Graphics Workshop). Chicano art historian Jacinto Quirarte (1988) makes the point that Chicano artists found inspiration in these Mexican art movements because they presented an example of artistic practices whose function was to educate and contribute to creating a new Mexican identity free of colonial interference. An understanding of these influences is important to an appreciation of the unique nature of the Chicano art movement.

There were many international and domestic influences on the Chicano art movement. In the United States government-sponsored art programs during and after the Great Depression were influenced by the Mexican mural movement and subsequently influenced Chicano artists. The Works Progress Administration (WPA) Section of Fine Arts and the Federal Art Project were two federally sponsored art programs intended to create "a cultural democracy." In an effort to make the arts accessible to all people regardless of demographics or economics these programs encouraged the proliferation of community art centers. Creating "cultural democracy" was similarly an intention of artists during the Chicano movement.

Emergence of a Mexican National Art: Challenging Colonial Art

As a colony of Spain, Mexico's art from conquest to independence was based on European aesthetics of beauty. Spain used colonial art as a tool to exalt its presence and its ideologies. Art officially sanctioned by the Spanish crown, including commissions and government-supported art academies, visually represented not an autonomous nation, but rather a subservient colony that had hardly begun the long process of forging its own distinct national identity. Art in colonial Mexico reinforced Spanish economic, political, and spiritual domination. The curriculum of the main art school in Mexico, the Royal Academy of San Carlos, is one of the best examples of how state-sanctioned art in Mexico during the colonial period favored and promoted European aesthetics.

The Spanish crown established the Royal Academy of San Carlos in 1785. Throughout modern Mexican history the academy has played a highly significant role in educating the artists who have created a visual representation of what it means to be Mexican, including Diego Rivera, José Clemente Orozco, and David Alfaro Siqueiros. Eventually the academy would undergo sweeping changes, but throughout much of its history, whether under royal or Mexican government control, European standards were imposed on the curriculum and the instructors were almost exclusively from Europe and Spain.

Jean Charlot, a muralist and writer, wrote a clear account of the structure of the Academy of San Carlos in his book *Mexican Art and the Academy of San Carlos, 1785–1915*. The first director of the academy was Jerónimo Antonio Gil, master engraver to the Spanish king. He was sent to the Spanish colony of Mexico to "supervise the art standards" and ensure that the school's curriculum "followed the pattern set by European academies" (Charlot 1962, 20, 25). The process of selecting the second director of the academy is perhaps the most telling example of the academy's mission to exalt Spanish ideals. A call was placed in 1793 to academicians of merit, men who had graduated from one of the two royal academies, San Fernando of Madrid or San Carlos of Valencia (Charlot 1962). The new director would be selected through a competition that included making a painting based on an assigned historical theme, that of Christopher Columbus's landing in America—a landing, of course, that led to Spain's dominion over the New World.

The art academy's glorification of the Spanish conquest of America, in effect validating the erasure of indigenous life and culture, was just one way that the academy used art and visual representation to exalt European culture while suppressing any notion of a national Mexican identity or culture. Academic instructors degraded those aspects of culture outside of Spanish control, such as the folk art seen in the streets and churches, viewing them as ignorant and shameful. Following Mexican independence, the school, no longer funded or controlled by the Spanish crown, was renamed the National Academy of the Three Fine Arts of San Carlos in Mexico. The name change was to represent national control over the school, and it marked the first time in the academy's history that students and instructors began to visually elaborate on a national art. The efforts were small, however, certainly not enough to overcome centuries of colonial indoctrination, and art instruction continued to import aesthetics from European cultural centers such as Germany, via Rome and Barcelona, and later, Paris. This trend continued right up until the Mexican Revolution (Charlot 1962).

In 1910, President Porfirio Díaz chose to celebrate the one hundredth anniversary of Father Hidalgo's uprising against Spain by hosting a gigantic display of contemporary Spanish art. Although the exhibition was part of a celebration of Mexican independence from colonial rule, Mexican artists were entirely left out of the exhibition. The national identity propagated by the government was inextricably linked to European ideas and representations. It would take a violent decade-long revolution to finally shake Europe's hold over Mexican art.

Even before the Mexican Revolution, however, there were already developments pointing to the articulation of a new national identity. Despite its history of upholding European standards, the Academy of San Carlos became a focal point of creative unrest. While Porfirio Díaz was celebrating Mexican independence by lauding Spanish art, students in the academy rebelled by hanging an exhibition of work by Mexican art students and practicing artists—work that represented a true celebration of Mexican identity. Art instructor Gerardo Murillo, later known as Dr. Atl, influenced and guided this significant rebellion. Adopting the name Atl, the Náhuatl word for water, was a reflection of Murillo's adherence to Mexican nationalism, a nationalism that incorporated the nation's indigenous roots. His exhibition, "Show of Works of National Art," held at the Academy of San Carlos, was one of the first to incorporate racial consciousness

Mexico rejected Mexican style art

in the creation of a Mexican style. Whereas previous exhibitions and instruction denied and excluded the indigenous history and culture of Mexico, this exhibition incorporated such pieces as Saturnino Herrán's "The Legend of the Volcanoes," based upon an indigenous myth, and Jorge Enciso's "Anáhuac," a life-size Native American standing at dawn in front of a cactus and a lake (Charlot 1962).

During the Mexican Revolution, Dr. Atl was appointed director of the Academy of San Carlos and also served as head of propaganda for Venustiano Carranza's military efforts in Mexico City. Dr. Atl had traveled extensively around Europe and was the first to draw his students' and colleagues' attention to the Italian mural renaissance as an important form of social art. His guidance and leadership had a great impact on emerging artists, and as a result, his teachings would continue to influence the course of art in the postrevolutionary period. Painter and muralist José Clemente Orozco, in particular, recognized the importance of Dr. Atl's anticolonialist and Mexican nationalist ideas. "As we listened to the fervent voice of that agitator Dr. Atl," Orozco recalled, "we began to suspect that the whole colonial situation was nothing but a swindle foisted on us by international traders. We too had character, which was quite the equal of any other. We would learn what the ancients and the foreigners could teach us, but we could do as much as they and more" (Rochfort 1993, 18). Atl's ideas were a reflection of Mexico's larger movement away from the Porfiriato (as the administration of Porfirio Díaz is called) and neo-colonialist intervention. Artists experienced an awakening, a realization that art could and should take into account influences from all sources, and that artists could create and represent an authentic Mexican culture.

Atl's ideas about the social and political role of the artist in society were also influential. He strongly believed artists should participate in the revolutionary struggles taking place, a position directly opposed to the traditional idea that art should be free of political influence or activity. In his nomination speech as the director of the academy, he spoke of the importance of working collectively in workshops to teach new forms of art making. He also urged the students to create a consciously national art that would be monumental in form and accessible not just to the elite, but to the wider public. In 1914, at the height of the Mexican Revolution, Dr. Atl convinced Orozco and the young David Alfaro Siqueiros, as well as other academy students, to join his efforts to support Carranza and the recently formed Constitutionalist army in the southern town of Orizaba (Rochfort

1993). Once there, Dr. Atl used printing presses taken from the academy to establish the newspaper *La Vanguardia*. Siqueiros served as the paper's military correspondent and Orozco provided illustrations. Both artists' active participation in the revolution would greatly influence their work in the postrevolutionary period.

As the Mexican Revolution began, so too did a revolution in Mexican art. Rather than look to Europe or to the halls of the classical art academies for inspiration and validation, future revolutionaries and artists began looking at what surrounded them on a daily basis. They turned to the indigenous population in Mexico, recognizing indigenous culture as a valid subject of art, and perhaps more importantly, as an intrinsic part of their own patrimony. Artists and revolutionaries continued looking for other nontraditional art forms, delving further into their own culture and history for inspiration. One such art form was found in print shops. Here meticulous draftsmen and storytellers practiced a highly skilled craft that interacted with society on a scale unattainable for most traditional art forms.

José Guadalupe Posada

José Guadalupe Posada (1852–1913) was a printer and illustrator, working first in **lithographic** studios in Guanajuato, Mexico, and later utilizing **relief printing** techniques to produce broadsides in Mexico City. When Posada died in 1913, at the onset of the Mexican Revolution, he was largely unknown. Only one of the three neighbors who certified his death knew his proper name, and the state paid for a sixth-class burial (Mock 1996). We do not know where he lived, and only two photographs of him have survived. Posada's personal anonymity, however, certainly didn't extend to his work; his methods, creativity, and purpose influenced all strata of Mexican life. Scholars estimate Posada produced upwards of twenty thousand images in broadsheets, pamphlets, and chapbooks. These reproductions touched the lives of ordinary Mexicans who had little or no experience with fine art and the exhibitions of the academic artists at the Academy of San Carlos. His influence on modern Mexican art, on the **Mexican mural renaissance,** and on the art and structure of the Chicano art movement cannot be overstated. Anita Brenner, in her seminal book *Idols behind Altars*, described José Guadalupe Posada as a "prophet of two revolutions, both of them violent" (Brenner 1929, 185), referring to the coinciding political and cultural upheaval of the early twentieth century. In 1944,

the Art Institute of Chicago held the first retrospective in the United States of Posada's work, calling him the "Father of Modern Mexican Art" (Miliotes 2006, 3). Posada, more than any other figure, represents the cultural renaissance of **Mexicanidad.** Artists seeking imagery and art media that expressed and represented authentic Mexican culture discovered in Posada a model of the artist as social activist and agitator, as a people's spokesman and documenter, and as a creator of culture. For this reason he left an indelible imprint on Mexican artists in the 1920s and on Chicano artists emerging in the late 1960s.

Who was José Guadalupe Posada?

José Guadalupe Ruiz Aguilar Posada was born in Aguascalientes, Mexico, in 1852. He learned to read and write at an elementary school operated by his brother, José Cirilo, and developed his drawing skills at the Municipal Academy of Drawing. By the age of fifteen he was registered as a painter in the general census of Aguascalientes (Mock 1996, 3). In 1868, Posada began an apprenticeship with lithographer José Trinidad Pedroza. Several years later, Posada accompanied Pedroza to León, Guanajuato, where Posada made illustrations of religious imagery and political caricatures for a variety of objects such as books and cigar boxes (Ittmann 2006, 6). In 1876, Posada took sole control of the workshop following Pedroza's relocation back to Aguascalientes. Over a twelve-year period, Posada continued providing illustration services for several publications while teaching lithography at a León high school.

Lithography had flourished in Mexico during the nineteenth century. Claudio Linati, an Italian nobleman, had introduced the printing method to the country. Linati established a periodical entitled *El Iris* which, although it lasted only a year, served as a catalyst for the creation of other periodicals and journals publishing lithographs full of political and social satire (Williams 2006). Working within this printmaking tradition, Posada would make his breakthrough upon moving to Mexico City in 1888. There, he entered his most prolific and influential period of production, opening his own workshop and finding freelance work illustrating at least twenty-three different periodicals. He soon joined the print shop of Antonio Vanegas Arroyo as a salaried illustrator. Vanegas Arroyo's operation produced thousands of images, ranging from commercial advertisements and children's stories to playing cards, recipes, and prayer sheets (Mock 1996, 7).

The Broadside Defined

The broadside sheets Posada illustrated were the most notable pieces published by Vanegas Arroyo. The broadsides accompanied events, verses, and songs, and especially **corridos**. Printed on one or both sides of a large sheet of inexpensive paper, the broadside was widely circulated. Combining bold headlines, illustrations, and text, the broadsides publicized scandals and human-interest stories of all types, becoming a form of street literature. The news, stories, songs, and illustrations documented the times, creating a people's history (Frank 1998). The broadside was a popular art form that— as opposed to fine art which reached only academics, museums, and galleries—presented stories and events to the largely poor and illiterate or semiliterate segment of Mexican society. For those who were illiterate the story of the corrido would be illustrated in a direct manner, often at the top of the broadside. For those who could read, the broadside would provide the story in a lyrical fashion as well. Despite heavy restrictions and repression of the press during the two decades leading up to the Mexican Revolution, Posada and Vanegas Arroyo were a part of a large, vibrant press movement that flourished as it brought often sensationalized news and images to the Mexican people.

THE BROADSIDE'S CONTENT: CALAVERAS AND CORRIDOS

Of the many varied topics illustrated and discussed in the broadsides, two in particular are of historical importance to the development of Chicano art: the **calavera** (skull) and the **corrido** (ballad). In Vanegas Arroyo's print shop the calavera was animated to represent a number of scenarios or political and public figures. Posada is most closely associated with popularizing the image of the calavera, but it was Manuel Manilla, an illustrator working for Vanegas Arroyo before Posada joined the publishing house, who first began using calaveras in broadsides. Vanegas Arroyo owned Manilla's and Posada's plates and would often use images by both of them in one broadside.

The calavera is viewed as a unique expression and representation of the relationship between life and death in Mexico (figure 1). This is especially true in the context of Mexico's annual **Day of the Dead** celebrations. Rather than mourning the loss of those who have passed on, the abundant and colorful festival celebrates and pays homage to their lives. Posada, tapping

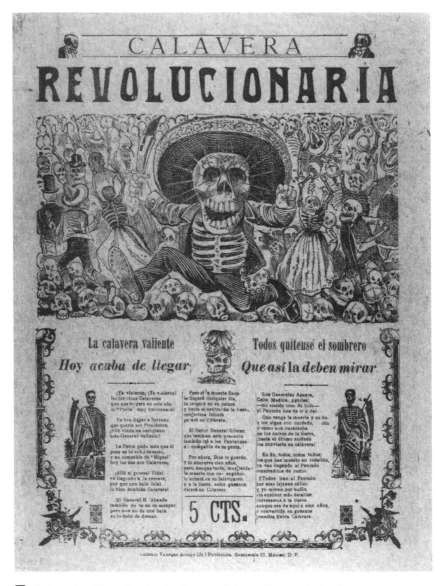

1. José Guadalupe Posada. *Revolutionary Calavera*. Photo-relief etching on green wove paper, 400 x 300 mm, ca. 1910. (William McCallin McKee Memorial Endowment, 1943.1288; Photo: Karin Patzke; Reproduction: The Art Institute of Chicago)

into this experience, used the calavera as a reminder that death spares no one. He satirized those who lived life forgetting this very important point.

THE BROADSIDE AND THE COMMUNITY

Many of the images Posada produced accompanied corridos. The late Américo Paredes, foremost Chicano scholar of Chicano oral histories and literature, described corridos as "narrative folk songs, especially those of epic themes, taking the name from 'correr,' which means to run or to flow, for the corrido tells a story swiftly and without embellishments" (Paredes 1958, xi). For many Mexicans and Chicanos, the corrido has long served as one of the most important forms of oral history and storytelling. It has also been a vital means of documenting social and political changes, and passing knowledge from one generation to the next. The famous ballad "El Corrido de Gregorio Cortez," the story of a Mexican wronged by white aggressors along the U.S.–Mexico border, is one example of storytelling relevant to both Chicanos and Mexicanos.

Corridos published in broadsides incorporated visual imagery and lyrics, and had a common language understood by all segments of Mexican society. *Corridistas*, or musicians who traveled from one market to another, distributed the broadsides as they sang. The corridistas' audiences, usually poor and illiterate, bought the corridos for a few centavos to look at the illustrations, often while the corridistas played their songs. This gave listeners a dynamic experience, an opportunity to fully access the information conveyed in the song.

Posada and the Revolution

At the beginning of the Mexican Revolution, Posada began illustrating broadside corridos that addressed political subjects as varied as the entry of a presidential candidate into Mexico City, labor strikes, fuel shortages, soldiers, heroes such as Pancho Villa and Emiliano Zapata, and *soldaderas*, women soldiers active in the revolution (Mock 1996). Although he died early in the revolutionary period, his representations of revolutionary change in Mexico and his efforts to reach the populace with his art would have a lasting impact. In the 1920s, Mexican artists led a revolutionary cultural project funded and supported by Mexican Education Secretary José Vasconcelos. Posada was one of their strongest models. He was seen as a thoroughly Mexican artist who created art separate from European

ideals, forms, and aesthetics. His work embraced and represented the unique characteristics of Mexican society and history.

Posada's Legacy and Influence

Most art historians consider Posada the bridge between traditional and modern Latin American and Mexican art. He is credited as a forerunner of the graphic traditions of the Taller de Gráfica Popular of Mexico City in the 1930s and 1940s, as well as of the muralists of the modern Mexican movement (Mock 1996). Diego Rivera paid homage to Posada in his mural at the Hotel del Prado in Mexico City. In this mural Rivera depicts his father as José Guadalupe Posada and his mother as Calavera Catrina, Posada's critique of vanity, an image of a calavera adorned with flowers, feathers, and bows. Rivera spoke of Posada as one of his most influential teachers (Frank 1998, 230), and both Rivera and José Clemente Orozco spoke in their autobiographies of their experiences as young artists passing by his studio on their way to the Academy of San Carlos and observing his working method. Rivera went so far as to say that he and Posada had philosophical conversations about art and expression. In a similar vein Orozco wrote, "Posada used to work in full view, behind the shop windows, and on my way to school and back, four times a day, I would stop and spend a few enchanted minutes watching him, and sometimes I even ventured to enter the shop and snatch up a bit of the metal shavings that fell from the aluminum-coated metal plate as the master's graver passed over it" (Mock 1996, 13). The close proximity of Posada's workshop to the Academy of San Carlos very likely brought Orozco and Rivera past his storefront, but many scholars, such as Patrick Frank, have questioned the extent to which the young Rivera and Orozco interacted with the master printer. Nevertheless, their personal reflections show the extent to which his working method and illustrative style influenced the **Mexican mural renaissance.**

Likewise, Posada's influence on the Mexican muralists would in turn inspire the Mexican American artists seeking to develop new working methods and representations of **Chicanismo.** Posada's rapid and prolific production of artwork geared toward the impoverished, semiliterate Mexicano would be an important example for Chicano artists who sought to create a more popular, accessible art form. The academicians at the Academy of San Carlos viewed craftsmen like Posada as creators of low culture, but Chicano artists, attempting to portray their own sociopolitical and

cultural experience, saw Posada as an artist unabashedly depicting his culture and society. More than any other Mexican artist of the late nineteenth and early twentieth centuries, Posada's countless works remain as a testament to his times.

The Mexican Revolution and the Mexican Mural Movement

The structure and execution of the **Mexican mural movement** had immeasurable influence on the Chicano art movement. The content, approach, and execution of the murals after the end of the Mexican Revolution in 1920 later became a model for Chicano artists seeking to engage their respective communities. The Mexican muralists set forth a working philosophy in opposition to the traditional studio-to-commercial gallery route. Using a monumental and public art form they brought creative production into spaces accessible to all members of their community. The Mexican mural movement as a whole approached art as a transformative tool that could tell stories and histories, depict positive representations of society, and create imagery to which all sectors of society could relate. The muralists had an agenda, a specific collective goal: to inspire a Mexican nationalism independent of the yoke of Spanish colonialism. This format and agenda would later inspire Chicano artists working towards social change, who also sought to create and inspire a form of nationalism, a quest for a homeland, and a space within the larger U.S. society.

As mentioned, Porfirio Díaz's 1910 exhibition celebrating the one hundredth anniversary of Mexican independence is one example of the contradictions in Mexico's first century of nationhood. A celebration of independence that exalted the nation's colonizers is analogous to the course of the country during Porfirio Díaz's thirty-year regime. While the country surged ahead, attempting to compete economically and militarily with the most powerful North American and European nations, the overwhelming majority of the Mexicano mestizo and indigenous population was left behind. Driven by a strong sense of national pride and a mantra of "order and progress," the Porfiriato did much to bring massive economic and industrial progress to Mexico, but its efforts to lift Mexico from its impoverished past were flawed primarily because the project favored the Mexican elite and foreigners over the majority of the Mexican population.

Led by a group of bureaucrats and intellectuals known as the *Científicos*

(scientific thinkers), the Porfiriato's ideology was largely social Darwinist and racist. A leading Científico, Francisco Bulnes, wrote in *The Future of the Latin American Nations* (1899) that Indians, Africans, and Asians were destined to permanent inequality because of their cultural traits and characteristics. For Científicos such as Bulnes, white European and North American modernity was the model for Mexico's transformation into a modern industrial state (Rochfort 1993). Accordingly, the Porfiriato encouraged massive foreign investment, which would be fed by cheap labor. This resulted in significant areas of Mexico's agricultural land coming under foreign control. By 1910, 90 percent of Mexico's population lived under a system of debt peonage controlled by large haciendas, many of them foreign-owned. For the majority of Mexicanos, the postcolonial era was an arduous struggle for mere survival. Those seeking to become legitimate participants in developing Mexico's democracy and culture found avenues blocked by a repressive dictatorship and a system that enriched only foreign investors and the nation's aristocracy. The Porfiriato and its oppressive social structure would soon become a target for revolutionaries such as Emiliano Zapata and Pancho Villa seeking "Tierra y Libertad," the basic rights of land and liberty.

The Mexican Revolution and ensuing political turmoil following the fall of the Porfiriato led to the emergence of a Mexican art movement known as the Mexican mural movement. In 1920, at the beginning of General Álvaro Obregón's administration, José Vasconcelos, a Mexican *criollo* educated in the United States, was appointed rector of the National University in Mexico City. Vasconcelos had ambitions to create a new revolutionary culture through educational programs. Vasconcelos called upon "all intellectuals of Mexico to leave your ivory towers to sign a pact of alliance with the Revolution" (Folgarait 1998, 16). After one year as rector, he was appointed secretary of state for public education. Vasconcelos used both posts to fund massive literacy and cultural art projects. Guided by Mexican nationalism and a search for the "roots of the real Mexico," Vasconcelos believed that Mexico, after years ravaged by violence, could find redemption through education (18). Developing the concept of Mexicanidad, this educational revolution sought to incorporate indigenous and mestizo Mexicans and both the urban and rural sectors of society.

Vasconcelos's most radical, controversial, and lasting contribution was official government financial support and commissioning of Mexican artists to paint murals on the walls of Mexico's most prestigious buildings.

Vasconcelos, seeking to encourage a cultural renaissance in Mexico, recruited the most accomplished and notable artists in the country for this massive public art project. Importantly, he imposed no ideological, political, or cultural dogmas on the muralists' artistic creations (Rochfort 1993). Upon commissioning Diego Rivera to paint his first mural in 1921, Vasconcelos told Rivera to "paint what you want, with only two conditions: that it have Mexican content and that it be good painting" (Folgarait 1998, 16).

His efforts resulted in an explosion of mural production. Numerous artists were commissioned to paint murals, including Dr. Atl, Roberto Montenegro, Xavier Guerro, Jorge Enciso, Jean Charlot, Fermín Revueltas, and Ramón Alva de la Canal. Of the many commissioned artists, however, three artists known as Los Tres Grandes—Diego Rivera, David Alfaro Siqueiros, and José Clemente Orozco—would emerge as the most influential. They would have the longest-lasting impact on the development and historical significance of the Mexican mural movement. In an effort to describe briefly the mural movement's influence on Chicano art, I will focus on the unique efforts, perspectives, and mural production of these three artists.

Los Tres Grandes were all educated at the Academy of San Carlos, but each took a divergent path to participation in the Mexican mural movement. José Clemente Orozco was a student of Dr. Atl's at the academy and was involved in Dr. Atl's 1910 counter-exhibition to Porfirio Díaz's exhibition showcasing contemporary Spanish art. During the revolution, Orozco worked as a graphic artist for revolutionary newspapers. By 1921 he was an artist of some stature and was hired as a professor of drawing at the National School of Fine Arts, formerly the Academy of San Carlos. David Alfaro Siqueiros, the youngest of Los Tres Grandes, was only fourteen years old at the onset of the Mexican Revolution. Like Orozco, Siqueiros was deeply influenced by Dr. Atl's teachings and ideas about the artist's role in society. Siqueiros is the only one of the three to have seen military combat during the revolution, and he was involved in several important battles. Following the revolution he traveled around Europe for three years before returning to participate in the emerging cultural movement promoted by Vasconcelos. For his own part, Diego Rivera did not witness the violence of the revolution firsthand. Leaving Mexico in 1907, Rivera spent the majority of the next fourteen years painting and traveling throughout Europe. Deeply influenced by cubism and European modernist painting, Rivera would return to Mexico in 1921 and undergo a

transformative process, soon emerging as one of the most important Mexican muralists. Los Tres Grandes would challenge one another and individually push the representation of Mexican society and culture in directions not previously seen anywhere in the Americas.

José Clemente Orozco

After completing his education at the Academy of San Carlos, José Clemente Orozco established a studio, attempting to fulfill Dr. Atl's vision of creating a national art. His first body of work, known as *The House of Tears*, depicted prostitutes and brothel scenes. Orozco also worked as an illustrator and graphic artist for *El Imparcial* and *El Hijo del Ahuizote*, two newspapers that actively engaged in revolutionary politics. Although José Guadalupe Posada was not resurrected as an antecedent to the nationalist art movement until after the revolution, he undoubtedly had an influence on Orozco's development as an illustrator and graphic artist. Although Orozco's training at the academy exposed him to printmakers working in a neoclassical style, copying European prints and paintings, his work is more closely tied to the graphic tradition of José Guadalupe Posada and printmaking-publishing houses such as Vanegas Arroyo's (Bailey 1980).

Following Dr. Atl to Orizaba in support of Carranza's revolutionary efforts, Orozco illustrated the newspaper Dr. Atl established, *La Vanguardia*. Orozco never directly engaged in battle, but he was profoundly affected by the violence of the revolution. Two years in Orizaba left Orozco disillusioned with the unending bloodshed and the complexity of the various factions fighting one another. Of witnessing trainloads of wounded being unloaded in Orizaba, he recalled, "Tired, exhausted, mutilated soldiers, sweating . . . in the world of politics it was the same, war without quarter, struggle for power and wealth, factions and sub-factions past counting, the thirst for vengeance insatiable" (Rochfort 1993, 26). In 1916, Orozco returned to Mexico City with the intention of reestablishing himself as an artist. He exhibited in solo and group exhibitions and received mostly negative responses to his work. He found Mexico City an inhospitable place for artists and the following year moved to the United States, where he spent the next three years living in tremendous poverty in San Francisco and New York. In the United States Orozco worked as a sign painter and barely made a living wage painting doll faces. In 1920, Orozco moved back to Mexico City, seriously disheartened at the lack of recognition and support for his artwork.

In 1923, owing to the advocacy of art critic Walter Pack and poet Juan Tablada, José Vasconcelos gave Orozco his first mural commission, to be painted at the National Preparatory School in Mexico City. Orozco was the last of Los Tres Grandes to receive a commission—both Rivera and Siqueiros had already completed murals at the same location. The first commissions reflected Vasconcelos's ideas and aesthetics; they also revealed the challenge Mexican artists faced in developing a public art movement supportive of the new revolutionary Mexican culture. Their efforts were groundbreaking, but not without their faults.

These challenges and contradictions are reflected in Orozco's first commission. Initially, he sought to create a metaphorical mural carrying the central theme of "The Gifts of Nature to Man" with panels depicting subthemes of virginity, youth, grace, beauty, intelligence, genius, maternity, and force. Of these panels, only *Maternity* remains because Orozco destroyed the rest and replaced them the following year with a series of images representing the violent political struggles of the revolution. The repainted panels include the *Destruction of the Old Order*, *Revolutionary Trinity*, *The Strike*, *The Trench*, and *The Rich Banquet while the Workers Fight*. The panel from the original work stands in stark contrast to the repainted panels. With its imagery of a mother holding a baby surrounded by angels, all figures anglicized and softly rendered in orange, red, and yellow hues, *Maternity* is a painting reminiscent of Botticelli and the Italian Renaissance painters—clearly a reflection of Orozco's early Eurocentric classical education at the Academy of San Carlos. The repainted panels, on the other hand, were more reflective of his work as an illustrator for revolutionary newspapers and as a firsthand witness to the revolution's violence and warfare. He depicted the end of an oppressive colonialism, the violence of the revolution, the exploitation of the poor, and the contradictions of the revolution's many different warring factions. Following this first cycle of murals, Orozco emerged as a muralist with an individual and distinct monumental style.

David Alfaro Siqueiros

David Alfaro Siqueiros, like Rivera and Orozco, was educated at the Academy of San Carlos. Like Orozco, he was heavily influenced by the ideas of Dr. Atl. But it was his activity fighting for the Carranza army that first differentiated him from his fellow muralists. More than any other artist, he saw himself as a politically engaged citizen. This was reflected not

only in his radical politics, but also in his willingness to drop artistic production for political causes he deemed worthy of his efforts.

Like Orozco, Siqueiros followed Dr. Atl to Orizaba in 1914 and participated in the development of *La Vanguardia*, providing illustrations and serving as the newspaper's military correspondent. Deciding to leave Orizaba, Siqueiros transferred to Veracruz to join Carranza's army. Once there, he quickly rose from private soldier to second captain under General Díguez. He was involved in many important battles and witnessed harsh violence and suffering among the general population. In 1918, Siqueiros returned to Mexico City and began painting again. This transition from artist to soldier or activist would become a pattern he would repeat throughout his life. Paintings from this period portrayed his experiences in the revolution. Siqueiros reflected on the Mexican landscape and the populations caught in the middle of the warfare, in portrayals of "the Indian, the Spanish and popular tradition of the country, of the human beings that lived together, that worked together, [and that] fought together in our land, that is the labouring masses, workers, peasants, artisans and Indian tribes" (Rochfort 1993, 28). Siqueiros made a number of political paintings representing this vast cultural landscape.

After a year in Mexico City he moved to Guadalajara and began meeting with an artist collective known as Centro Bohemio. Discussions with the collective developed and congealed Siqueiros's views on the artist's role in society, and especially in postrevolutionary Mexico. Questions the Centro Bohemio addressed were basic and essential: For whom were they producing art? And what should be the object of their work? Siqueiros's involvement in Centro Bohemio was an early example of his many attempts to work collectively with other artists.

Following his time in Guadalajara, Siqueiros used a government scholarship to travel around Europe for three years, where he studied painting, including the Italian Renaissance, and came into contact with French painters. He was also in frequent contact with Diego Rivera, then living in Paris, and their discussions on art and revolutionary Mexico led Siqueiros to publish a manifesto in the Spanish magazine *Vida Americana*. Siqueiros was notable for articulating his ideas about art and politics in spirited manifestos. One such manifesto entitled "Three Calls to American Painters: Detrimental Influences and Tendencies," outlined his views on the course of Mexican art in a revolutionary society. In 1922, Vasconcelos persuaded Siqueiros to return to Mexico, as Rivera had done the year

before, and accept a mural commission at the Colegio Chico at the National Preparatory School in Mexico City.

Just as Orozco did a year later, Siqueiros painted in a stairwell a collection of thematically diverse, metaphorically driven panels. *The Elements*, a two-hundred-square-meter panel, depicted a hovering angel surrounded by the symbols of fire, water, air, and land. Siqueiros worked on the commission for nine months. The following year in the same stairwell, he began painting the first images representing revolutionary content. The original metaphorical and symbolist depictions of the *Burial of the Worker* and the *Call to Liberty* changed into direct and clear depictions of the social and political struggles of the times. *Burial of the Worker* represents a group of workers carrying a coffin on which the insignia of a hammer and sickle is painted. *Call to Liberty* depicts a group of peasants breaking chains off their wrists. Both images express solidarity with class struggle and portray dignity and resistance in the face of injustice. However, art historian Leonard Folgarait views the images in a critical light, arguing that the merely somber scenes did not reflect the larger forces that had created either class struggle or the death of the worker. Siqueiros himself was openly critical of the first murals painted at the National Preparatory School. "I painted the elements: fire, earth, water, etc.," he explained, "inspired by the figure of an angel, more or less in a colonial style. . . . We wanted to help the Mexican revolution, but we were doing a very bad job of it. What we were doing as public art might well have been interesting from the point of view of general culture, but from the point of view of what we were going through at the time it was hopeless" (Rochfort 1993, 35). Like Orozco, Siqueiros understood that in his first attempts at muralism he was learning while doing. The artists struggled to create images driven by both their creative aspirations and their responsibility to the cultural change occurring in postrevolutionary Mexico.

Siqueiros's and Orozco's first murals at the National Preparatory School would be stopped unfinished in 1924 due to political backlash from the predominantly upper-class student population. A group of conservative students took issue with the direct and political imagery in Orozco's *The Rich Banquet while the Workers Fight* and Siqueiros's the *Burial of the Worker*. Following Vasconcelos's resignation, President Obregón ordered a suspension of all murals in progress. Orozco would be invited back eighteen months later in 1926 to complete his commission, but Siqueiros would never return to complete his mural at the Colegio Chico.

Syndicate of Technical Workers, Painters, and Sculptors

In 1922 Siqueiros formed, along with Diego Rivera and Xavier Guerrero, the Syndicate of Technical Workers, Painters, and Sculptors (Sindicato de Obreros Técnicos, Pintores y Escultores). The syndicate attempted to organize a union protecting the interests of the artists working under government commissions and to proclaim a unified political platform. The syndicate produced *El Machete*, a newspaper serving as a forum for debate on current political issues and the role of art in society. Rivera, Orozco, and Siqueiros, as well as other artists commissioned by Vasconcelos, published articles and produced illustrations for the publication. In 1924, in the seventh issue of *El Machete*, the syndicate published a significant manifesto that greatly affected the direction of the mural movement. Authored by Siqueiros and signed by artists such as Jean Charlot, Fernando Leal, and Roberto Montenegro, among others, the manifesto claimed that art and politics are inseparable, and that artists need to be accountable to the revolutionary aims of Mexico by representing soldiers, farmers, and workers, while identifying with indigenous Mexico and oppressed peoples everywhere (Folgarait 1998, 50).

This was the first unified call for artists to move away from Mexico's colonial legacy by representing indigenous Mexico. The manifesto also repudiated easel painting, which the artists considered an art form accessible only in museums or in the homes of the rich. The signers of the manifesto pledged to promote public art, which they viewed as the property of all people and therefore more democratic. The manifesto sought to bring forth a new order that moved away from individualism and toward the collective well-being of the country. Declaring that "art must no longer be the expression of individual satisfaction which it is today, but should aim to become a fighting, educative art for all" (Rochfort 1993, 39), the syndicate sought to promote a new interaction between art and society. They recognized the historically negative effects of colonialism; producing public and social art was their attempt as artists to promote equality amongst Mexican citizens who had historically been neglected and oppressed by unjust economic and social orders.

Both Orozco and Siqueiros, upon suspension of their contracts at the National Preparatory School, began producing work for the pages of *El Machete*. After Vasconcelos left office, Siqueiros became openly critical of the government in the pages of *El Machete*. The new secretary of educa-

tion, Puig Cassauranc, demanded that the syndicate quit publishing the newspaper or the government would suspend their mural contracts. Resolved not to compromise, Siqueiros declared, "If they snatch from us the walls of public buildings, we have in the pages of *El Machete* moveable walls for our great mural painting movement" (Rochfort 1993, 49). Having lost government patronage and with no other employment opportunities in Mexico City, Siqueiros moved to Guadalajara, whose governor was a former member of Centro Bohemio. Once there, Siqueiros began working as an assistant on a mural commission with another former member of the collective. For a period of six years starting in 1925, he ceased painting altogether, devoting himself entirely to working for trade unions in Jalisco.

Diego Rivera

Diego Rivera, the most prolific painter of Los Tres Grandes, was also educated at the Academy of San Carlos prior to the revolution. But unlike Siqueiros and Orozco, Rivera spent the revolutionary years outside of Mexico. After spending seven years at the academy, Rivera traveled to Spain. Aside from a brief return to Mexico in 1910, he would spend the next fourteen years in Europe, traveling extensively through Spain, France, Belgium, and London. He studied and made copies of paintings by Goya, Velázquez, El Greco, Brueghel, and Bosch (Rochfort 1993). Rivera spent considerable time as a cubist painter, heavily influenced by Picasso, Braque, and Juan Gris. Ultimately moving away from a cubist style, Rivera worked under the influence of other European artists such as Cézanne, Ingres, Renoir, and Gauguin. While in Europe, Rivera began using Mexican imagery and depicting the revolution, though still within cubist and European painting traditions. In 1919, Rivera and Siqueiros met and began a dialogue about the revolution and the artist's role in Mexico. At the same time, Vasconcelos contacted Rivera, encouraging him to return to Mexico and participate in the cultural education program.

Through the support of Vasconcelos and the Mexican ambassador in Paris, Rivera traveled to Italy to study Renaissance frescos. After eighteen months studying and copying Italian murals, Rivera returned to Mexico to undertake his first mural commission in the Bolivar Amphitheater at the National Preparatory School. Rivera was already thirty-six years old with considerable experience as a practicing artist, and he enjoyed a strong reputation in Mexico for his accomplishments. Despite Rivera's reputation and experience, Vasconcelos recalled that upon his return from France,

Rivera was a "Frenchified artist" who knew little of his native land. In order to reacquaint Rivera with Mexico, Vasconcelos sent the artist to Tehuántepec, where he spent several months observing and sketching indigenous communities.

Rivera was the first of Los Tres Grandes to be commissioned, and like Orozco's and Siqueiros's initial attempts, Rivera's first mural represented very little of the revolutionary and radical politics that would characterize his later monumental works. His first commission, *Creation*, was a metaphorical, almost Christian-like, representation, depicting man and woman and the elements of earth, water, wind, and fire. This early attempt mirrored the metaphorical attempts of Orozco and Siqueiros. While the mural didn't reflect any radical or revolutionary politics, Rivera did depict figures representing **mestizaje** and a landscape influenced by his trip to Tehuántepec.

Though Rivera signed the syndicate's manifesto in *El Machete*, he managed to sidestep the political backlash and turmoil both Siqueiros and Orozco experienced while painting their first murals at the National Preparatory School. In 1923, Rivera was appointed head of the Department of Plastic Crafts at the Ministry of Education, and after Vasconcelos resigned, he managed to continue working with the new education minister, Puig Cassauranc. Rivera resigned from the syndicate in 1924 after dismissing the attacks on Siqueiros's and Orozco's murals as a minor affair. Rivera managed to further alienate members of the syndicate when he decided to chip from the wall frescoes painted by Jean Charlot and Xavier Guerrero, when their work interfered with his planned mural for the newly built Secretariat of Education building. Despite his political alienation during this period, Rivera's creative output flourished. Choosing to continue working with the government, he eventually emerged as the leader of the mural movement.

Rivera began the Secretariat of Public Education mural in 1923 and completed the work in 1929. Rivera's mural is monumental, containing 239 panels and covering 15,000 square feet. With a general theme of Mexican nationalism, the mural represented the diverse array of labor performed throughout the geographically diverse Mexican landscape. These images of labor included intellectual labor in technology, medicine, sciences, and the arts. Also depicted were popular Mexican religious and political traditions, as well as their evolution. Rivera included images of daily life in both the cities and the countryside. On the ground floor of the ministry, Rivera

painted a series of panels called *Los Tehuanas*, portraying the economy of the primarily indigenous regions of southern Mexico. *The Sugar Refinery*, *The Dyers, Entry into the Mine*, and *Exit from the Mine* are all separate panels portraying the struggles, hard labor, and culture of a population that had never before been so prominently represented. In addition to showing the daily struggles of the indigenous populations, Rivera also portrayed rituals and celebrations, especially those particular to mestizo and indigenous Mexicans. He sought to celebrate aspects of Mexican culture long suppressed or ignored, first by colonial Spain and later by the white Mexican elite. The panels representing *The Burning of the Judases*, *The Dance of the Deer*, *The Dance of the Tihuanas*, *The Dance of the Ribbons*, and *The Corn Harvest Dance* showed aspects of Mexican culture found primarily in indigenous communities.

The Secretariat of Public Education mural was also important for its representations of the Mexican Revolution. While representing the struggles of the Indian worker, Rivera simultaneously depicted the success of the revolution in liberating the worker and Indian from economic and colonial exploitation. *The Liberation of the Peon* and *The New School* were two of many panels highlighting the changes brought about by the revolution. In *The New School*, Rivera showed a form of the rural education programs supported by Vasconcelos to increase literacy. Likewise, Rivera proudly represented revolutionary changes such as land redistribution and the organization of labor in *The Festival of the Distribution of Land* and *The Festival of the First of May*. Rivera hoped to portray revolutionary events as celebrations of Mexicanidad, just as the Day of the Dead and the ribbon dance were.

The Secretariat of Public Education mural was one of three Rivera completed during the 1920s. Its significance to the development of the **Mexican mural movement** is profound in terms of its scope and its depth of subject matter, as well as its revolutionary imagery. During the five years it took to complete the mural, the groundwork for the Mexican mural movement was laid, including the relationship between Siqueiros, Orozco, and Rivera—their dealings with the Mexican government; and their stances on the various political developments taking shape nationally as well as internationally. Throughout the 1930s, 1940s, and 1950s, Los Tres Grandes would continue to create public murals challenging the status quo in both politics and art. Siqueiros would continue painting public works until his death in 1974. The social mission and stylistic advancements of the

Mexican mural movement would influence artists around the world, especially in the United States throughout the twentieth century.

The Mexican Muralists' Legacy in the United States

The Mexican mural movement had a profound influence on the development of public art in the United States. Rivera, Orozco, and Siqueiros were recognized as cultural heroes in the United States, especially by cultural workers engaged in creating art during periods of social and political turmoil. The administrators of the WPA and the artists who benefited from their support recognized Mexican muralism as an art form that could engage the public during periods of social, political, and economic change. Artists, especially Chicanos/Chicanas, during the U.S. political upheaval of the 1960s and 1970s, would look to Los Tres Grandes for a blueprint of how to create culturally and politically empowering public art.

The Mexican mural movement would influence American artists both directly and indirectly. Beginning in 1930, Los Tres Grandes visited the United States for varying periods, most often to produce public works, though the circumstances of their arrival varied greatly. Orozco fled to the United States in late 1927 following the decommission of his half-completed mural at the National Preparatory School. Siqueiros, after losing his commission, abandoned painting to organize union workers in western Mexico, resuming his creative work only in the early 1930s. An extremely productive time of creating and exhibiting paintings ensued, but due to his political activities Siqueiros was forced into exile in 1932. He traveled to Los Angeles and continued producing art, receiving several mural commissions, but again his political activities interfered and the U.S. government deported him. He returned to the United States in 1936, where in New York he worked with a number of contemporary American artists interested in politically charged public art. Diego Rivera, unlike Siqueiros and Orozco who both came to the United States because of political unrest and lack of institutional support in Mexico, entered the United States with much acclaim, notoriety, and large financial support from wealthy American capitalist patrons. Yet, Siqueiros and Orozco returned to Mexico following their U.S. sojourns as energized artists ready to complete their most successful works. Rivera, on the other hand, suffered from his American experience. Despite their diverse activities and experiences in the United States, all three muralists would have a profound effect on American artists over the next seventy years.

In 1930, Orozco became the first of Los Tres Grandes to complete a commission in the United States by painting his mural, titled *Prometheus*, at Pomona College in Claremont, California. *Prometheus* was the first successful expression of one of Orozco's most prominent themes: the tragic hero who sacrifices himself for the benefit of humankind. *Prometheus* was a precursor to his most monumental mural, *Man of Fire*, completed in Guadalajara in 1939. After completing *Prometheus*, Orozco quickly accepted a commission to create a mural for the dining hall at the recently built New School for Social Research in New York. The work was intended to showcase the most progressive aspects of contemporary art. He filled the New School with a series of panels depicting various international revolutionary and social movements. Following the New School mural, Orozco worked for two years at Dartmouth College, synthesizing his previous two works into *The Epic of American Civilization*, once again dealing with themes of heroism, sacrifice, corruption, class struggle, and finally, hope for the future of humankind. Each successive mural he completed in the United States improved upon his previous work, culminating in a highly developed style and a reputation as one of Mexico's greatest and most important artists. Upon his return to Mexico in 1934, Orozco would use his experience in the United States to create what are generally regarded as his greatest works (González and Miliotes 2002, 19).

Diego Rivera spent four years working in the United States. He arrived in 1930 as an acclaimed international artist and as the major artistic figure in Mexico. He went first to California, where wealthy patrons commissioned murals and he was promised prominent exhibitions, including a 120-work exhibition at the California Palace of the Legion of Honor (Hurlburt 1989). Rivera completed three murals in California between 1930 and 1932. His first mural commission was for the stairwell of the newly built San Francisco Stock Exchange Luncheon Club. Rivera was instructed by the architect and commissioner of the mural to glorify capitalism, a departure from the oppositional and revolutionary images prominent in his first Mexican murals. In a far subtler manner than in his previous works, Rivera depicted workers liberating and processing California's vast mineral resources, as well as the abundance of food and technology produced in the state. This mural began Rivera's focus on American industrial and capitalistic development. Following the San Francisco Stock Exchange mural, Rivera painted a small private fresco in the home of a prominent San Francisco businessman, then another fresco at the

California School of Fine Arts, now known as the San Francisco Art Institute (figure 2). These mural commissions were followed by a major retrospective of Rivera's paintings, drawings, prints, and portable frescos at New York's Museum of Modern Art (MOMA). Rivera's exhibition at MOMA broke attendance records, drawing twenty thousand more people than the Matisse exhibition held in the same year (Hurlburt 1989). Although Rivera had courted wealthy patrons in San Francisco, the MOMA exhibition began his relationship with America's most powerful capitalists, including the Rockefeller family.

Rivera's last three murals completed in the United States, from 1932 to 1934, were ambitious works that were all shrouded in controversy. Following the financial and critical success of the MOMA exhibition, the Arts Commission of the City of Detroit commissioned Rivera to paint the interior courtyard of the newly built Detroit Institute of Arts. The president of the Ford Motor Company, Edsel Ford, son of company founder Henry Ford, funded the commission. Rivera attempted an ambitious mural of twenty-seven panels and proceeded to complete a masterwork depicting the history of technological development in the region from its agricultural beginnings to the impact of the automobile (Downs 1999). Rivera completed this work at the height of the Depression during a period when Ford's workers were struggling for better working conditions and a living wage to support their families. Edsel Ford, who paid Rivera $20,000 to complete the work, and Rivera, who not only accepted the commission but depicted the very workers suffering the effects of Ford Motor Company's downsizing and layoffs, were both roundly criticized.

The Rockefellers funded Rivera's subsequent mural commission in the entryway to the new Rockefeller Center. Rivera's theme for this mural was *Man at the Crossroads Looking with Hope and High Vision to the Choosing of a New and Better Future*. His mural sketch was a single large rectangular panel representing two opposing views of society. Separated by a central image, capitalism and socialism were represented on opposite sides of the mural; socialism providing peace and equality, capitalism producing disparities between the working and bourgeois classes. The clear trumpeting of socialism over capitalism was not what caused the controversy, however, but rather Rivera's inclusion of a prominent portrait of Lenin that led Rockefeller to ask Rivera to change his image. Rivera refused and demanded he be allowed either to complete his mural or to destroy it in its entirety. Rockefeller and the Rockefeller Center project managers stopped

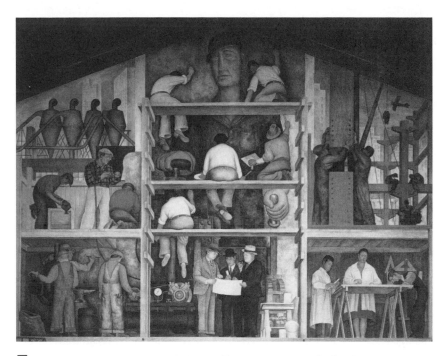

■ 2. Diego Rivera. *The Making of a Fresco, Showing the Building of a City.* San Francisco Art Institute. Fresco, 1931. (Courtesy of San Francisco Art Institute)

work on Rivera's mural and destroyed the half-completed fresco. Rivera completed more works in the United States, but after a commission to paint a mural in Chicago for the World's Fair was cancelled, he returned to Mexico in 1934 in a state of depression, suffering from stress and humiliation over his failure to complete the Rockefeller commission.

David Alfaro Siqueiros had two brief and productive stays in the United States during 1932 and 1936. While in the United States Siqueiros experimented with new technologies, seeking to increase the accessibility and permanence of exterior murals. Siqueiros was interested in moving away from fresco painting, a labor-intensive process not durable enough to withstand outdoor weather. In 1932, Siqueiros painted three murals in Los Angeles, only one of which exists today. All were experimental in style and medium. The first, *Street Meeting*, was executed at the Chouinard School of Art, where he briefly taught fresco. The second mural, *Tropical America*, was painted on the second-story wall of a building on Olvera Street, a prominent Mexican and Mexican American community in Los Angeles.

The imagery in *Tropical America* depicted the mass deportations of Mexican nationals occurring at the time, the harsh conditions experienced by Mexican migrant workers, and the repressive tactics used to quell their unionizing efforts (Goldman 1981). Because of its strong political content, that mural was soon whitewashed. His last mural, *Portrait of Mexico Today*, is the only one to survive the elements, political repression, and deterioration resulting from his experimental painting techniques. Depicting revolutionaries in a pastoral scene, the mural was executed in the private residence of filmmaker Dudley Murphy, in Pacific Palisades. This mural has since been moved from its original location and now resides in the permanent collection of the Santa Barbara Museum of Art.

Deported for his political activity in 1932, Siqueiros would not return to the United States until 1936, when he was an official Mexican delegate to the American Artists Congress in New York City. His work during this time would prove incredibly influential, not only to the development of his mural practice, but also to a generation of American artists dedicated to both public political art and experimental techniques. Within two weeks of his arrival, Siqueiros had organized a group of artists to participate in the Siqueiros Experimental Workshop, then known as the Laboratory of Modern Techniques in Art (Hurlburt 1976). This initial group of workshop participants included Jackson Pollock, the famous American abstract expressionist painter, and Luis Arenal, a Mexican artist who would later cofound El Taller de Gráfica Popular in Mexico.

The artistic production at the Experimental Workshop was threefold. Participants created "art for the people," making temporary public works for political events. The artists worked with Siqueiros to develop floats for the May Day parade held in 1936 and created posters for the Communist Party USA convention and anti-fascist rallies (Hurlburt 1976). Activity in the workshop occurred in spurts, followed by quiet periods during which Siqueiros would develop his own artwork. Siqueiros completed a number of experimental easel paintings, often in collaboration with workshop artists. Whereas the collaborative projects, such as the floats and posters, had the largest impact on fellow workshop participants, Siqueiros's experimental paintings would have the largest impact on his own future murals. He considered the fundamental problem of revolutionary art to be technical in nature (Hurlburt 1976), and he worked to solve technical limitations by using new technology such as spray guns and nitro-cellulous pigments. By experimenting with new techniques and materials, Siqueiros was able to

gain new surfaces and compositions impossible with traditional oil paints or fresco. "The absorption of the colors on the surface," Siqueiros described in discussing his painting revelations, "produced snails and conches of forms and sizes almost unimaginable with the most fantastic details possible" (Hurlburt 1976, 242).

Siqueiros used these techniques and surfaces in two paintings, *Birth of Fascism* and *Stop the War*. The composition and painting method of these works clearly anticipated Jackson Pollock's paintings of the late 1940s and early 1950s (Hurlburt 1976). Of Los Tres Grandes, Siqueiros is perhaps most notorious for his political activism—leaving the workshop to fight in the Spanish Civil War and participating in a failed attempt to assassinate Leon Trotsky—but his Experimental Workshop's emphasis on innovative techniques and use of new materials to create a truly revolutionary art form would have a lasting influence on American and Mexican artists.

◼ Works Progress Administration Section of Fine Arts and the Federal Art Project

The arts in Mexico during and after the Mexican Revolution served to heal the consciousness of a war-torn country and to empower its populace culturally and politically. Likewise, during America's Great Depression the U.S. federal government saw the arts as a way of alleviating the severe hardship its citizens were experiencing. In 1933, as the economic situation worsened, private patronage for the arts almost completely stopped. Once private support dried up, artists were faced with a paramount question: were they important enough that they deserved federal government support? (Mathews 1975). Without federal support they would surely be forced into nonartistic activities. In 1933, American artist George Biddle wrote to his friend President Franklin Delano Roosevelt, encouraging him to view the Mexican mural movement as a model:

> The Mexican artists have produced the greatest national school of mural paintings since the Renaissance. Diego Rivera tells me that it was only possible because President Obregón allowed Mexican artists to work at plumber's wages in order to express on the walls of the government the social ideals of the Mexican revolution. (Hurlburt 1989, 8)

Biddle asked Roosevelt to address the cultural gloom wrought by the Great Depression, to use artists to help "reshuffle the constituent parts that

formed the dreary design of our national life" into a "picture of democratic justice and spiritual beauty" (Mathews 1975, 316). Biddle envisioned a cultural project similar to the mural movement in Mexico where artists provided an uplifting message to a struggling nation.

The federal government responded the same year with the creation of a Section of Fine Arts, which put visual artists to work decorating public buildings. In 1935, the WPA was established to employ millions of unemployed workers. The agency was primarily geared towards infrastructure projects, but a portion of its funding was directed towards projects for visual artists, theater workers, writers, and musicians. The direct goal of these relief efforts was to hire the best artists to adorn newly built federal and WPA buildings. The indirect goal was to promote and encourage cultural democracy. The WPA and the Federal Art Project were seen by their proponents as means to enrich the lives of ordinary citizens. It was vital for these programs to create cultural consumers, people who would value and promote art, not as an expendable luxury, but as a community asset. Museums were increasingly viewed as institutions containing "legacies from rich men's houses," rather than accessible public spaces (Mathews 1975, 320). In order to create cultural democracy, New Deal programs had to be physically, intellectually, and emotionally accessible to the public. Cultural democracy would come about only if participation and accessibility were paramount in the creative process.

The WPA looked to the mural as an art form that would encourage and promote both accessibility and participation. The WPA also supported community art centers as spaces that could decentralize the nation's cultural resources (Mathews 1975). Community art centers were designed to be places where qualified art teachers could offer the general public opportunities to become part of the art-making process. They were also seen as places where "an art-conscious public would be born" and ordinary Americans would discover that art was not exclusively reserved for elite institutions, but rather constituted "beauty for use"—enriching, inspiring, and essential to their communities (323). Attempting to create cultural democracy through the WPA and the Federal Art Project was certainly idealistic and had to negotiate bureaucracy and politics to receive funding and support. Although this project never fully realized nationwide success, the advocates of cultural democracy laid a foundation for the arts to interact with society in new ways and serve as empowering and spiritually uplifting experiences.

■ Taller de Gráfica Popular

Mexico enjoys a long tradition of printmaking, beginning with José Guadalupe Posada and the production of popular broadsides. One Mexican printmaking institution in particular influenced and inspired Chicano artists: Taller de Gráfica Popular (TGP). In 1937, Pablo O'Higgins, Leopoldo Méndez, and Luis Arenal founded the TGP as a printmaking collective and workshop with the specific intent of promoting collectivism and collaboration while defending and enriching Mexico's national culture. TGP artists made their own prints that affirmed the overall goals of the workshop and became part of the TGP's portfolio. The TGP also accepted commissions to make posters and visual propaganda for organizations and causes consonant with the political goals of TGP artists. In their initial "Declaration of Principles" the TGP affirmed that "in order to serve the people, art must reflect the social reality of the times and have unity of content and form," while at the same time defending "freedom of expression and artists' professional interests" (McClean-Cameron 2000, 26). The TGP's founders also affirmed their intent to work collaboratively for and with workers' organizations and progressive movements.

The work and importance of the TGP has often been overlooked because of the historical and scholarly attention paid to Mexican muralism. The founders of the TGP were trained in the style and philosophy of the Mexican mural movement, and many of the printmakers were active in mural production right up to the founding of the TGP. TGP artists were also active in the socialist movements in Mexico advocating for radical changes in Mexico's class structure. Like the muralists, TGP artists utilized their own personal styles, but their prints primarily expressed a leftist point of view. Prints made at the TGP depicted and affirmed Mexico's revolutionary history and independence, while also drawing attention to the country's poor and dispossessed. Aside from their own prints, workshop artists produced posters, leaflets, and graphics for Mexico's left-wing organizations such as the Mexican Communist Party, the Confederation of Mexican Workers, and the League of Revolutionary Writers and Artists (LEAR) (Wechsler 2006).

Although the Taller de Gráfica Popular was physically and culturally centered in Mexico, it enjoyed an international reputation. It drew members from the United States, South America, and the Caribbean. Three of the most important twentieth-century African American artists—Elizabeth

Catlett, Charles White, and John Woodrow Wilson—were members of the TGP. Charles White and Elizabeth Catlett were married when they arrived in Mexico, but Catlett remained in Mexico when White eventually returned to the United States, as did Wilson. She would remarry, become a Mexican citizen, and continue as a longtime member of the TGP. These three important African American artists were accepted and revered in Mexico in a way they had never experienced in the United States, where racism and segregation persisted (Wechsler 2006). Although most of the American artists who worked at the TGP eventually returned to the United States, their experience and interaction in Mexico at the TGP would influence their lifelong artistic activities.

Most of the TGP artists were initially trained in lithography and worked in a tradition established by the printmaking of José Clemente Orozco and his colleagues at the San Carlos Academy. In the 1940s, however, under the leadership of Leopoldo Méndez, the TGP moved towards exclusively relief printing, particularly woodblocks and **linocuts.** Relief printing, such as woodblock and linocut, was a much more immediate and accessible printing method than traditional lithography. Lithography was a much more expensive and time-consuming process requiring large presses and, at that time, limestone blocks to produce prints. In contrast, woodblocks and linocuts can be made with simple carving tools and a piece of linoleum or scrap wood. Relief printing brought the TGP closer to the tradition of Posada's work and helped serve its populist aspirations. The relationship of linocut to folk tradition, and by extension to artisan labor, provided an example for artists anxious to identify themselves with the working class (McClean-Cameron 2000). The TGP would make some of the most important visual art to emerge from Mexico in the twentieth century. Simultaneously, it provided a framework for artists who wished to work individually and collectively, using the arts, in particular popular art forms such as the print, to empower the population and serve important political and social movements.

This structure and effort undoubtedly served as an inspiration, foundation, and framework for how Chicano artists would use the print to collectively effect change by engaging communities that did not typically frequent galleries and museums. To this day, exhibitions continue to be organized in the United States that highlight the artistic contributions of the TGP. In 2007 the Snite Museum of Art at the University of Notre Dame organized an exhibition titled The Women of the Taller de Gráfica

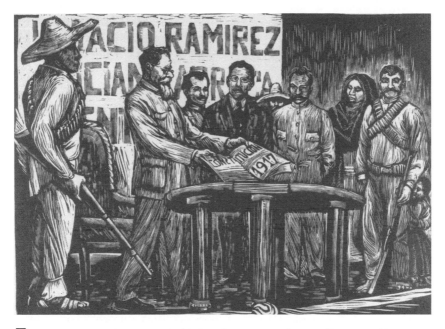

■ 3. Elena Huerta. *Constitución del 17*. Relief print, date unknown. (Courtesy of University of Notre Dame, Snite Museum of Art)

Popular. This exhibition centered on the artistic contributions of prominent women printmakers and on images created at the TGP that featured representations of women. Elena Huerta's print *Constitución del 17* is an especially powerful representation of the revolutionary period in Mexican history (figure 3). Her work, like that of most TGP members, provided a visual narrative of revolutionary Mexico and imagery that looked to a future of greater equality and independence.

■ OSPAAAL and Cuban Printmaking

The Cuban Revolution culminated in 1959 with the overthrow of Fulgencio Batista's government. The poster production in the ensuing revolutionary government, and the role of its cultural activities in society, served as an inspiration for Chicano and Chicana artists. The period immediately following the revolution was characterized by drastic changes where "human capital was more important than financial capital, when public voluntarism was commonplace and self-sacrifice expected" (Cushing 2003, 7).

Beginning in the early 1960s, Cuba began a cultural transformation with efforts to create widespread literacy, free health care, and a new revolutionary and socialist cultural image. As scholar Lincoln Cushing notes, "The noncommercial mass poster was the direct fruit of the revolution, a conscious application of art in the service of social improvement" (7). Many artists used the poster as a means to express a new, independent, and revolutionary artistic vision.

Cuban poster production came primarily from three different sources. The Cuban Institute of Cinematic Art and Industry (ICAIC) was established immediately following the revolution and has been one of the most important cultural institutions in Cuba, with a vital international film presence. To this day, ICAIC has a **silkscreen** workshop responsible for producing posters for all Cuban films and all international films shown in Cuba. ICAIC has been credited with creating a uniquely Cuban style of poster art in the postrevolutionary period (Cushing 2003). Artists, rather than just producing movie advertisements, were given the opportunity to interpret the film in visual imagery. Editora Política, the official publishing department for the Cuban Communist Party, employed artists to make books, brochures, billboards, and posters. Lastly, the Organization in Solidarity with the People of Africa, Asia, and Latin America (OSPAAAL) was responsible for some of the most iconographic, creative, and powerful posters made internationally (see www.ospaaal.com). OSPAAAL is not an arm of the Cuban government, but rather a United Nations–recognized and official nongovernmental organization based in Cuba. Many of the posters sponsored by OSPAAAL were distributed through their magazine *Tricontinental*. From 1966 to 1989, *Tricontinental* reached eighty-seven countries and was translated into four different languages. OSPAAAL posters supported liberation struggles in Vietnam, Africa, and Asia, as well as the civil rights struggles in the United States.

Cuba's revolutionary art production in the 1960s and early 1970s was one model for artists who melded activism with artmaking at the onset of the Chicano movement. Chicano art historian and scholar Tere Romo has written on the relationship between Cuban and Chicano poster making. After the Cuban Revolution the flourishing poster production often reached Chicanos through *Tricontinental*. Leading Chicano poster maker Rupert García came to admire the dynamic and diverse visual representations of political issues portrayed in this magazine. Many Chicano artists, such as Malaquias Montoya and Juan Fuentes, would be influenced by

Cuban poster production and often create posters in solidarity with many Cuban issues and themes.

■ Conclusion

This chapter has presented a select few of the varied influences on the development of the Chicano art movement. Most of these art projects used art to interact with society through direct activism, applying the arts as a pedagogical tool and in the service of community development. The **Mexican mural movement,** the WPA art programs, the Taller de Gráfica Popular, and the production of posters in postrevolutionary Cuba all represented various ways that the visual arts could serve larger social movements within society.

■ Discussion Questions

1. How did the Academy of San Carlos influence Mexican artists before the Mexican Revolution? How did the academy's teaching restrict the development of a national artistic and cultural identity?

2. How did José Guadalupe Posada's broadsides reach viewers and the community? In what ways was this a popular art form?

3. How did the later activities of Los Tres Grandes, El Taller de Gráfica Popular, and OSPAAAL compare and contrast with Posada's work?

4. How did the Mexican mural movement serve the goals of the Mexican Revolution? How did the Mexican government work with or against the muralists in developing a new art movement? Why was this important in developing Mexicanidad?

5. Discuss the importance of the Syndicate of Technical Workers, Painters, and Sculptors and the development of their publication *El Machete*. What do the activities and philosophies of this group and its publication illuminate about the role of the artist in postrevolutionary Mexico?

6. Discuss the WPA's goals of creating a cultural democracy. What does cultural democracy mean and how did government programs during the Great Depression aim to promote it?

■ Suggested Readings

Charlot, Jean. *An Artist on Art: Collected Essays of Jean Charlot*. Honolulu: University Press of Hawaii, 1972.

——. *Mexican Art and the Academy of San Carlos, 1785–1915*. Austin: University of Texas Press, 1962.

——. *The Mexican Mural Renaissance, 1920–1925*. New Haven: Yale University Press, 1963.

Consejo Nacional para la Cultura y las Artes. *60 Años TGP: Taller de Gráfica Popular*. Mexico City: Instituto Nacional de Bellas Artes, 1997.

Craven, David. *Art and Revolution in Latin America, 1910–1990*. New Haven: Yale University Press, 2002.

Cushing, Lincoln. *Revolution! Cuban Poster Art*. San Francisco: Chronicle Books, 2003.

Downs, Linda Banks. *Diego Rivera: The Detroit Industry Murals*. New York: W. W. Norton, 1999.

Edwards, Emily. *Painted Walls of Mexico: From Prehistoric Times until Today*. Austin: University of Texas Press, 1966.

Folgarait, Leonard. *Mural Painting and Social Revolution in Mexico, 1920–1940: Art of the New Order*. New York: Cambridge University Press, 1998.

——. *So Far from Heaven: David Alfaro Siqueiros' The March of Humanity and Mexican Revolutionary Politics*. Cambridge: Cambridge University Press, 1987.

Fondo de Cultura Económica. *Mural Painting of the Mexican Revolution*. Mexico City: Atria, 1967.

Frank, Patrick. *Posada's Broadsheets: Mexican Popular Imagery, 1890–1910*. Albuquerque: University of New Mexico Press, 1998.

Gallo, Rubén. *Mexican Modernity: The Avant-Garde and the Technological Revolution*. Cambridge, MA: MIT Press, 2005.

——. *New Tendencies in Mexican Art*. New York: Palgrave Macmillan, 2004.

Goldman, Shifra. *Contemporary Mexican Painting in a Time of Change*. Albuquerque: University of New Mexico Press, 1981.

Helm, MacKinley. *Man of Fire: An Interpretive Memoir*. New York: Harcourt, Brace, 1953.

Helms, Cynthia Newman, ed. *Diego Rivera: A Retrospective*. New York: W. W. Norton, 1986.

Herrera, Hayden. *Frida Kahlo: The Paintings*. New York: HarperCollins Publishers, 2002.

Hurlburt, Laurance P. *The Mexican Muralists in the United States*. Albuquerque: University of New Mexico Press, 1989.

——. "The Siqueiros Experimental Workshop: New York, 1936." *Art Journal* 35, no. 3 (1976): 237–46.

Ittmann, John. *Mexico and Modern Printmaking: A Revolution in the Graphic Arts, 1920–1950*. New Haven: Yale University Press, 2006.

Katzew, Ilona. *Casta Painting: Images of Race in Eighteenth-Century Mexico*. New Haven: Yale University Press, 2004.

Mathews, Jane De Hart. "Arts and the People: The New Deal Quest for Cultural Democracy." *Journal of American History* 62, no. 2 (1975): 316–39.

Metropolitan Museum of Art. *Mexico: Splendors of Thirty Centuries*. New York: Bulfinch Press and Metropolitan Museum of Art, 1990.

Miliotes, Diane. *José Guadalupe Posada and the Mexican Broadside*. New Haven: Yale University Press, 2006.

Prignitz-Poda, Helga. *El Taller de Gráfica Popular en México, 1937–1977*. Mexico City: Instituto Nacional de Bellas Artes, 1992.

Rochfort, Desmond. *Mexican Muralists: Orozco, Rivera, Siqueiros*. London: Laurence King, 1993.

Art and the Chicano Movement

The **Chicano art movement** arose during the second half of the 1960s and is characterized by two distinct periods of activity: the first from 1968 to 1975 and the second from 1975 to 1981. The first period challenged the dominant culture and worked to set an alternative to mainstream art and art institutions. The second period saw a change in the movement's oppositional nature, including in the way **Chicano** artists have negotiated mainstream art institutions and the dominant culture.

Emergence of a Chicano Art Movement

As described in the introduction, the Chicano art movement was part of a larger movement of Chicanos struggling for self-determination and reclamation of their community's history and culture. In 1965, the **United Farm Workers** began a five-year strike to unionize farmworkers in Delano, California, and the **Crusade for Justice** was established in Colorado as the first Chicano civil rights organization. In 1968, **Mexican American** students in East Los Angeles staged a walkout to demand changes in the educational system (the East Los Angeles Blowouts). In 1969, at the height of Chicano civil rights activism, the Crusade for Justice organized the first National Chicano Youth Liberation Conference, where cultural workers and activists from around the nation met to organize their efforts into a cohesive and clearly articulated movement.

Activists at the National Chicano Youth Liberation Conference looked to artists to empower the Chicano community by helping to create a vision of a new culture that enabled self-determination. In "El Plan Espiritual de Aztlán," cultural empowerment was identified as one of the seven primary goals of the Chicano movement. Chicano activists stated that

> cultural values of our people strengthen our identity and the moral back-bone of the movement. Our culture unites and educates the family of La Raza towards liberation with one heart and one mind. We must ensure

that our writers, poets, musicians, and artists produce literature and art that is appealing to our people and relates to our revolutionary culture. ("Plan Espiritual de Aztlán")

This manifesto was a potent call for artists to produce art "not only for the community, but with the community" (Romo 2001, 93). Thus, artists had a role in a larger movement for self-determination and social justice.

In March 1970, Chicano artists developed the ideas on art and culture set forth in "El Plan Espiritual de Aztlán" at the Crusade for Justice's second National Chicano Youth Liberation Conference. Artists discussed in depth how Chicano art could serve La Causa, the cause of Chicano civil rights. According to conference documents, participants advocated that Chicano art should be nationalistic, so that it would relate to the Chicano community, and it should educate people on the ideas of **Chicanismo.** The artists also announced their opposition to the "gringo dollar system," proclaiming that Chicano artists would remain dedicated to self-determination and would refuse to succumb to commercialism. Chicano artists and activists understood "succumbing to commercialism" to mean exhibiting and selling their artwork in traditional commercial galleries that were not accessible to Mexican Americans. Not succumbing to commercialism meant refusing to make art a simple commodity and instead seeking to transform the role art could play in society. Artists understood that if Chicano art was to be "an art of our people," then it needed to be exhibited in areas where Chicanos live—the barrios and the field camps. They explicitly stated that Chicano art would not be created for tourists or as an "ornament to please the gringos." Accordingly, they declared their refusal to exhibit work in mainstream institutions and galleries (Goldman 1984).

Chicano artists were reacting to the failure of major art institutions to incorporate Chicano culture or art into their collections or exhibitions. In conference discussions, there are also echoes of the central tenets proclaimed by the WPA **cultural democracy** advocates. Chicano artists wanted to promote greater accessibility and participation from all sectors of society by creating public art and establishing community art centers. They sought to employ media, such as the poster and the mural, that would reach the widest possible audience. Artists also understood the importance of creating imagery relevant to the community's experience. Furthermore, they saw artist collectives and community art centers (or *centros*) as essential not

only for providing accessibility, but also for combating individualism and competition, which were seen as counterproductive to achieving social justice for the Mexican American community (Goldman 1984).

■ Rasquachismo: A Chicano Sensibility

These artistic and activism-oriented efforts are well described by a sensibility called **rasquachismo.** Rasquachismo has many connotations and connections. Scholar Tomás Ybarra-Frausto describes rasquachismo as "a core aesthetic category in Chicano cultural production. . . . Rasquachismo is a pervasive attitude rooted in the aesthetics of resourcefulness; *la buena presentación de las cosas* (a fine display of things). A rasquache world view is a compendium of all survivalist *movidas* (strategies) improvised to cope with adversity" (Ybarra-Frausto 1994, 135). In other words, rasquachismo is a uniquely Chicano aesthetic and strategy of using whatever is at hand to create art, to effect change in society, and to transform one's environment. To "be *rasquache*," or to practice rasquachismo, is to be unpretentious and resourceful, to use what is accessible for artistic creation. Rasquachismo is a method of approaching the world that does not allow a lack of resources to stop a person's creative development or contribution. Rasquachismo is an important concept to keep in mind when reading about and viewing Chicano visual art, including altars and various types of sculptures that utilize everyday materials.

The **silkscreen** and the mural both fit within Ybarra-Frausto's description of rasquachismo, as both media cope with adversity through improvisation: because the walls of museums were historically denied to Chicano artists, they turned to painting on walls within their own communities. Because Chicano activists and community members did not have the means to own large printing presses or access to the mainstream media, they turned to silkscreen printing as a simple technique they could utilize with little money and few materials.

With these objectives in mind, the artists in the first phase of the Chicano art movement were "marked by a totally noncommercial community-oriented character in the attitudes and expectations of the art groups, the purposes they served, the audiences they addressed, the facilities that were established to promote the arts, and the collectives that flourished" (Goldman and Ybarra-Frausto 1985, 32).

Geography of Chicana and Chicano Art Production

Geographic differences influenced the kind of art produced in various Chicano and Mexican American communities. For instance, although Los Angeles developed a number of prominent poster artists and workshops, it was most notable for its mural production. Los Angeles is characterized by a car culture and urban sprawl. The landscape's numerous stucco and concrete buildings were well suited to the mural, serving a "billboard-like" function in the barrios (Lipsitz 2001, 73). The six to seven hundred murals in East Los Angeles alone attest to this fertile environment.

The San Francisco Bay Area, on the other hand, is characterized by high population density and an efficient public transportation system that encourages pedestrian traffic. The visibility of the poster—hung in stores, on neighborhood walls, and on telephone posts across San Francisco, Oakland, and Berkeley—to pedestrians encouraged its production there. The high density also brought various immigrant communities and cultures into close contact, encouraging cultural overlap and third world solidarity. Thus, the imagery produced by Bay Area artists had a more international flavor. Los Angeles, where urban sprawl produced more homogenous communities, was characterized by greater nationalism. Although both cities are known for their vibrant murals and poster and print production, geography played a central role in the overwhelming production of muralism in Los Angeles and silkscreen **talleres** and workshops throughout the Bay Area.

The majority of research conducted on Chicano art has focused geographically on the Southwest. Chicanos have long had a strong presence in the Midwest, yet their creative production there has been seriously neglected in scholarly documentation and research. Fortunately, current research initiatives are correcting this oversight. One such initiative is the Midwest Latino Arts Documentary Heritage Project, led by Notre Dame University's Institute for Latino Studies, which is working to provide reference tools and a directory of primary source materials for researchers, archivists, and librarians. Currently, the majority of the documentation on Chicano art in the Midwest has focused on Chicago, Illinois, and on Michigan.

In 1970, the Midwest was home to an estimated 1.5 million persons of **Latino** origin. Chicago and Michigan, in particular, have long had large

and vibrant Chicano communities. Michigan was the third largest user of migrant labor in the United States, while Illinois had the largest Mexican and Mexican American population in the Midwest. Unlike in the Southwest, where many Chicanos/as were native to the region, the Mexican and Mexican American population in the Midwest originated from labor migration. During and after World War I, the private sector recruited and contracted Mexicans to work in the railroad, manufacturing, and agricultural industries. Dr. Gilberto Cárdenas (1976), in one of the first scholarly articles to address the Chicano experience in the Midwest, noted that the seasonal migration and immigration to the Midwest by Mexicans should be compared to the type of migration that occurred during the Great Depression. Immigrant and labor experiences would fuel the content of Midwestern Chicano art.

■ The Poster

Over the course of the twentieth century, political posters have been widely used as a propaganda tool by both government institutions and political dissidents. Activists during the 1960s, lacking major financial resources, editorial pull, or access to the mainstream press (Wells 2001), turned to the poster as the medium of choice for visually communicating the ideas behind a variety of social justice campaigns. Posters, especially silkscreened posters, are usually inexpensive to produce. With few resources, a silkscreen printmaker, using a wood silkscreen frame and squeegee, can produce hundreds of posters relatively quickly and with the same artistic potential as a fine art print.

Chicano artists produced many of their early posters using the silkscreening process because they did not have a commercial base to support their artistic production. Offset **lithography** was used when funding enabled a massive printing of a single poster. For the most part, however, Chicano artists used silkscreen printing for their artistic expression, developing and expanding the possibilities of the craft. In the process, they contributed thousands of posters advocating for social change.

Posters were not just a reflection of, but were direct and vital components of, the social justice movements taking place across the United States. Posters helped "call a movement into being through artistic expression" (Lipsitz 2001, 73), reflecting the community's cultural and political ideology. Chicana and Chicano printmakers used the medium to support the

UFW Delano Grape Boycott as well as subsequent unionizing struggles throughout California and the Southwest. In 1965, Andrew Zermeño, chief illustrator and artist for the UFW's newspaper *El Malcriado*, produced the offset poster *Huelga!* (Strike!) during the first year of the UFW's five-year boycott. Malaquias Montoya, reflecting the UFW's effort to force California's Central Valley grape growers to sign union contracts, produced a dramatic silkscreen poster advertising a June 6, 1968, rally to "Stop the Grapes" in Coachella. The artist used his talent to produce a visually stunning piece of art that simultaneously listed information on how to contact the organizers of the protest. As a result, these posters serve as both artworks and historical documents reflecting the activism and efforts of the Mexican American civil rights era.

Poster Production of the 1968–69 Third World Strikes

In 1968 a group of student activists at San Francisco State College formed the Third World Liberation Front (TWLF) with the goals of opening up college admissions to students of color and establishing a Third World College where the Department of Raza Studies would be formed and housed. In contrast to the nationalist ideals espoused by many Chicano movement organizations, the TWLF was truly an international coalition, exhibiting solidarity amongst people who had shared a common history of poverty and discrimination in the United States. The TWLF brought together the Black Students Union, the Latin American Students Organization, the Filipino American Students Organization, and El Renacimiento, a Mexican American student organization. The TWLF strike lasted almost six months, from the end of 1968 into 1969, and accomplished the establishment of the Ethnic Studies Department containing both Black and Raza Studies programs (Romo 2006).

Chicano Art scholar Shifra Goldman called the TWLF strike the "greatest moment for the Chicano poster movement" (Goldman 1984, 51) because of its integration of an organized cadre of artists in a poster-making workshop. Rupert García, then an art student at San Francisco State, began his poster production in this workshop. In 1978, García, who would become one of the most influential and prolific Chicano poster makers, explained how he served the student movement through his art:

> My participation in the strike was both physical and through making silk-screen posters in support of the strike and on other issues. I was critical

of the police, of capitalist exploitation. I did posters of Che, of Zapata, and other Third World leaders. As artists, we climbed down from the ivory tower. We abandoned notions that the artist was supposed to be against society, against people, be different, exotic. It was in the workshop, not the classroom, that I learned silkscreen printing. I also learned to work in a collective—critiquing, sharing, subduing one's ego. I had planned to be an easel painter, but the strike changed that. (Goldman 1984, 52)

In 1969, as the TWLF strike ended at San Francisco State, a similar strike arose across the bay at UC Berkeley.

From January through March 1969, UC Berkley students went on strike, making similar demands as their counterparts at San Francisco State had. Malaquias Montoya, then an art student at UC Berkeley, eventually became one of the most important Chicano artists to emerge during this period. Montoya had extensive knowledge of silkscreen printing from his years working as a commercial printer in San Jose. He used his printmaking skills and creative ability to serve the social movements taking place all around him. As Montoya states, "during my two years in Berkeley, at the University from 1968 to 1970, I hardly went to school, because of the grape strike, the Third World strike, and the reconstitution of classes. All the time I was there I used my talent—my art work—to help in different causes" (Berkowitz 2006, 114). Through campus activism, Montoya continued to use his printmaking to support social justice campaigns and community-based organizations. Hired at UC Berkeley soon thereafter, he taught poster making within the academy, promoting it as a valid art-making practice and tool for social change.

Chicano activists sought to create institutional change by opening the doors of educational opportunity to the Chicano community. As a result, they made universities their ground zero. Believing that universities should exist to serve the community, Chicanos and Chicanas sought to reclaim space within them. Many of the posters produced during the 1968 and 1969 student protests were created at printmaking workshops in and around university campuses. In the workshop environment, Chicano artists adopted the example set by the Taller de Gráfica Popular in Mexico, which encouraged collectivism. Later, "as the call to cultural and political activism on behalf of a Chicano agenda proved harder to realize within an institutional setting, these production workshops (talleres) moved to community sites" (Romo 2001, 99). Moving closer to the community was in line

with the movement's intention to work within the community to create change, rather than seek validation and support from historically exclusive institutions. (Talleres and community art centers are discussed further in chapter 5.)

The Chicano Poster: International Solidarity, Labor Struggles, Antiwar Campaigns, and Geographic Diversity

The late-1960s proliferation of the poster was part of a larger "international and domestic phenomenon" (Wells 2001, 172). Posters were produced by countless organizations and individuals working to end the Vietnam War, support the civil rights movement, and raise awareness of black liberation, feminism, lesbian and gay rights, and the ecology movement (Wells 2001). From the outset, Chicano posters addressed issues that were multiculturally, ethnically, and geographically diverse.

Although the Chicano poster movement developed primarily in California, other parts of the country contributed distinct and important works to the movement. In Chicago, artist Carlos Cortéz used the poster as a tool to support Chicano and working-class labor issues. Born in 1923, Cortéz lived and worked in Milwaukee until 1965, when he moved to Chicago. A member of the art collective MARCH (Movimiento Artístico Chicano), he contributed greatly to the Chicano art movement with his printmaking and poetry. He often depicted issues of cultural reclamation, but most of his work dealt with working-class labor issues. In 1947, he joined the Industrial Workers of the World (IWW), a radical labor union, and from 1969 to 1975, he edited the *Industrial Worker*, IWW's newspaper. His posters were often direct, single-color **linocuts** or silkscreens publicizing or promoting worker organizing issues. Cortéz also portrayed prominent figures in historical class struggles such as IWW leader Joe Hill, labor leader Mother Jones, César Chávez, Mexican revolutionaries Ricardo Flores Magón and Emiliano Zapata, and anarchist labor organizer Lucy Parsons (Bennett 2002). Cortéz's 1974 two-color poster *¡Sera Toda Nuestra! Con la Huelga General por la Libertad Industrial* promotes the power of laborers to use their collective solidarity across race, class, and gender lines to peacefully bring about change. In the print *Homage to Posada* Cortéz connects the cultural and political production of MARCH with the work of José Guadalupe Posada in Mexico (figure 4).

Especially compelling to Chicano activists and artists was the plight of third world nations struggling against external colonizers. In their view,

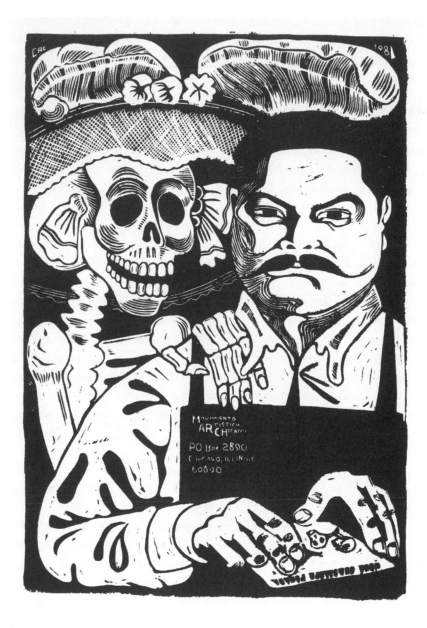

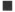 4. Carlos Cortéz. *Homage to Posada*. Linocut, 1981.

Mexicans living in the U.S. Southwest constituted an "internal colony," because they did not have a voice in the government structures and organizations that controlled their lives. Accordingly, Chicano activists and artists were inspired by and supported liberation movements taking place throughout Latin America (Romo 2006). In 1968, inspired by Cuba's OSPAAAL posters and by the death of Cuban communist revolutionary Che Guevara, Rupert García created a poster supporting the TWLF student strike bail fund. His poster *Right On!* was a simple black-and-white print of an iconic high-contrast photographic image of Che. By using the revolutionary hero as a symbol, García tied the efforts of the Third World Strike into the liberation struggles occurring throughout Latin America.

Malaquias Montoya used his poster production to support both domestic and international causes. Addressing his affinity for Cuban printmaking, Montoya states, "I don't know if the Cuban posters influenced me, but I was certainly inspired by them, especially their use of color, their simplicity, and most of all their dedication to revolutionary ideals" (Romo 2006, 58). He created numerous posters expressing solidarity with Cuba, usually in relation to other international struggles. For instance, in 1973 Montoya produced posters expressing solidarity between Cuba and Vietnam, and between Vietnam and **Aztlán**, the latter entitled *Vietnam Aztlán* (figure 5). These posters were the first of many works that tied Chicano and Latin American liberation movements with those occurring in the rest of the world.

Chicano artists used the poster throughout the 1970s and 1980s to support antigovernment struggles in Chile, Argentina, Nicaragua, El Salvador, and Angola. Chicano artists saw these struggles as ideological battles to end colonization and foreign intervention that were being thwarted by imperialist intervention, particularly through U.S. funding and support of counterrevolutionary forces. In 1979, Malaquias Montoya created the poster *STOP!!* in support of efforts to end U.S. investment in the Pinochet regime in Chile. In 1976, Juan Fuentes created a poster publicizing a poetry benefit to support Nicaraguan resistance to U.S. intervention. Fuentes's poster highlights the revolutionary Augusto C. Sandino, the inspiration behind the Nicaraguan independence movement and an inspiration to Chicano activists looking to Latin America for examples of courageous anti-imperialist leaders. Likewise, Louie "The Foot" González, in 1981, created a poster for the Salvadoran People's Support Committee. González used a photographic image of a young boy soldier to express support

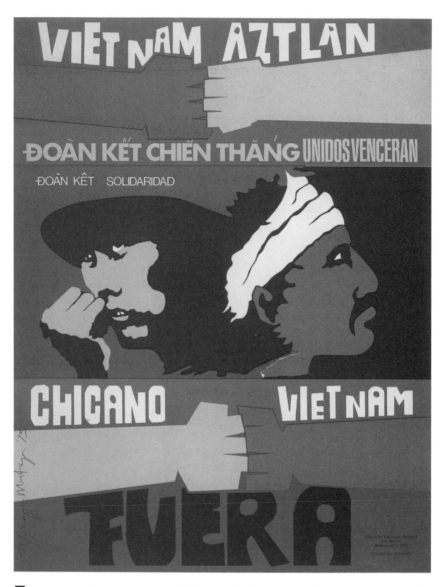

5. Malaquias Montoya. *Vietnam Aztlán*. Offset lithograph, 1973. (Courtesy of the artist)

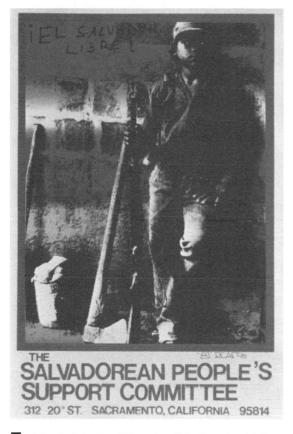

THE
SALVADOREAN PEOPLE'S
SUPPORT COMMITTEE
312 20ª ST. SACRAMENTO, CALIFORNIA 95814

■ 6. Louie "The Foot" González. *Salvadoran People's Support Committee*. Silkscreen, 1981. (Courtesy of the artist)

for the revolutionary efforts of the Farabundo Martí National Liberation Front (figure 6).

Cultural Affirmation and the Print: Mid-1970s

Chicano art scholar Tomás Ybarra-Frausto describes the efforts of the Chicano art movement as consisting of "cultural reclamation, historical reconstruction of social memory, action, and self invention" (Ybarra-Frausto 1994, 129). From the Chicano movement's outset, artists used their skills to support activist efforts, and silkscreen posters were an ideal way to meld art making and activism. In the 1970s, Chicano artists began using silkscreen printmaking to visualize ideas behind Chicano as a new political

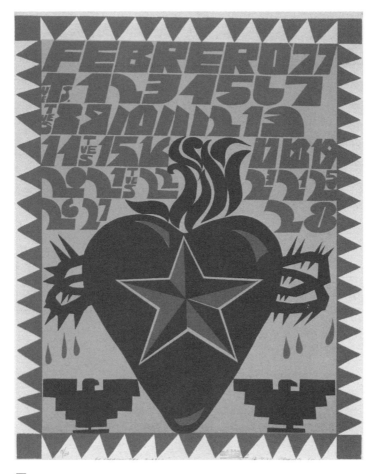

7. Carlos Almaraz. *El Corazón del Pueblo* (The Heart of the Village). Silkscreen, 1976. (Courtesy of the artist)

and cultural identity and Chicanismo as a manifestation of Chicano political-cultural consciousness. Artists began using the silkscreen poster both to articulate the Chicano experience and to educate the community about Chicanismo. Chicano artists refuted the **modernist** ideas of the artist as "outsider," separate from his or her community. Instead they viewed the artist as cultural worker and visual educator.

As artists continued producing posters to publicize events and community-based activities, they also created other works emphasizing Chicano cultural heroes, indigenous Mexicano culture, **pachucos,** and

urban youth. The use of community printmaking to develop *calendarios* (calendars) is one widely cited example of cultural reclamation. Calendarios are common throughout Mexican American and Chicano communities because Mexican businesses annually hand them out for free to their customers. Calendarios are found in many Chicano and Latino homes, and their imagery is often culturally affirming. Using this model, Chicano artists began making silkscreen-printed calendarios as cultural and historical educational tools. Individual artists, sometimes with the support of community centers, produced calendarios containing six to twelve prints, often by a variety of artists. Once the calendar was outdated, people would frequently cut off the dates and save the individual prints, valuing them as pieces of art. Carlos Almaraz's 1976 poster titled *El Corazón del Pueblo* is an example of artistic melding of the calendario with significant cultural and political representation (figure 7). A bleeding heart and graphic UFW symbols are in the foreground, while the days of the month (February) fill the poster's background. Scholar Tere Romo calls the iconic Chicano cultural and political symbols in this print a "perfect example of the seamless juncture of political, popular, and individual iconography that marked this period of poster production" (Romo 2001, 104). The calendarios were an effective means of injecting art into the everyday lives of the Chicano community while simultaneously affirming cultural reclamation.

The Print as Art: 1975–Present

Chicano art scholars Shifra Goldman and Tere Romo have both written about the gradual transition of silkscreen posters from political tools to art products and commodities. Chicano posters began as visual statements supporting a community's quest for self-determination, publicizing organizations, committees, and community events. Tere Romo writes that as grant funding began drying up, Chicano community arts organizations began seeking alternative sources of funding. These efforts included selling artwork, especially posters, in order to recoup the costs of poster production. Similarly, as Goldman explains, through the 1980s poster collectives continued activity "on behalf of the community, but diminishing public and private funding . . . necessitated some changes in the way they operate[d]" (Goldman 1984, 57). Posters using directly political imagery, which were often given away free to the community, were difficult objects to market to consumers with the means to purchase art.

Although the poster remains a tool for political change and a means of

serving the Chicano community, as artists began to experiment with personal imagery in the poster, political messages increasingly gave way to aesthetic qualities (Romo 2001). Shifra Goldman describes a schism opening up between artists who continued serving the still largely working-class Mexican population and those who were beginning to enter the mainstream art world of galleries and museums. Richard Duardo is cited as an example of a poster artist who, in the late 1970s, began working with Chicano artists in Los Angeles to bridge the gap between poster production and a commercially viable business. Duardo was a master printer at Self Help Graphics and Art Inc. in Los Angeles and later established his own business with the intention of "providing interior decorators with fine posters that, for the first time, would include those of Chicano artists" (Goldman 1984, 57). In his own work, Duardo created images representing Los Angeles's new wave and punk scenes while incorporating Mexican American cultural icons such as pachucos.

In an effort to finance the ongoing production of fine art prints, Self Help Graphics in 1982 announced the publication of a suite of silkscreen prints by the Chicano artist Gronk. As discussed in chapter 5, the sales of this print portfolio funded the establishment of an **atelier** program at Self Help Graphics. Gronk's portfolio "represented a new direction for Self Help (Graphics), strengthening the connection of their work in East L.A. to the mainstream art world and art market" (Guzmán 2005, 16). The subsequent atelier program at Self Help provided selected Chicano artists the opportunity to develop a limited-edition silkscreen print while working and experimenting under the guidance of a master printer. As Tere Romo (2001, 110) states, "no longer bound by publicity requirements or political agendas, the imagery reflected individual aesthetics and/or personal interpretations."

■ The Mural

The civil rights movement prompted an explosion of cultural expression from all communities fighting for self-determination, equality, and justice. The WPA murals and the **Mexican mural renaissance** provided an artistic legacy for artists who sought to serve a larger public than just those who visited mainstream art venues. Like the poster, the mural provided Chicano artists and activists with an art form that bypassed mainstream media and institutions. The Chicano movement placed a heavy emphasis on

developing, serving, and seeking validation from the Chicano/Latino community. The cultural expression and art making that emerged from the Chicano movement sought to redefine notions of universal culture and the idea of the American melting pot, which had historically promoted the blending of distinct cultures into a homogenous Eurocentric Protestant mainstream. Murals created by Chicano artists reclaimed public spaces, encouraged community participation, and aided community development. Chicano murals also provided visual imagery that supported civil rights struggles while reclaiming "cultural heritage" (Barnet-Sánchez and Cockcroft 1990, 9).

Chicano artists turned to the Mexican mural renaissance as part of a larger effort to recover their cultural patrimony and identity through art practices. The rich artistic history in Mexico served as an inspiration for Chicano cultural reclamation. Just as postrevolutionary Mexican artists rediscovered Posada, Chicano artists looked to the Mexican mural movement and found examples of the "knowledge, technique, concept, [and] style" needed to produce significant public artworks (Goldman 1994a, 112). Chicano artists, not just in muralism but in their entire creative output, found inspiration in the political nature of the Mexican mural renaissance and its intention to create a new culture. Chicanos were involved in a similar process of reclamation, developing a new identity with a political consciousness, and appropriating parts of their past that they'd long been taught to despise and now trumpeting them as their own.

One distinguishing aspect of Chicano muralism was that unlike the Mexican mural renaissance, which was supported by a revolutionary government and often executed in prominent government buildings, Chicano murals were painted in predominantly Mexican American barrios or working-class communities. In addition, from 1969 to 1975, during the height of political activism, grassroots organizations, artist-run community art centers, local merchants, and the artists themselves were the primary sponsors of mural production (Barnet-Sánchez and Cockcroft 1990). Another distinctive element of Chicano muralism was that the mural was most often not an exhibition of an individual's artistic expression, but rather a collaboration among multiple artists and community members. Chicano murals were almost always created in outdoor public spaces, and their collaborative creation was a way of giving the entire community ownership of the mural. Non-artist community members didn't just have access to the mural, they also watched it come into being, were often

encouraged to participate in the painting process, and continued to live with its presence on a daily basis. The new Chicano mural movement also adopted the perspective that the community had the right "to decide what kind of art it wants" (Barnet-Sánchez and Cockcroft 1990, 9). In an effort to ensure that the imagery and content accurately reflected the community, Chicano artists often entered into dialogue with community members about their culture and social conditions before developing a concept—even when the mural was to be located in the muralist's own barrio.

As the Chicano movement's influence expanded, so too did Chicano muralism in cities throughout the United States. Beginning in the late 1960s, Chicano muralism flourished in Chicago, Santa Fe, Phoenix, Denver, San Francisco, Los Angeles, and San Diego. Like posters, Chicano murals were often executed and promoted by collectives, the monumental task being divvied up amongst a team of artists. Collectives and centros such as Mechicano Art Center and Goez Gallery in Los Angeles; Artes Guadalupanos de Aztlán in Santa Fe, Denver, and Phoenix; Galería de la Raza in San Francisco; Toltecas en Aztlán in San Diego; Royal Chicano Air Force in Sacramento; and the Mexican American Liberation Art Front in Oakland and Berkeley all promoted or participated in the Chicano mural movement (Arreola 1984).

Early Mural Activity

The first murals by Chicano artists began to appear in 1968, springing up, often spontaneously, throughout the Southwest and Midwest. Chicano muralism often accompanied Chicano movement struggles such as the UFW Delano Grape Boycott. Mario Castillo's *Metafísica*, painted on the Urban Progress Center on Halsted Street in Chicago, and Antonio Bernal's mural in Del Rey, California, are two examples of early murals. Scholars cite the latter, painted on two panels on the UFW Teatro Campesino Center, as the first Chicano mural completed in California (figure 8). Bernal's mural is the first of an estimated more than 1,500 Chicano murals completed in California since 1968. This mural is significant because the imagery it represented became prevalent in many Chicano murals. In one panel, Bernal painted a pre-Columbian image of Bonampak, the ancient Mayan city in Chiapas, Mexico; in the other panel he painted a series of prominent Mexican revolutionaries and American civil rights leaders marching together. Francisco "Pancho" Villa, Emiliano Zapata, Joaquín Murrieta, César Chávez, Reies López Tijerina, Malcolm X, and Dr. Mar-

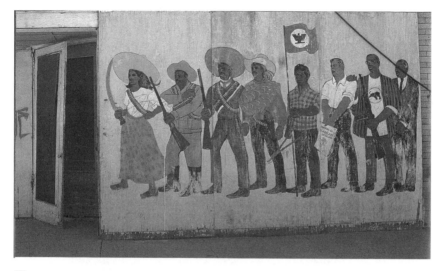

■ 8. Antonio Bernal. Portion of *The Del Rey Mural*. Mural, El Teatro Campesino Cultural Center, Del Rey, California, 1968. (Photo by Robert Sommer)

tin Luther King Jr. all follow "La Adelita," a Mexican soldadera (female soldier of the Mexican Revolution). Painted in a direct and interpretive style, the mural portrays a sense of solidarity in the historical progression of civil rights in the United States, thus representing America's approaching a more democratic society (Goldman 1990).

Collective Muralism

An early example of collective mural production occurred in the late 1960s in the East Bay Area with the development of an important Chicano art collective called the Mexican American Liberation Art Front (MALAF). Composed of Esteban Villa, René Yañez, Malaquias Montoya, and Manuel Hernández-Trujillo, MALAF was very short-lived, but all its artists became significant contributors to the Chicano art movement, especially to muralism. Esteban Villa would promote muralism and public art in the Sacramento Valley, while Malaquias Montoya and Manuel Hernández-Trujillo would create murals through their affiliation with the East Oakland Development Center (Goldman 1990). René Yañez would move to San Francisco and be one of the founders of Galería de la Raza, which would promote muralism in its own mural space as well as throughout the city. (MALAF is discussed further in chapter 4.)

Artes Guadalupanos de Aztlán, a collective begun by three brothers, Samuel, Albert, and Carlos Leyba, had a significant impact on the development of Chicano muralism in the greater Southwest. In 1971, the brothers produced a mural together to commemorate the death of their brother George. They were later joined by Gilberto Guzmán, Gerómino Garduño, and Pancho Hunter. Artes Guadalupanos intended from the outset that its art would be used as a source of empowerment. As Garduño writes, the collective wanted to counteract the negative aspects of its community such as "poor housing, lack of jobs, urban renewal, the degradation of welfare, delinquency, alcoholism . . . and possibly the worst, was heroin addiction and death by overdose" (Cockcroft, Weber, and Cockcroft 1977, 203). The collective's painted images tied together pre-Columbian motifs with positive and inspiring images of Chicanos and Chicanas. In its first three and a half years, Artes Guadalupanos created seventeen murals in Santa Fe, New Mexico; Denver, Colorado; and Phoenix, Arizona, a significant production in areas historically overlooked by art historians in favor of cities with larger Mexican American populations.

Chicano Park

The history and significance of Chicano Park in San Diego is central to Chicano muralism because of the great quantity of murals painted there and the activism behind the park's creation. Since 1967, San Diego city officials had led the residents of Barrio Logan to believe that a community park would be built in their neighborhood. In 1969, the Coronado Bridge was built, bisecting Barrio Logan in order to connect San Diego and Coronado, a peninsula located immediately off the coast. The following year, as it became apparent that no park was going to be constructed in their neighborhood, Chicano residents of Barrio Logan began considering constructing their own park, especially upon learning that the area underneath the Coronado Bridge was to be turned into a California Highway Patrol station. On April 22, 1970, community activists, students, and families from Barrio Logan occupied the Coronado Bridge underpass for twelve days, demanding that the City of San Diego immediately begin construction of a community park in the location. During the twelve-day occupation, numerous community members began constructing the park themselves, using "shovels, pickaxes, hoes, and rakes to prepare the ground for the planting of grass, shrubs, and flowers" (Rosen and Fisher 2001, 100).

Negotiations with the City of San Diego eventually yielded a 4.5-acre park, later expanded to 7.4 acres.

In March 1973, Barrio Logan community activists began transforming the newly established Chicano Park into a "liberated territory" that reflected the community's culture and aspirations. Since then, forty murals have been created on twenty-four concrete pillars and two abutments supporting the San Diego end of the Coronado Bridge (see figure 35). Two Chicano art collectives, Los Toltecas en Aztlán and El Congreso de Artistas Chicanos en Aztlán, executed the first murals at the park (see chapter 5 for the history of Los Toltecas). These artists, primarily from the San Diego region, painted pre-Columbian and Chicano nationalist images. In 1974 and 1975, artists from throughout California, primarily Los Angeles and Sacramento, were invited to add murals. A third phase of mural activity took place at Chicano Park from 1978 to 1981, with a notable twenty-day mural marathon.

The murals created at Chicano Park represent a vast array of visual styles, but similar themes permeate the majority of them: Chicano history, culture, spirituality, and community activism. Many Chicano Park murals are worthy of discussion, but the following two demonstrate the breadth and historical significance of Chicano Park as well as the diverse political issues and cultural elements that were expressed in public murals. In 1973, Toltecas en Aztlán and El Congreso de Artistas Chicanos en Aztlán created *Quetzalcóatl* with the support of Barrio Logan community members. *Quetzalcóatl* was one of the first murals painted at Chicano Park, and its imagery represents a pre-Columbian deity alongside various global, spiritual, and culturally empowering symbols such as the Chinese yin-yang symbol, a Catholic rose, and the UFW Huelga Eagle. In 1975, Celia Rodríguez, Irma Lerma Barbosa, Antonia Mendoza, Rosalina Balaciosos, Barbara Desmangles, and community volunteers created *Corazón/Aztlán* on a wall supporting a Coronado Bridge exit ramp. This was the third and final mural to occupy this location. It depicts two generations of Chicanos both separated and connected by a large central heart with arteries running between families.

In contrast to these murals, which largely have culturally empowering representations, *Varrio Sí. Yonkes No!* and *Chicano Park Takeover* display the political activism of the Barrio Logan community. *Varrio*, created in 1977 by Raúl José Jacquez, Álvaro Millan, Victor Ochoa, and

Armando Rodríguez, supported activists seeking to remove forty-eight Anglo-owned auto scrap yards from their neighborhood. *Varrio* is a variation of *barrio*, and *yonkes* is a reference to junkyards. The mural's title is prominently displayed along the top of the support column, and below it are images of community members with placards demanding environmental improvements in their neighborhood. *Chicano Park Takeover* was completed in 1978 and renovated in 1991. The work both documents and pays homage to the initial takeover of Chicano Park in 1970. The imagery shows community members using tools to transform the dirt under the Coronado Bridge into a community park. Chicano Park remains an example of the marriage between Chicano activism and art making.

Balmy Alley and the Mission District

San Francisco is estimated to have six hundred murals, the largest concentration of which are found in the Mission District. The Mission District's geography, location, and population density provided an environment ripe for mural production. It is a culturally rich and ethnically diverse neighborhood, inhabited by many residents of Latin American descent, especially from Central America, as well as a considerable Mexican American population. Beginning in 1973, Balmy Alley was transformed from a mundane backstreet in the Mission District to an internationally renowned mural center. In 1973, Patricia Rodríguez and Graciela Carrillo, who would participate in forming the northern California collective Mujeres Muralistas (Women Muralists), painted their first mural on a garage door across the alley from Rodríguez's apartment (Drescher 1994). Mujeres Muralistas would later create a number of significant murals throughout the Mission District, and their collective grew to include Consuelo Méndez, Miriam Olivo, Xochitl Nevel-Guerrero, Irene Pérez, Ester Hernández, and Susan Cervantes. Throughout the 1970s, these women created at least six other murals in Balmy Alley.

In 1984, Raymond Patlán, a muralist who had previously participated in Chicago's early Chicano mural movement, loosely organized a group of people under the name PLACA to fill Balmy Alley with murals opposing U.S. intervention in Central America and celebrating Central American culture (Drescher 1994). During that summer, twenty-seven murals were created by at least thirty-six artists. The result was a "block-long gallery" that has become known throughout the world (Drescher 1994, 27). Juana Alicia's mural *We Hear You, Guatemala* is a strong example of the public

artwork that provided dignity to those struggling for democracy and justice in Central America, while simultaneously portraying the rampant violence and death in the Central American revolutionary struggles of the 1970s and 1980s.

The Precita Eyes Mural Arts Center, a community-based organization started by Susan Cervantes in 1977, has greatly fostered muralism in the Mission District. Precita Eyes began with the goal of promoting and supporting the mural movement that emerged during the late 1960s and early 1970s, and to this day it sponsors new mural projects and supports restoration and preservation of Mission District murals. The center also conducts art education classes for youth and adults and provides guided tours of the Mission District murals to students and tourists. Within an eight-block walk of Precita Eyes are more than eighty accessible murals. As mural scholars Robin Dunitz and James Prigoff describe, one can walk into Precita Eyes on any given day and expect to find "children engaged in arts and crafts, artists drawing from the figure, professional muralists collaborating on a portable mural, a slide presentation to a group of educators or public school students, or an intense planning session for a new monumental mural project for the Mission District community" (Dunitz and Prigoff 1997, 23). Arts organizations such as Precita Eyes continue to support Chicano muralism's original objective: to create public art that authentically represents a community's history and culture.

Muralism in Los Angeles

With the largest Mexican American population in the United States, Los Angeles also contains the most Chicano murals. By 1978, it was estimated that one thousand murals had been painted throughout the city. Several important organizations, agencies, and galleries supported and encouraged the appearance of Chicano muralism in Los Angeles, including Goez Gallery, Mechicano Art Center, and the Cultural Arts Section of the Department of Recreation and Parks. The Cultural Arts section of the Department of Recreation and Parks established the Inner City Murals Project, and in 1974 the Los Angeles City Council funded Judy Baca's Citywide Mural Program (see chapter 5).

The Mechicano Art Center moved to East Los Angeles in 1971, providing spaces for artists to create murals, teaching silkscreen printing, and funding mural creation throughout East Los Angeles. Before 1973, funding for arts activities came from the National Endowment for the Arts and

the Los Angeles Housing Authority. Grants from the Housing Authority were intended to use murals to combat graffiti and encourage community development. In 1973, the Mechicano Art Center organized a series of murals within the Romona Gardens Housing Project, which had a high proportion of Mexican and Chicano residents. Among the artists who completed or worked collectively on the estimated twenty murals at Romona Gardens were Joe Rodríguez, Manuel Cruz, Wayne Alaniz Healy, Judithe Hernández, Willie Herrón, Leo Limón, Armando Cabrera, Ismael Cazarez, and Carlos Almaraz (Goldman 1990). *La Adelita*, created in 1976 by Los Four—Carlos Almaraz, Gilbert Sánchez Luján, Roberto de la Rocha, and Frank Romero—was a powerful visual representation of the famous Mexican **corrido** about the revolutionary soldadera and an example of the cultural reclamation practiced by muralists at Romona Gardens. In 1975, Charles Felix, working in association with Goez Gallery, organized a similar mural project at the Estrada Courts Housing Project in East Los Angeles, where thirty-five murals were eventually completed (Arreola 1984). Willie Herrón and Gronk, two members of the Chicano art collective Asco, painted a prominent mural at the Estrada Courts entitled *Black and White Moratorium Mural*. Created in a cinematic frame-by-frame style, the mural represented different images of the East Los Angeles community, including the 1970 Chicano Moratorium protest against the Vietnam War and the ensuing violence. Organizers of both ambitious mural projects were inspired by Judy Baca, a young muralist who had used public art to bring together rival gangs.

In 1969, the Cultural Affairs Division of the City of Los Angeles hired Judy Baca as a resident artist. Working through the Los Angeles Department of Recreation and Parks, Judy Baca created various public art projects, and in 1975, with funding from the Los Angeles City Council, she developed the Citywide Mural Project. Through this program, Baca led or organized more than 185 murals in predominantly Chicano, Asian, white, and black neighborhoods (Bond 1982). In 1974, she began one of the most ambitious American mural projects ever when the U.S. Army Corps of Engineers, seeking to control urban blight, asked her to create a mural in a Los Angeles flood-control channel. Using her position with the Citywide Mural Project, Baca raised funds from local schools, the fire department, community organizations, businesses, and grants to create a mural that would unite youth in an educationally empowering experience (Bond 1982).

In 1976, Baca established the Social Public Art Resource Center (SPARC), which is still an active and vital cultural institution in the Los Angeles area. From 1976 through 1983, under the auspices of SPARC, Baca led more than four hundred fourteen- to twenty-one-year-old youths and seven hundred volunteers in the creation of *The Great Wall of Los Angeles*. The *Great Wall*, consisting of almost three thousand feet of murals, represents and rewrites California history from the dinosaurs through the prehistoric Indian settlements, the Spanish conquest, and the migration of blacks, Mexicans, Chinese, Japanese, and whites to California (Goldman 1990). The *Great Wall* provides a visual perspective of history, incorporating parts of American history often left out of mainstream accounts: the Zoot Suit Riots, the Women's Suffrage Movement, the Civil Rights Movement, and the Japanese internment in World War II. Many *Great Wall* panels merit discussion, but one in particular demonstrates the artistic excellence and cultural and political integrity of Baca's project: *Division of the Barrios and Chávez Ravine* depicts the takeover by eminent domain of Chávez Ravine, a primarily Chicano neighborhood appropriated by the city to make room for a new stadium to house the Los Angeles Dodgers in the 1950s and early 1960s (figure 42). The mural portrays a part of recent Los Angeles history not often discussed, while alluding to the larger issue of forced displacement of poor neighborhoods and residents.

Muralism in the Midwest

Most murals in Chicago were products of the early Chicano art movement. The large presence of murals sponsored by New Deal Programs such as the Federal Art Project heavily influenced Chicago's Chicano artists. Likewise, the strong presence of the Mexican muralists served as an inspiration, most notably Diego Rivera's masterful mural at the Detroit Institute of Arts. The influence of the early muralist tradition would continue for generations. Scholar and artist George Vargas, in his 1988 dissertation on Latino art in the Midwest, noted that in Chicago more than three hundred contemporary murals embellish diverse communities throughout the city.

As noted earlier, Mario Castillo painted one of the first Chicano murals, *Metafísica*, for the Urban Progress Center in a Mexican and Mexican American neighborhood on Chicago's lower west side. Castillo, leading a group of Chicano youth, painted images of Chicano culture and anti-war sentiments. In 1971, Raymond Patlán, later a strong presence in San Francisco's Mission District, led a group of Neighborhood Youth Corps

workers in creating *Hay Cultura en Nuestra Comunidad*, a depiction of diverse Latino histories and cultures. In the same year, Patlán painted *Reforma y Libertad*, which depicted Mexican history from Moctezuma to Benito Juárez. Both of these early murals were painted at Casa Aztlán, a Chicago community center that served various educational, health, and family needs (Vargas 1988). These early murals evidence the way in which Chicano communities across the United States engaged in art that promoted community development and cultural empowerment.

Formed in Chicago in 1972, the collective Movimiento Artístico Chicano (MARCH) was chartered in 1975 and was responsible for many of the early Chicago-area murals. MARCH artists were not only muralists but also photographers, humanists, educators, filmmakers, and graphic artists. Despite these divergent areas of expertise, mural production was their primary vehicle for promoting cultural empowerment. Some members included Mario Castillo, Ray Patlán, Ray Vásquez, Saul Vega, Aurelio Díaz, José Nario, and José González (Vargas 1988). MARCH, like its counterparts in the Southwest, sought to create a new space where Chicanos could create a new visual culture that would further their community's attempts at self-determination.

Conclusion

This chapter has addressed the poster and the mural as two art forms unique to the Chicano movement. An ongoing criticism of scholarship on the Chicano art movement is its geographic focus on the Southwest. The Midwest Latino Arts Documentary Heritage Initiative at the University of Notre Dame's Institute for Latino Studies has made significant strides in documenting the contributions of important Chicano artists and collectives such as MARCH. Geography is central to understanding the various kinds of art produced during and after the Chicano movement. The San Francisco Bay Area's poster and mural movement was unique for many reasons, one being its visual representation of Chicano solidarity with the third world. Likewise, the sprawling nature of Los Angeles fostered a type of muralism that made Judith Baca's *Great Wall of Los Angeles* possible. And finally, San Diego's Chicano Park is an example of how a community embodied rasquachismo by demanding ownership of an underpass and developing it into a center for Chicano muralism. These are

but a few of the examples of artistic production that were central to the larger Chicano movement.

■ Discussion Questions

1. Why did the poster emerge as a Chicano art form? What were the social and political implications of this medium? In what ways does the Chicano use of posters relate to José Guadalupe Posada's broadsides and the work of the Taller de Gráfica Popular?

2. Discuss how the print became a vehicle for cultural affirmation. In your opinion, why did the silkscreen poster remain a prominent Chicano art form after 1975?

3. Why did the mural emerge as a Chicano art form? Why was collectivity important for mural creation? Discuss the varied iconography of Chicano murals.

4. Discuss the importance of Chicano Park. How is Chicano Park an example of the intersection of art and activism?

5. Historically, little attention has been paid to the cultural creations of Chicano artists residing in the Midwest. Why is this oversight problematic?

■ Suggested Readings

Bond, Evagene H. *La Comunidad: Design, Development, and Self-Determination in Hispanic Communities*. Washington, DC: Partners for Livable Places, 1982.

Cárdenas, Gilberto. "Los Desarraigados: Chicanos in the Midwestern Region of the United States." *Aztlán: A Journal of Chicano Studies* 7, no. 2 (1976): 153–85.

Cockroft, Eva Sperling, and Holly Barnet-Sánchez, eds. *Signs from the Heart: California Chicano Murals*. Venice, CA: Social Public Art Resource Center, 1990.

Cockroft, Eva Sperling, John Weber, and Jim Cockcroft. *Toward a People's Art: The Contemporary Mural Movement*. New York: E. P. Dutton, 1977.

Davidson, Russ, ed. *Latin American Posters: Public Aesthetics and Mass Politics*. Santa Fe: Museum of New Mexico Press, 2006.

Drescher, Timothy W. *San Francisco Murals: Community Creates Its Muse, 1914–1994*. St. Paul, MN: Pogo Press, 1994.

Gaspar de Alba, Alicia. *Chicano Art Inside/Outside the Master's House: Cultural Politics and the CARA Exhibition*. Austin: University of Texas Press, 1998.

Goldman, Shifra M., and Tomás Ybarra-Frausto. *Arte Chicano: A Comprehensive Annotated Bibliography of Chicano Art, 1965–1981*. Berkeley, CA: Chicano Studies Library Publications Unit, University of California, 1985.

Keller, Gary D. *Triumph of Our Communities: Four Decades of Mexican American Art*. Tempe, AZ: Bilingual Press, 2005.

Keller, Gary D., Joaquín Alvarado, Kaytie Johnson, and Mary Erickson. *Contemporary Chicana and Chicano Art: Artists, Works, Culture, and Education*. 2 vols. Tempe, AZ: Bilingual Press, 2002.

Keller, Gary D., Mary Erickson, and Pat Villeneuve. *Chicano Art for Our Millennium: Collected Works from the Arizona State University Community*. Tempe, AZ: Bilingual Press, 2004.

Kunzle, David. *The Murals of Revolutionary Nicaragua, 1979–1992*. Berkeley: University of California Press, 1995.

Mexican Fine Arts Center Museum. *The African Presence in México*. Chicago: Mexican Fine Arts Center Museum, 2006.

Noriega, Chon, ed. *Just Another Poster? Chicano Graphic Arts in California*. Santa Barbara: University Art Museum, University of California, 2001.

Ochoa, María. *Creative Collectives: Chicana Painters Working in Community*. Albuquerque: University of New Mexico Press, 2003.

Rosen, Martin D., and James Fisher. "Chicano Park and the Chicano Park Murals: Barrio Logan, City of San Diego, California." *Public Historian* 23, no. 4 (2001): 91–111.

Visions of Peace and Justice. Berkeley: Inkworks Press, 2007.

Prominent Themes in Chicano Art

As scholar Alicia Gaspar de Alba (2001, 206) states, "the **Chicano art movement** functioned as the aesthetic representation of the political, historical, cultural, and linguistic issues that constituted the agenda of the Chicano civil rights movement." Artists visually addressed many of the issues and challenges involved in creating a new cultural identity and politics of self-determination for the **Chicano** community. Chicano nationalism and pre-Columbian culture were prominent themes in all forms of Chicano art. Chicanos and Chicanas were interested in representing a new culture that embraced the totality of the pre-Columbian past. Likewise, issues of immigration and the U.S.–Mexico border have figured prominently in Chicano art and have been the subjects of numerous thematic exhibitions. Representing labor struggles has also been particularly important, especially in relationship to farmworkers and service industry workers throughout the United States. Another important theme has been the representation of Chicana feminism and issues of gender and sexuality. While the Chicano movement was demanding equality in U.S. society, Chicanas were struggling for gender equality, even within the Chicano community. Third world liberation and solidarity as well as antiwar campaigns have all been central to many various visual artworks. These are a few of the issues that will be discussed more thoroughly in this chapter.

Chicano Nationalism and Pre-Columbian Culture

Self-definition was a central goal of the Chicano movement, and Chicano artists and activists set out to reclaim culture and history lost through the levels of Spanish and American colonization that occurred in Mesoamerica and the U.S. Southwest.

Rodolfo "Corky" Gonzales, the founder of the **Crusade for Justice,** was one of the first poets to articulate this cultural reclamation. In 1967,

Gonzales's poem, *Yo Soy Joaquín/I Am Joaquin*, expressed the movement's quest for an independent and empowering identity. The poem articulated the confusion Chicanos felt as they sorted through the multiple layers of **Mexican American** identity:

Yo soy Joaquín,
perdido en un mundo de confusión:
I am Joaquín, lost in a world of confusion,
caught up in the whirl of a gringo society,
confused by the rules, scorned by attitudes,
suppressed by manipulation,
and destroyed by modern society

. . .

The confusion that Gonzales expresses has multiple connotations. There are simultaneous struggles to understand the cultural **mestizaje** of Mexican Americans while also trying to negotiate the cultural borders within U.S. society. Activists, poets, and artists like Gonzales deconstructed the mentality that assimilation was the only way for Mexican Americans to be fully accepted in the United States. They believed that rather than turning Chicanos into Americans, assimilation produced confusion and insecurity and stunted the growth of the Chicano community. They saw a lack of cultural awareness and pride as the main reason the community was unable to reach its full potential.

The 1969 drafting of "El Plan Espiritual de Aztlán" at the Chicano Youth Leadership Conference in Denver signaled a cultural nationalist philosophy for the Chicano movement. **Aztlán,** the mythical Aztec homeland in the north, became a symbol of a Mexican American homeland. Chicanos would no longer accept the dominant society's perception of them as foreigners or illegal aliens. Aztlán provided them with a creation story, allowing them to legitimately reclaim the Southwest as their rightful home. Aztlán not only gave historical value to the movement's demands for self-determination but also related **Chicanismo** to America's indigenous past. Chicano artists began using Aztlán as a metaphor, showing that "the United States is neither a wholly sovereign national state nor an endpoint of migration, but rather a part of a more extensive political, economic, historical, and cultural landscape, one that predates the arrival of European civilization" (Pérez-Torres 2001, 153).

In using Aztlán to describe both a metaphorical and a physical return to

an ancestral homeland, Chicano artists helped the Chicano community make a visual connection to its past. Some scholars have critiqued Aztlán as speculative and not verifiable by archaeology, and thus as a myth of Chicano activists and artists. But mythologizing is a large part of the creation of any cultural or national identity. The oversimplified notion of the melting pot and the misplaced religious fervor behind Manifest Destiny show that the creation of American identity has been no exception. For a modern political and cultural community systematically deprived of its history and ethnicity, mythologizing is not a negative process, but a very natural one Chicanos had long been denied (Goldman and Ybarra-Frausto 1985). Aztlán provided a grand historical foundation for the movement's larger political, cultural, and social goals.

Chicano artists visually represented mestizaje, in terms of not only the cultural mixture of Spanish and Native American cultures, but also the way Mexican Americans navigated American culture. Amado Peña's 1974 **silkscreen** *Mestizo* uses the "Mestizo Head" as an iconic symbol of Chicano cultural and political consciousness. Native American motifs serve as a background for a "tripartite" head representing an "extended mestizaje," one that includes the Spanish, Native American, and U.S. cultural heritage (Gaspar de Alba 1998, 50). Xavier Viramontes's 1974 silkscreen *Boycott Grapes* ties Chicano cultural mestizaje into the **UFW's** national grape boycott (figure 9). In this image the main focal point is a dark brown Aztec god figure. He is squeezing grapes, symbolizing the blood and sweat of the farmworkers. The poster reinforces that Mexican American farmworkers come from a culturally rich background and deserve to be treated with dignity and respect. The Galería de la Raza in San Francisco, where Viramontes worked, first printed the silkscreen poster, then the UFW mass-produced it as an offset **lithograph.**

Chicano artists actively set out to represent the full breadth of Mexican American history from the Spanish genocide and colonization of Mesoamerica to the U.S. occupation and annexation of the Southwest. Royal Chicano Air Force (RCAF) poet and artist Louie "The Foot" González created many silkscreen prints representing the complexity of Mexican American mestizaje and the historical legacy of colonialism. In his 1976 silkscreen *Cortés' Poem*, González used poetry and humor to poke fun at the many historical occurrences that helped create contemporary inequality for Mexican Americans. This silkscreen, like many of those produced by artists associated with the RCAF, was a collaboration. Louie González

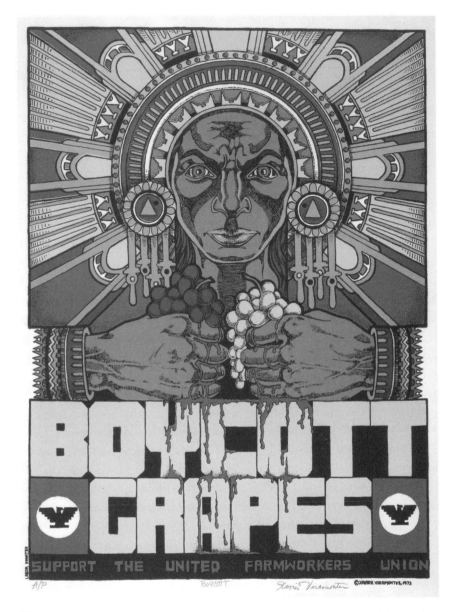

■ 9. Xavier Viramontes. *Boycott Grapes*. Offset lithograph, 1973. (Courtesy of the artist)

wrote the poem and designed part of the print, while Ricardo Favela added much of the background imagery. Using satire typical of the RCAF art collective, González attempts to heal the wounds of this painful history. The poster's background consists of a patterned pre-Columbian motif made up of the UFW Eagle logo. González then utilizes his poetry as an image, describing the various ways the Spanish, French, U.S., and Mexican leaders abused the Mexican and Mexican American populations (figure 10). *Cortés' Poem* begins

> Cortés nos chingó in a big way
> españa nos chingó in Spanish
> francia nos chingó with music
> los estados unidos nos chingó un chingote
> santa ana nos chingó like a genuine chinguista
> porfy nos chingó for a long long time
> y nosotros nos chingamos
> i swear!!!
> something's very wrong . . .

Cortés' Poem was printed as both a silkscreen color print and as a monochromatic calendario image.

Scholars Shifra Goldman and Tomás Ybarra-Frausto, in the introduction to their 1985 Chicano art bibliography, describe the sense of Chicano-Indian unity that emerged during the Chicano movement. The American Indian movement and the Chicano movement worked together to establish D-Q University in northern California, which from 1970 to 1978 was a "joint Indian-Chicano educational institution whose name derived from Deganawidah, the founder of the Iroquois Confederacy, and Quetzalcoatl, Toltec leader, statesman, and deity from Central Mexico" (Goldman and Ybarra-Frausto 1985, 38). To benefit D-Q University, Louie "The Foot" González created a silkscreen poster that proclaimed this ethnic unity through printing the labels "Chicano/Indian," as if they were interchangeable or one. The text-based poster demonstrates the ways Chicano and Native American activists used their commonalities to support self-determination.

James Luna's photographic triptych *Half Indian/Half Mexican* (1992) is a contemporary artistic representation of how Chicanos relate to their pre-Columbian past (figure 11). Luna challenges traditional anthropological views of Mexicans and Native Americans in three self-portraits, two

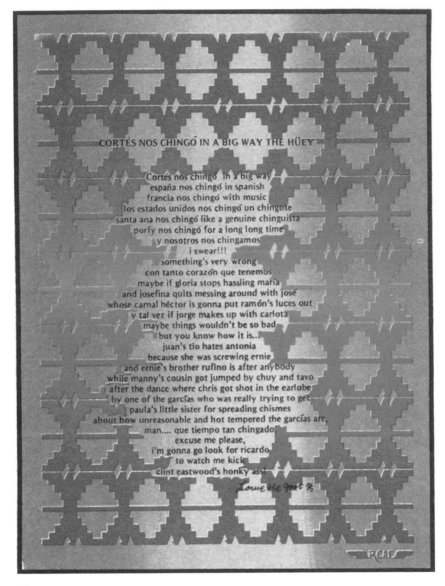

CORTÉS NOS CHINGÓ IN A BIG WAY THE HÜEY

Cortés nos chingó in a big way
españa nos chingó in spanish
francia nos chingó with music
los estados unidos nos chingó un chingote
santa ana nos chingó like a genuine chinguista
porfy nos chingó for a long long time
y nosotros nos chingamos
i swear!!!
something's very wrong
con tanto corazón que tenemos
maybe if gloria stops hassling maría
and josefina quits messing around with josé
whose carnal héctor is gonna put ramón's luces out
y tal vez if jorge makes up with carlota
maybe things wouldn't be so bad
but you know how it is...
juan's tío hates antonia
because she was screwing ernie
and ernie's brother rufino is after anybody
while manny's cousin got jumped by chuy and tavo
after the dance where chris got shot in the earlobe
by one of the garcías who was really trying to get
paula's little sister for spreading chismes
about how unreasonable and hot tempered the garcías are,
man.... que tiempo tan chingado
excuse me please,
i'm gonna go look for ricardo
to watch me kick
clint eastwood's honky ass

Louie the foot %

RCAF

■ 10. Louie "The Foot" González and Ricardo Favela. *Cortés Poem*. Silkscreen, 1976. (Courtesy of Louie "The Foot" González)

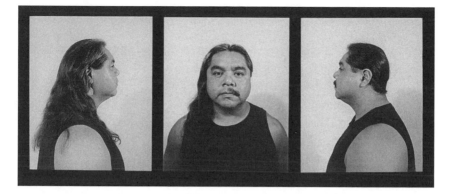

■ 11. James Luna. *Half Indian/Half Mexican*. Photograph, 1992. (Courtesy of Richard Lou)

profiles and one frontal view, that are purposely "reminiscent of those found in early anthropological photographs taken by taxonomists of race" (Cortez 2001, 370). In the left profile a clean-shaven Luna has long hair and wears an earring. In the right profile he has short hair and a mustache. In the central image he shows both sides of himself, leaving the viewer to question: is he Indian, Mexican, or both? In 1997 he reprised this triptych with a half-bearded face, showing his continuing exploration of identity. Through this powerful image Luna represents the complexity of Chicano culture and identification.

Chicana artist Yolanda López has created a diverse body of artwork recasting pre-Columbian, Mexican, and Chicano religious icons in contemporary situations. Her painting *Nuestra Madre* links the **Virgin of Guadalupe,** the patron saint of Mexico, with the indigenous Mexican deities Tonantzin and Coatlicue (Zamudio-Taylor 2001, 354). Chicana scholar Gloria Anzaldúa, in her seminal work *Borderlands/La Frontera: The New Mestiza*, discusses the various cultural markers that the Virgin of Guadalupe represents and embodies. Anzaldúa (1987, 30) states that "today, *La Virgen de Guadalupe* is the single most potent religious, political, and cultural image of the Chicano/*mexicano*. She, like my race, is a synthesis of the old world and the new, of the religion and culture of two races in our psyche, the conquerors and the conquered." Anzaldúa eloquently and passionately describes the Virgin of Guadalupe's apparition to the Aztec Juan Diego in 1531, in the same location where the Aztecs worshipped Tonantzin, Náhuatl for "Our Lady Mother." Delilah Montoya's photograph titled

La Virgen is a powerful representation of the complex cultural references and history that merge Tonantzin and Guadalupe into one mother figure. Recognizing the cultural influences surrounding the Virgin of Guadalupe is essential to understanding how and why artists, writers, scholars, and activists unearthed and reclaimed a fully Chicano culture.

Many Chicana and Chicano artists represented their pre-Columbian past through the use of *nepantla*, the Náhuatl word for a place of transformation. Gloria Anzaldúa describes nepantla as a way to visualize the metaphorical and physical border created through European and American colonization and conquest. In 1995, Los Angeles artist Yreina Cervántez created a triptych of lithographs entitled *Nepantla*. Through the work, Cervántez describes her personal negotiation of mestizaje and cultures that are often irreconcilable. She examines both her indigenous roots and spirituality, and also the ideological and artistic perspectives imposed on her by the dominant white culture (Cortez 2001, 368). Like James Luna does in his photographic triptych, Cervántez makes clear that in Chicana and Chicano consciousness there is no way to choose among the multiple layers of pre-Columbian, European, mestizo, Mexican, and Mexican American identities; they must be taken together. In the series' last lithograph, Cervantes states that the closest we can come to transformation, or nepantla, is through negotiation: "We grew up in two Americas—the ancient one that had existed for our ancestors for tens of thousands of years and the new one that is written about in history books. The tales of those two Americas are rarely compatible" (Cortez 2001, 370).

Lastly, in his early paintings Mel Casas, a Chicano painter from Texas, directly attempted to use humor and popular cultural icons to represent mestizaje in the Chicano experience. Beginning in 1965, Casas created a series of paintings called *Humanscape: Visual Conundrum Series*. The paintings address the aesthetic tensions of the U.S.–Mexico borderlands, bringing the legacies of folk art into the domain of U.S. **pop art** (Keller et al. 2002, vol. 1). In his 1970 painting *Humanscape 62: Brownies of the Southwest* Casas foregrounds various pre-Columbian and Mexican cultural images (figure 12). The Aztec serpent and deity Quetzalcóatl lines the front of the painting, and behind it stands a young Chicana who could either be a Brown Beret (a Chicano nationalist group) or a Brownie (young Girl Scout). A very large plate of brownies provides the backdrop for both images. Using a two-dimensional surface, Casas depicts numerous dimensions of the Chicano experience: Chicanos' relation to U.S. culture (eating

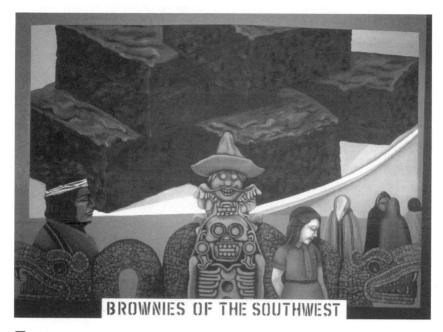

BROWNIES OF THE SOUTHWEST

■ 12. Mel Casas. *Humanscape 62 (Brownies of the Southwest)*. Acrylic on canvas, 1970. (Courtesy of the artist)

brownies and participating in Girl Scouts), Chicano political identity (being a Brown Beret), and Chicano historical identity (acknowledging Mexican and indigenous roots); additionally, the painting relates Chicano art to the wave of U.S. pop art. As Casas states, "Chicano art, at least for now, is a social mirror (*espejo social*). Its nature of intent and expectation is to avoid cultural schizophrenia by seeking a visual identity" (Keller et al. 2002, 1:118). Casas's work points to the complexity of this visual identity.

■ Immigration and the Border

The border has figured prominently in Chicano art both metaphorically and physically. Describing the historical importance of the border, sociologist Mario Barrera states that "people of Mexican descent became a U.S. ethnic group as a result of the Mexican American War of 1846–1848, which ended with the forced cession of half of Mexican territory . . . the entry of this group into the United States as conquered people exerted a profound influence on their subsequent history" (Mesa-Bains 1993, 20).

Mexican nationals had one year to move back to the newly defined Mexico or else become U.S. citizens. Although the 1848 Treaty of Guadalupe Hidalgo explicitly protected their rights and property, many Mexican nationals had their rights abused, lost their land to speculators and violence, and experienced daily acts of discrimination, while the new geopolitical border separated families and created economic fragmentation (Davalos 2001).

Chicano art scholar Karen Mary Davalos describes subsequent waves of Mexican immigration as a diaspora. The violence and danger of the 1910–1917 Mexican Revolution pushed many Mexicans into the United States. In addition, ongoing U.S. political and economic intervention in Mexican affairs fomented turmoil and instability, creating the conditions for large waves of immigration. U.S. economic policies such as the twenty-two-year Bracero Program, a guest worker system from 1942 to 1964, also contributed to large waves of immigration. The Bracero Program (Emergency Farm Labor Program) legally brought more than ten million Mexican workers into the United States with temporary worker status. As early as 1916, Mexicans were recruited to Chicago as railroad workers, and in 1918, agribusiness in the Midwest imported workers to harvest sugar beets (Davalos 2001). To this day, the U.S. private sector continues to recruit Mexican workers. Nevertheless, during periods of economic depression Mexican and Mexican Americans are often targeted and deported as threats to American workers, sometimes regardless of their citizenship status.

Davalos makes clear, however, that she means diaspora as more than just a scattering due to migration. Mexican Americans live in a diaspora because their culture and history are not fully accepted in mainstream American culture and society. People of a diaspora often "experience an 'ongoing history of displacement, suffering, adaptation, or resistance' that requires them to create alternative sources for establishing culture, memory and solidarity" (Davalos 2001, 23). This is an excellent description of some of the motivations for creating work about the border and around issues of immigration, especially in relationship to the U.S.–Mexico border. Accordingly, the popular Chicano saying, "We didn't cross the border, the border crossed us," becomes central to understanding the ways Chicano artists have visually combated issues of immigration.

Chicano artists have represented this sentiment in numerous ways. Yolanda López's *Who's the Illegal Alien, Pilgrim?* began as a drawing in 1978 and was reproduced as an offset lithograph in 1981 (figure 13). The drawing

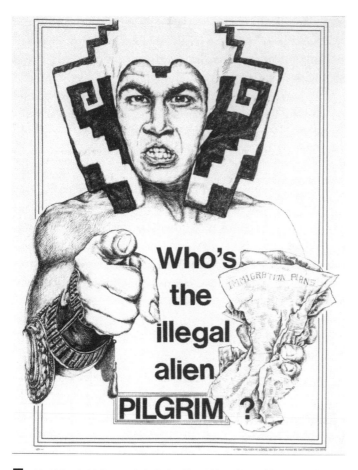

■ 13. Yolanda M López. *Who's the Illegal Alien, Pilgrim?* Pen and ink on paper, 1978. (Courtesy of the artist)

depicts a Chicano wearing a Toltec-style headdress and pointing a finger at the viewer, demanding an answer to the question, "Who is the illegal alien, PILGRIM?" López's poster expresses the Chicano movement sentiment that Mexicans and Mexican Americans are indigenous to the Americas and have greater cause to be represented as full citizens than the European foreigners who landed on Plymouth Rock (Keller et al. 2002:2, 91).

In *Borderlands/La Frontera* Gloria Anzaldúa discusses the border as both a metaphor and a geopolitical reality. The physical border she deals with is the Texas and U.S. Southwest–Mexican border, but the "psychological borderlands, the sexual borderlands and the spiritual borderlands" are not

particular to the region. "In fact, the Borderlands are physically present wherever two or more cultures edge each other, where people of different races occupy the same territory, where under, lower, middle and upper classes touch, where the space between two individuals shrinks with intimacy" (Anzaldúa 1987, preface). The U.S.–Mexico border is 1,951 miles long, and the majority of it has no constructed border markers or restraints on passage across it, despite current political efforts to create a physical border. John Valadez's painting *The Border* powerfully represents the border in Anzaldúa's sense as a metaphorical space where cultures collide. Valadez depicts a beautiful, unpopulated region similar to most of the area where the Rio Grande separates the United States and Mexico. In the clouds above this picturesque landscape, however, exists a violent clash between Spanish colonists and Native Americans. Though the conquest took place hundreds of years ago, its historical legacy continues, and so does the clash of cultures in the collective memory of Chicanos and Mexican Americans.

While John Valadez represents the pristine landscape that exists across much of the U.S.–Mexico border, many other Chicano artists have represented the militarization of the region. Since the 1990s, the U.S. government has sponsored numerous initiatives to "seal the border" that have heavily militarized the U.S.–Mexico border, especially in urban areas. Enacted in 1994, Operation Gatekeeper, one of these highly publicized anti-immigration efforts, fortified a sixty-six-mile swath of the U.S.–Mexico border in the San Diego–Tijuana corridor. The Border Patrol initiative pushed illegal immigration away from the urban centers and into the desert. As a result, hundreds of people have died each year attempting to make an extremely perilous crossing into the United States. Many Chicano artists have focused on the dangers of the border, often using barbed wire as a direct and metaphorical representation of the border's precarious and incongruous nature. Malaquias Montoya's 1981 silkscreen *Undocumented* represents an undocumented immigrant wounded and tangled in a web of barbed wire (figure 14). The wire symbolizes not only the dangers of the militarized border, but also the painful and contradictory experiences of Chicanos caught between two cultures. Rupert García, in the graphic poster titled *¡Cesen Deportación!* (Stop Deportation!), represents the barbed wire as a direct barrier to social justice (figure 15).

Otoño Luján's 1993 silkscreen *Break It!* also uses barbed wire to represent the U.S.–Mexico border fence. Luján depicts two armed Chicanos

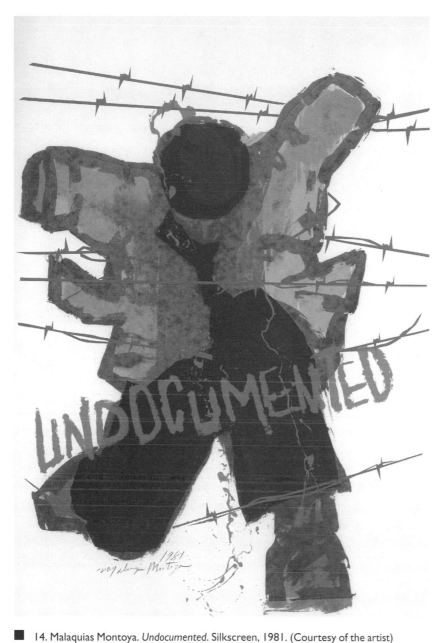

14. Malaquias Montoya. *Undocumented*. Silkscreen, 1981. (Courtesy of the artist)

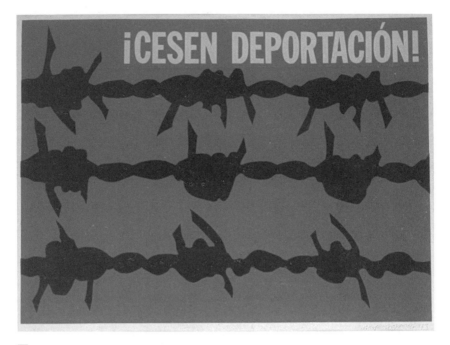

¡CESEN DEPORTACIÓN!

■ 15. Rupert García. *¡Cesen Deportación!* Silkscreen, 1973. (Courtesy of the artist, Rena Bransten Gallery, San Francisco, CA)

standing before the fence as the barbed wire is severed down the center of the print. *Break It!* calls people to action, to break down both the metaphorical and geopolitical borders. Yreina Cervántez's 1987 poster *¡Alerta!* utilizes barbed wire and images of running immigrants to add a human face to the undocumented workers who come to the United States. The barbed wire transforms into a rose, a reference to a popular workers' slogan—"We want bread, but we want roses too"—a demand for better wages and fair working conditions. A decade later, Jaclyn López García created a hand-colored photograph entitled *California Dreaming*, which depicts outstretched hands reaching for dollar bills over a barbed-wire fence. In the present American economy, where there is a great demand for low-skilled labor, especially in the meatpacking and agricultural industries, immigrants dream of financial well-being. As García depicts, however, immigrants can gain employment in the United States only if they are able to traverse the hazards of a militarized border.

The mainstream press, rather than portraying immigrants from Mex-

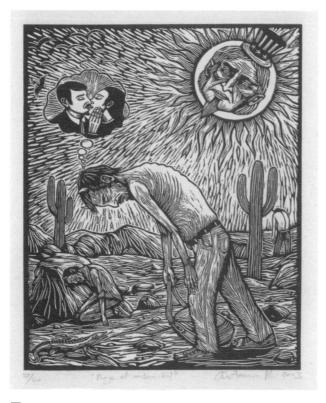

■ 16. Artemio Rodríguez. *Bajo el Mismo Sol*. Linocut, 2003. (Courtesy of the artist)

ico and Central America as contributing to the economy and society through their labor, paints them as threats to national security and to the continuance of U.S. culture. This portrayal feeds the country's historically xenophobic tendencies. Malaquias Montoya's 1983 silkscreen print *An Immigrant's Dream, the American Response*, articulates the result of this chauvinism, showing a dead immigrant wrapped in an American flag with a tag reading "Undocumented." Artemio Rodríguez's 2003 **relief print** *Bajo el Mismo Sol* also expresses America's contradictory attitude to immigrants. The print shows a man remembering the love he left behind as he dies underneath the hot desert sun, which bears the face of Uncle Sam (figure 16). Maceo Montoya's painting *Father and Son (Desert Crossing)* is another image of the perils of crossing the border through the southwestern desert (figure 17). Maceo Montoya often paints his works as a series that together provides a complete narrative. In the case of *Father and Son*

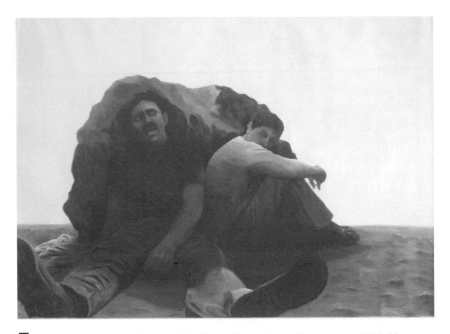

■ 17. Maceo Montoya. *Father and Son (Desert Crossing)*. Acrylic on canvas, 2004. (Courtesy of the artist)

(Desert Crossing), Montoya portrays the human side of the immigrant experience in the United States. Both Rodríguez's and Montoya's images depict the dangers of the border region in a world of border fences, spotlights, and random Border Patrol checkpoints, and the contradictions of anti-immigrant sentiment in the United States. Despite its need for low-skilled labor, the U.S. government still imposes extremely dangerous and harsh barriers on those wishing to participate in the American economy. Lastly, Byron Brauchli's 1994 photogravure print *Cruces del Camino* is part of a series showing sites along the U.S.–Mexico border where immigrants have died crossing. Today numerous public sculptures, altars, and paintings along the U.S.–Mexico border serve as memorials to the often anonymous immigrants who have died in their search for a better life.

As Artemio Rodríguez did with Uncle Sam in his print *Bajo el Mismo Sol* Chicano artists have often used popular American icons to reclaim their culture and symbolically redefine the landscape of the Southwest. Ester Hernández, in her 1976 etching titled *Libertad*, uses the Statue of Liberty to symbolically reclaim America as a homeland for Chicanos (figure 18). The

18. Ester Hernández. *Libertad*. Etching, 1976. (Courtesy of the artist)

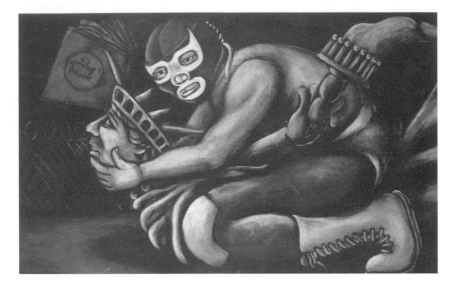

■ 19. Francisco Delgado. *Libertad*. Oil on masonite, 1998. (Courtesy of the artist)

original etching, later produced as a screen print, depicts a Chicana chipping away at the façade of the statue, revealing a base that reads *Aztlán* and a Mesoamerican indigenous-looking lower body. The revealing can be viewed as a literal claiming of the Statue of Liberty or as a reference to Chicanos reclaiming and re-creating a homeland in the United States. Both interpretations reference the various ways Chicano activists and artists have attempted to reframe the immigration debate. El Paso, Texas, artist Francisco Delgado, in his 1998 painting *Libertad*, shows a Mexican *luchador* wrestling the Statue of Liberty into submission (figure 19). A book bearing the logo and title of the "U.S. Border Patrol" falls from the statue's far hand. In effect, Delgado's luchador is attacking America's contradictory immigration policy.

Luis Jiménez is a Texas-born artist who resided and worked in New Mexico. A celebrated Chicano artist who has created a variety of drawings, sculptures, and prints that represent the Chicano experience in the United States, Jiménez is best known for his large public fiberglass sculptures and his highly rendered lithographs and drawings. His work is diverse in its themes and could be discussed in many of the thematic sections of this chapter. But his drawings and sculptures that address issues of the U.S.–Mexico border have received critical attention from both mainstream and

Chicano art communities. In particular, Jiménez created a series of sculptures and drawings titled *Border Crossing* that depict a man carrying a woman on his back crossing either a river or desert terrain. Shifra Goldman, in writing about Jiménez's work, has referenced his multiple cultural influences:

> Coming from an immigrant family in El Paso, cheek-by-jowl with Ciudad Juárez . . . Jiménez obviously recognized his relationship to this flow of human beings and undertook to imbue it with religious symbolism. *Border Crossing*, in which a man carries a woman and child on his shoulders, is reminiscent of the Holy Family crossing into Egypt—migrants of their own time—or of St. Christopher carrying the Christ Child across dangerous waters. Their destination will also be their place of work, of subsistence, of escape from danger. (Goldman 1994b, 17–18)

Border Crossing is one of many Jiménez pieces that address issues of immigration while also referencing a variety of cultural and political issues.

Labor

In their efforts to achieve community self-determination, Chicano activists sought to remedy class divisions and to empower the working poor. Mexican American laborers in both urban centers and agricultural areas often worked in wretched conditions. Workers who attempted to unionize and demand better conditions were almost always confronted by law enforcement sympathetic to wealthy capitalists and agricultural growers. To discourage organizing efforts, law enforcement often threatened and carried out deportations. As a result of this painful history, the labor activism of the UFW became one of the central inspirations of the Chicano movement. In 1965, led by Dolores Huerta and César Chávez, the UFW joined striking Filipino grape pickers in the Delano region of California. Mexican Americans and Chicanos across the United States followed the struggles of the UFW as they confronted the powerful agricultural industry. Chicano artists were particularly inspired by the UFW struggle because of its recognition of art as a tool to support social justice campaigns.

The UFW used art to help show that the farmworkers' unionizing effort was both a labor issue and a civil rights issue. César Chávez and Luis Valdez conceived of El Teatro Campesino (The Farmworkers' Theater) as a union-organizing tool. The *teatro* traveled with the striking farmworkers

and performed *actos*, or improvised skits. These actos were often performed on the backs of flatbed trucks in the fields where workers were picketing. The UFW also recognized the importance of developing strong symbols that represented the movement's efforts. The UFW's red, black, and white eagle flag became a symbol not only for unionizing efforts, but for all Chicano civil rights activism. The UFW also used the Virgin of Guadalupe to express the cultural background of Mexicans and Mexican Americans struggling for their rights in the workplace. During the 1960s, politicians and business owners still labeled union activists as communists, or "red agitators." By using the image of the Virgin of Guadalupe the UFW strikers presented themselves as law-abiding, religious citizens.

In 1964, the UFW created *El Malcriado: The Voice of the Farm Worker*, a newsletter/newspaper that supported and publicized the union's organizing efforts. Andrew Zermeño served as the primary illustrator of *El Malcriado* for many years, creating effective caricatures to relate the stories of farmworkers. Zermeño's most notable creation was the underdog, "Don Sotaco," who was constantly treated with disrespect by the boss, "Patroncito," and the labor contractor, "Don Coyote" (figure 20; Goldman and Ybarra-Frausto 1985). Zermeño's work for *El Malcriado* produced some of the most iconic images to emerge from the Chicano movement. Zermeño also made posters supporting the union, often including imagery that portrayed the breadth of Mexican American culture. Artworks by Los Tres Grandes and by artists from the Taller de Gráfica Popular were often reworked for the covers of *El Malcriado*. In 1965, Zermeño's poster *Huelga!* (Strike!), depicting a UFW worker lunging forward while carrying the UFW flag, represented the determination and passion of the Delano Grape Boycotters.

The UFW struggle inspired Chicano artists in a number of different media. In 1969, Salvador Roberto Torres created a series of oil paintings using the UFW eagle. In *Viva La Raza*, Torres carved the painting's title out of heavy green, white, red, and black oil paint (figure 21). Photography was another central medium used to document the farmworkers' struggle. Photographs helped publicize the farmworkers' plight as agricultural fields were often outside of the mainstream media's radar. George Ballis is one of many photographers who documented the dignity of the UFW's actions and the injustice of police brutality that occurred at the picket lines. Beginning in 1965, Ballis followed the various UFW struggles, often donating his photos to the UFW and sympathetic publications. Over

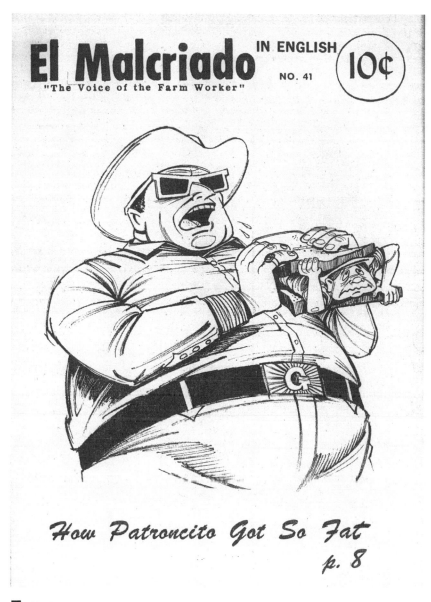

20. Andy Zermeño, *How Patroncito Got So Fat*. Illustration for *El Malcriado*, no. 41 (Courtesy of Reuther Library, Wayne State University)

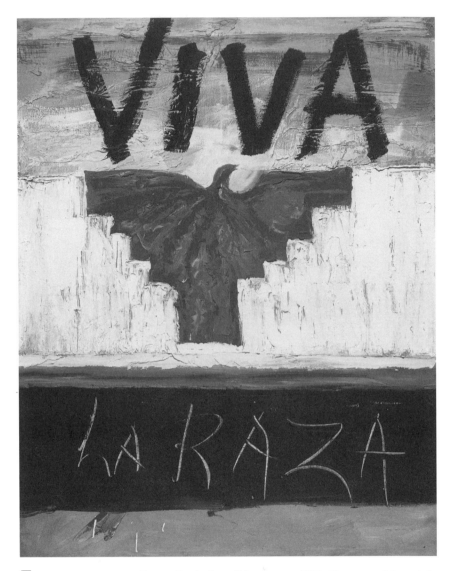

■ 21. Salvador Roberto Torres. *Viva La Raza*. Oil on canvas, 1969. (Courtesy of the artist)

the course of six or seven years documenting the UFW, Ballis amassed more than thirty thousand images. Francisco Domínguez is a contemporary photographer who has continued to document the struggles of workers in the agriculture industry. Domínguez's photographs give dignity and visibility to an often invisible working population.

The demand for a living wage was central to the UFW's initial efforts, but in 1969 César Chávez declared that "the real issue is the danger that pesticides present to farm workers.... We have come to realize ... that the issue of pesticide poisoning is more important today than even wages" (Gordon 1999, 51). For the rest of his life, Chávez would continue to fight for protection against pesticides that poisoned and caused disease and birth defects amongst farmworkers and their children. In 1982, Ester Hernández created *Sun Mad*, an iconic screenprint highlighting the UFW's continuing struggle to eliminate the use of harmful pesticides in agricultural fields (figure 22). Hernández's screenprint alters the highly recognizable Sun-Maid Raisins box, portraying a smiling skeleton instead of a healthy young girl. Text at the box's bottom reads, "Unnaturally grown with insecticides, miticides, herbicides, fungicides." Hernandez was initially motivated to create this piece after learning that the aquifer in her hometown, which was the location of Sun-Maid Raisins, was contaminated with pesticides. While Hernández did not explicitly make the screenprint for the UFW, it was utilized as visual support for one of their campaigns to end pesticide use. What also makes this screenprint unique is its ability to link pesticide use with consumers who purchase foods grown using pesticides. Juana Alicia's 1983 San Francisco Mission District mural *Las Lechugeras* also powerfully addresses the pesticide issue (featured in *Signs from the Heart: California Chicano Murals*). Women lettuce pickers are depicted with babies growing in their wombs while a crop duster flies immediately overhead.

Chicano artists have prominently depicted leaders of the Mexican American labor movement. Yreina Cervántez's 1990 Los Angeles mural *La Ofrenda* (The Offering) presents a portrait of UFW cofounder Dolores Huerta (figure 23). To this day, Dolores Huerta continues as a labor activist and civil rights worker standing up to the injustices of the agricultural labor industry, as well as advocating for equal representation and equality for women. Cervántez's mural ties Dolores Huerta's story into the larger immigrant rights struggles and antiwar movements, particularly in Central America. Barbara Carrasco's 1999 silkscreen *Dolores* presents a colorful graphic portrait of the labor activist, her face alone an effective symbol of resistance and hope (figure 24).

Artists have represented Mexican American workers using all media. Hector Dio Mendoza's sculpture *Cheap Labor* references recent and historical Mexican American labor issues (figure 25). The United States initiated

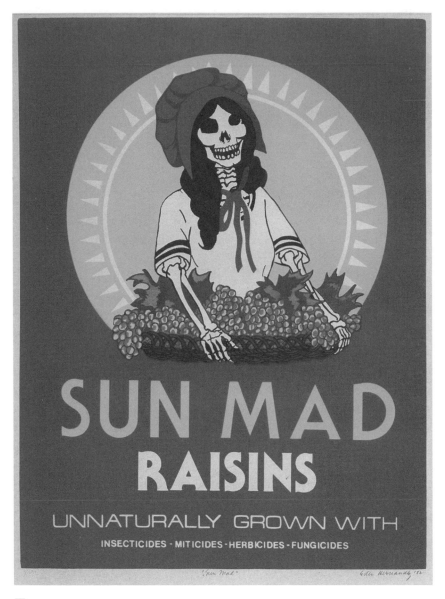

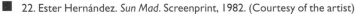

■ 22. Ester Hernández. *Sun Mad*. Screenprint, 1982. (Courtesy of the artist)

23. Yreina Cervántez. *La Ofrenda*. Mural, Los Angeles, 1989. (Photo by Jim Prigoff)

the Bracero Program to import cheap labor from Mexico to serve in a variety of industries suffering from labor shortages during World War II. To this day, the U.S. government continues to propose guest worker programs in order to gain cheap immigrant labor without providing the promise of full citizenship. To express this, Mendoza has sculpted two arms, or *brazos*, that are packaged the way meat is typically sold in U.S. supermarkets. Instead of the usual labeling, such as USDA certifications and market pricing, the arms are tagged with stickers that promise a "value pack" of "cheap labor." The brazos in Mendoza's work represent U.S. efforts to use cheap human labor without recognizing the full humanity of the workers who bring food to America's tables.

Today, union campaigns such as the Justice for Janitors movement have brought the working conditions of Mexican Americans in the urban service industries to the forefront. Justice for Janitors was established in Denver in 1985 by the Service Employees International Union. On June 15, 1990, Justice for Janitors' efforts were spotlighted after Los Angeles police officers brutally beat nonviolent activists supporting the campaign. In *¡Sí, Se Puede! Janitor Strike in L.A.*, a children's book authored by Diana Cohn, Francisco Delgado, a painter and printmaker from El Paso, uses clear and direct illustrations to depict the struggles families face during unionizing campaigns. The book is an example of the various creative ways art has been used to amass support for workers seeking to obtain living wages and decent working conditions.

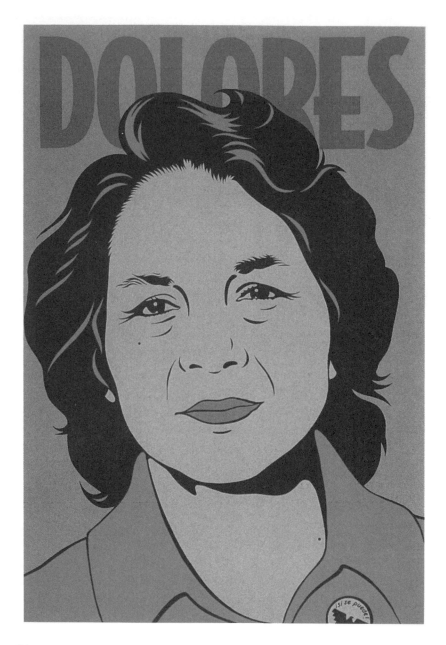

 24. Barbara Carrasco. *Dolores*. Silkscreen, 1999. (Courtesy of the artist)

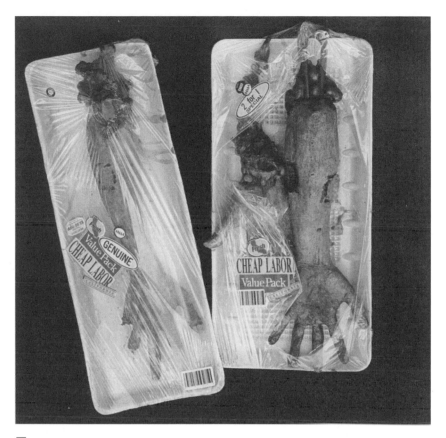

■ 25. Hector Dio Mendoza. *Cheap Labor.* Mixed media, 1999. (Courtesy of the artist)

■ Chicana Feminism and Sexuality

The women's movement and the development of a feminist discourse developed simultaneously with the Chicano movement. Since the beginning of the Chicano movement women were active in creating visual imagery to support a new Chicano and Chicana political identity. However, although the Chicano movement demanded an end to racism, poverty, and discrimination it did not address the need for basic changes in male-female relations or the status of women (Goldman and Ybarra-Frausto 1985, 42). Chicana activists found it contradictory that male activists were demanding an end to oppression in American society while denying the importance of Chicana self-determination, especially given the

traditionally patriarchal Mexican American culture. Women activists were often expected to participate in the movement by fulfilling traditional gender roles such as typing, cooking, and cleaning.

Considerable discussion of gender roles and Chicana equality occurred at the Crusade for Justice's first Chicano Youth Liberation Conference in 1969. Many Chicana conference participants demanded equal representation in the leadership of the movement, as well as an end to machismo. Despite or because of these demands for self-determination and equal representation, many Chicanas were ridiculed and labeled "Women's Libbers" or "aggringadas" (Ruiz 1998, 108). Furthermore, Chicanas who demanded equal treatment were often treated as *vendidas*, or traitors to the movement, and were cautioned against fighting for their rights because it would divide the Chicano movement at a crucial time. Thus, Chicanas faced multiple layers of oppression: not only discrimination against Mexican Americans in U.S. society, but also Chicanos' demands that they remain in traditional gender roles.

Chicana scholar Alicia Gaspar de Alba has described several influential strands of feminism that influenced Chicana artistic production. Radical, liberal, and Marxist feminism arose out of the primarily middle-class women's liberation movement. These three strands of feminism have collectively been labeled "white" feminism. In contrast Chicana feminism is described as a form of third world feminism, which accepts the white feminist critique of patriarchy while simultaneously acknowledging the inherent racism of American culture. Furthermore, Chicana feminism is identified as a critical perspective that places class and race as central elements of oppression, while acknowledging the effects of Catholicism, a history of colonization, and an unbalanced economy. In other words, issues of "language and culture, of nationality and citizenship, of autonomy and choice" play central roles in Chicana identity (Gaspar de Alba 1998, 124). Acknowledging this unique discourse, Chicana artists maintained that it was possible to engage in the development of Chicanismo while adopting a "feminist politics of identity" (124).

For many Chicanas, simply becoming an artist required breaking social norms and stereotypes, especially because the arts gave little promise of financial benefit to working-class families. Chicana artists also had to confront disempowering visual representations of women and Chicanas. One example is the adoption of the "warrior" image to support ideals of Chicano nationalism and cultural empowerment. In the archetypal image,

based on the Mexican myth of the origin of two volcanoes, Popocatepetl and Ixatccihuatl, a strong, light-skinned Aztec holds the dead body of a supine vestal virgin, portrayed as alluring and almost nude. This image is frequently represented on murals and calendarios and airbrushed on low-rider cars. Images such as these promote the idea of women as passive. As Chicana scholar Vicki Ruiz (1998, 106) asks, What "roles could women play in this hagiography of a pre-Columbian past" that represented women in such disempowering situations?

Chicanas also had to combat the traditional image and idea of La Malinche. Sold into slavery at a young age, La Malinche (Malintzin Tenépal) was eventually given to Spanish conquistador Hernán Cortés. She served as Cortés's translator and bore him a child. Rather than being viewed as a victim, La Malinche has been represented in Mexican and Chicano culture as a traitor who encouraged the conquest and colonization of the Americas. In addition, Chicanas have had to combat Christian notions of Eve as the source of original sin (Ruiz 1998). Alicia Gaspar de Alba explains that Chicanas in the movement were depicted either as Malinches, as traitors to the movement for encouraging women's self-determination, or as "Adelitas," the female soldiers in Mexican Revolution–era **corridos** who stood as loyal supporters and followers of their male counterparts. These two opposing representations of the Chicana experience were extremely problematic because neither concept encouraged self-determination.

Influential Chicana artist Santa Barraza has created numerous paintings that embrace and reclaim La Malinche as a metaphor for the contemporary and historic mestiza negotiation of multiple cultures. In her **retablo**-style painting *La Malinche*, rather than represent La Malinche as a traitor, Santa Barraza paints her as a "generous and forgiving individual who bore and nurtured a new strong race, an American hybrid" (Herrera-Sobek 2001, 10). Her back turned to the conquest's bloodshed and violence, Barraza's La Malinche is a metaphor of neplanta, the in-between place where culture, history, and identity are negotiated (figure 26). Work like Barraza's reverses traditionally disempowering representations.

Since the mid-1970s, Yolanda López and Ester Hernández, two leading figures in the Chicana art movement, have been reappropriating traditional representations of Mexican American and Mexican women. The Virgin of Guadalupe, the patron saint of Mexico, is one of the most prevalent images in Mexican and Mexican American culture. In 1660, the Roman Catholic Church proclaimed that the Virgin of Guadalupe was synonymous with

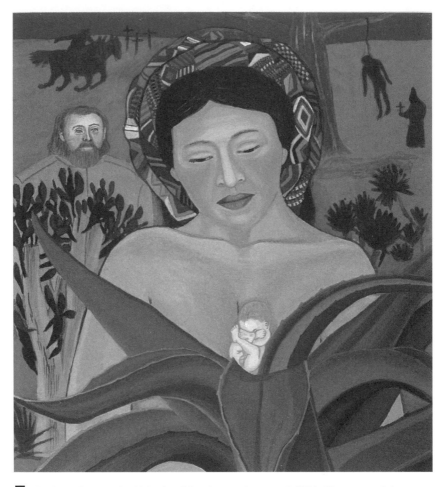

26. Santa Barraza. *La Malinche*. Oil and enamel on metal, 1991. (Courtesy of the artist; collection of Frederick Proull)

the Virgin Mary and officially made the Virgin of Guadalupe the patron saint of Mexico. Ester Hernández's 1975 print *La Virgen de Guadalupe Defendiendo los Derechos de los Xicanos* breaks the Virgin's traditionally tranquil and passive image, showing her "as a karate black-belt kicking at the invisible oppressor, be that Uncle Sam or the self-indulgent and over-bearing Diego Riveras of the Chicano Art Movement" (Gaspar de Alba 1998, 140). Similarly, Yolanda López has created multiple images situating the Virgin in active, empowering, and contemporary situations. López's

1978 triptych (series of three) oil pastel drawings places herself and female family members as active Virgin of Guadalupe–like figures (figures 27a–c). This triptych includes her pieces titled *Portrait of the Artist as the Virgin of Guadalupe, Margaret F. Stewart: Our Lady of Guadalupe,*and *Victoria F. Franco: Our Lady of Guadalupe*. In the first piece, López presents herself as the Virgin, running with her smiling face erect, in contrast to the Virgin's traditional solemn and downward-looking pose (figure 27a). López depicts herself holding a snake tightly in one hand while stepping on and crushing the angel, whom López has described as a symbol of patriarchy (141). On researching images of **Latinas** in progressive Chicano newspapers, López found that there were more representations of the Virgin than of Dolores Huerta or other prominent Mexican American women activists. Thus, López set out to reimagine the Virgin, turning her into an empowering image for Chicanas that encourages breaking out of traditional roles and expectations. As López says, "I felt that I had removed her from her bondage" (Keller et al. 2002, 2:80).

Contemporary Chicana artist Alma López has also used the Virgin of Guadalupe to represent both Chicana feminism and issues of sexuality. Most notable are López's digital prints, which use photography and **collaged** images to reformulate traditional Mexican and Mexican American images to represent the experience of Chicana feminists and queer Chicanas and Chicanos. Her 1999 digital print *Tattoo* shows a woman receiving a large tattoo of the Virgin of Guadalupe intimately embracing a *sirena*, or mermaid. This image is set against the backdrop of a typical U.S.–Mexico border fence and the Los Angeles metropolitan skyline. As Alma López describes her artwork in her artist communiqué titled "Mermaids, Butterflies, and Princesses"

> While I was creating Images for the series entitled *1848: Latinos in the U.S. Landscape after the Treaty of Guadalupe Hidalgo*, friends asked me to design a party flyer for a lesbian/bisexual women of color event. The image of two recognizable cultural female figures appeared to me: the Sirena/Mermaid from the popular lotería bingolike game and the Virgen de Guadalupe, the post-conquest Catholic mother of Jesus. In *Lupe and Sirena in Love*, they embrace, surrounded by angels with the Los Angeles cityscape and the U.S.–Mexico border as their landscape. Guadalupe and Sirena stand on a half-moon held by a Viceroy butterfly instead of the traditional angel. (López 2000, 189)

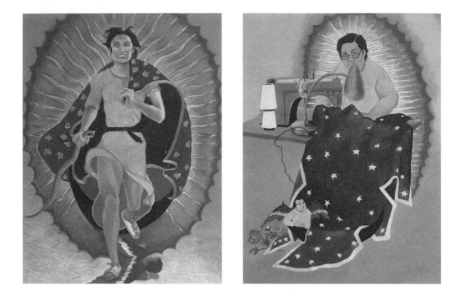

While representing the border and the urban Chicana experience, López also describes neplanta and mestizaje, expanding the cultural negotiation to include gay and lesbian experiences largely invisible due to discrimination at all levels of society. López's print *Ixta*, from the same year, repositions the traditional Mexican myth of the origins of Popocatepetl and Ixatccihuatl by representing the dormant and active volcanoes in the central Mexican Valley as two women. López reclaims this myth as the property of all Mexicans and Chicanos, regardless of gender or sexual orientation.

Chicano artists have also challenged patriarchal and heterosexual norms. Alex Donis and Daniel Salazar use visual representations of the lesbian, gay, and bisexual experience to challenge typical macho representations. Born in Chicago and raised in East Los Angeles, Alex Donis has been a prominent member of the Chicano art community since the 1980s. His work deals most often with the gay Latino experience and its relationship to heterosexual culture. "My objective with the work I do," he writes, "is to provide a more ample view of what 'art' can mean, while breaking down oppressive attitudes within religion, sexuality, and race" (Keller et al. 2002, 1:174). In 1997, Donis had a solo exhibition entitled *My Cathedral* that featured a series of works depicting a diverse array of popular culture icons engaged in same-sex kisses (Keller et al. 2002, 1:174). The painting

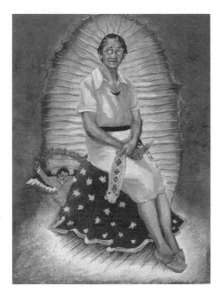

Che Guevara and César Chávez presented these two icons of the Mexican American and pan–Latin American struggle for independence and civil rights kissing in an embrace. Indicative of a still very homophobic society, Donis's exhibition was vandalized within one week of its opening.

Daniel Salazar's work also challenges a traditionally patriarchal and homophobic society. His works "explore and redefine machismo and traditional notions of masculinity through a reappraisal of gender roles" (Keller et al. 2002, 2:248). Appropriating historical photographs and icons, Salazar collages images to reposition Chicano and Mexican American men into situations outside traditional patriarchal roles. His series of images entitled *Machos Sensitivos* challenges Latinos to view gender roles in new ways. *El Valiente*, or the valiant one, is a traditional *lotería* card depicting a strong man. Salazar's *El Valiente* uses the same card, but collages the image to depict the man holding a box of diapers and carrying a baby wrapped in a serape. Salazar's "valiant man" is one who cares for and raises children. In *Toma Tiempo*, a photographic collage from the same series, Salazar appropriates a photograph of the Mexican revolutionary Francisco "Pancho" Villa and collages a bouquet of pink flowers into Villa's hands. Salazar thus repositions Villa as a peacemaker offering flowers instead of warfare. Rather than reflecting current society—representing men in typical macho

roles—Salazar's work presents men in caring and peaceful situations, demanding the viewer to see new possibilities in the way we construct our ideas of culture.

■ Family and Rituals

One of the goals of the Chicano movement was to represent authentically the many facets of the Mexican American and Chicano experience, ending the historical legacy of outside specialists and scholars defining Mexican and Mexican American culture. Chicano artists worked to create a grand new vision of Chicano identity but also dedicated themselves to portraying the more intimate aspects of the Chicano experience. This is especially true with respect to representations of family. Whether in urban barrios or rural towns, the Mexican and Mexican American family tradition stretches wide, including immediate and extended family members, as well as familial relationships gained through religious practices such as marriage and baptism. Familial issues, like all the themes discussed in this chapter, cross over into all sectors of the Chicano experience. The Vietnam War and antiwar activism greatly affected and influenced families. So has the border, by dividing and separating relatives and creating cultural divisions between generations. Family also intersects with spirituality and domestic spaces where the Chicano and Mexican American experience is perhaps most intimate and potent.

Alicia Gaspar de Alba, in her analysis of the seminal Chicano art exhibit CARA (Chicano Art: Resistance and Affirmation) describes the many representations of family in Chicano art as rituals of three main types: rites of passage, rites of season, and rites of unity (Gaspar de Alba 1998, 71). Carmen Lomas Garza, a prolific Chicana artist born and raised in south Texas, has thoroughly explored intimate Mexican American familial experiences. In particular, Garza represents the everyday events and festivities of the south Texas Chicano community. Garza has paid particular attention to ceremonies and rituals that bring communities and families together, including birthdays, playing games such as lotería, cooking, planting and harvesting crops, and traditional forms of healing. Two pieces featured in the catalogue *Contemporary Chicana and Chicano Art* (Keller et al. 2002, vol. 1) exemplify Garza's mastery in representing aspects of Chicano culture often unknown in larger American culture. *Abuelitos Piscando Nopalitos* and *Earache Treatment* each represents unique and inti-

mate Mexican American rituals. *Earache Treatment* portrays the folk remedy of burning a cone of newspaper to alleviate ear troubles, and *Abuelitos Piscando Nopalitos* is a narrative scene portraying Garza's grandparents' careful harvesting of cactus for cooking. Cacti and agave are prominently featured in Chicano art, particularly because these indigenous plants have been used since pre-Columbian times for food, their healing properties, and the production of alcoholic drinks (Keller et al. 2002, 1:264).

In *Milagro* (Miracle), Garza portrays a **magical realist** representation of Chicano spirituality within a vast Texas and Southwest landscape. In the painting various families come together to recognize and worship an apparition of the Virgin of Guadalupe on the side of a wooden water tower. In many of Garza's paintings, as in *Milagro*, the viewer looks at the scene from above, with a bird's-eye view of the rituals or daily activities of Mexican Americans. This perspective enables Garza to create "art that would elicit recognition and appreciation among Mexican Americans and at the same time serve as a source of education for others not familiar with [that] culture" (Keller et al. 2002, 1:264). In this sense, the viewer is treated to a wide view of Mexican American rituals and experiences while at the same time receiving an intimate view of everyday lives based on memories and lived experience.

Like Carmen Lomas Garza, realist painter John Valadez has created numerous paintings and drawings that directly represent experiences of Chicano families. *The Wedding*, an oil pastel drawing on paper, is a portrait of a bride and her mother (figure 28). Mexican American weddings bring together and create extended families, and serve as a rite of passage for the bride and groom. In Valadez's painting, the bride and her mother sit together in an open landscape. The mother sits on the bride's wedding dress, taking a prominent and dignified position as the one who arranges the rite of passage for this young woman's transition into adulthood and independence (Gaspar de Alba 1998, 72). Valadez's prominent and defiant placement of two generations of Chicanas circumvents the patriarchal tendency to diminish women's roles in the welfare and health of the Mexican American community.

Spirituality is central to Chicano ceremonies and rituals. Mexican and Mexican American religious and spiritual practices have historically combined pre-Columbian and Catholic religious practices. These issues warrant an analysis with respect to visual artworks that address spirituality, family, and rituals. In *Borderlands/La Frontera*, Gloria Anzaldúa discusses

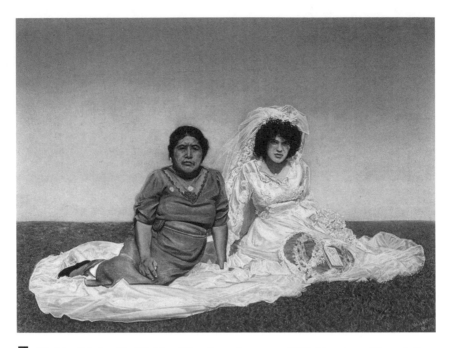

■ 28. John Valadez. *The Wedding*. Oil and pastel on paper, 1985. (Courtesy of the artist)

the melding of pre-Columbian and colonial Spanish culture in the Virgin of Guadalupe. Anzaldúa argues it was no coincidence that the Virgin of Guadalupe appeared to Juan Diego, whose Náhuatl name was Cuautlao-huac, at the same site where the Aztecs worshipped Tonantzin ("Our Lady Mother"). When the Virgin of Guadalupe appeared to Juan Diego she told him that her name was María Coatlalopeuh, which translated as "the one who is at one with the beasts." Other scholars have analyzed her name as meaning "she who crushes the serpent," the serpent representing Aztec religion. Chicanos have looked to prominent examples such as the imagery of the Virgin of Guadalupe as representative of the mestizaje that exists in all facets of Chicano life.

The **Day of the Dead** is another prominent example of a Mexican and Mexican American hybrid religious practice that incorporates both Spanish Catholicism and pre-Columbian spirituality. In the Roman Catholic calendar, November 1 is All Saint's Day and November 2 is All Soul's Day; both are referred to in Mexico as **El Día de los Muertos** or El Día de los Fieles Difuntos. These religious holidays link with pre-Columbian rituals

that pay homage and remembrance to the "sacred afterlife." Traditional Day of the Dead practices "include a special mass, home altars, visits to the graves of deceased relatives, candlelight vigils, the creation and consumption of special foods, prayer, and the arrangement of offerings of food, flowers, candles, and personal trinkets to the dead" (Davalos 2001, 144). Chicano artists have incorporated Day of the Dead practices into their art production since the emergence of the Chicano art movement and its cultural reclamation efforts. Most efforts have been ephemeral and not intended to be seen by the community or critics as artistic practices. Chicano artists have appropriated altars and *nichos* (niches, or boxlike enclosures traditionally used to display saints' images) to evoke the lives and contributions of deceased family members, friends, and community figures, documenting the collective memory of the Mexican American community (Davalos 2001).

The CARA exhibit contained numerous examples of altars or three-dimensional altar installations. One notable altar installation was Amalia Mesa-Bains's *Ofrenda for Dolores del Río*, which commemorated the screen actress who worked in films in both the United States and Mexico (figure 29). Carmen Lomas Garza, although primarily known for her drawings and paintings, has also created notable altars commemorating family members. *Ofrenda para Antonio Lomas* consists of a typical Garza tableau on the wall accompanied by garden tools. The woodcut scene depicts the artist's grandfather watering a garden, a metaphor for his efforts to nurture the artist's family (Davalos 2001). Both Mesa-Bains and Garza have created altars that visually recall traditional Day of the Dead practices but have placed them in environments where they are seen and respected as art.

Curanderos, or folk healers, are prominently represented in Chicano art, yet another example of Chicano artists' efforts to symbolize the complex cultural and spiritual experience of Mexican American mestizaje. Curanderos heal physical and spiritual ailments using alternative, often pre-Columbian or supernatural, forms of healing. Chicano artists from Texas have made various visual representations of curandero Don Pedrito Jaramillo. Born in 1829 in Guadalajara, Mexico, Jaramillo died in 1907 in Falfurrias, south Texas. Many Mexicanos and Chicanos along the Texas-Mexico border are familiar with Jaramillo's reputation as a curandero who possessed spiritual and supernatural healing powers. Texas artist César Martínez created two woodcuts in 1976 entitled *Don Pedrito Jaramillo*.

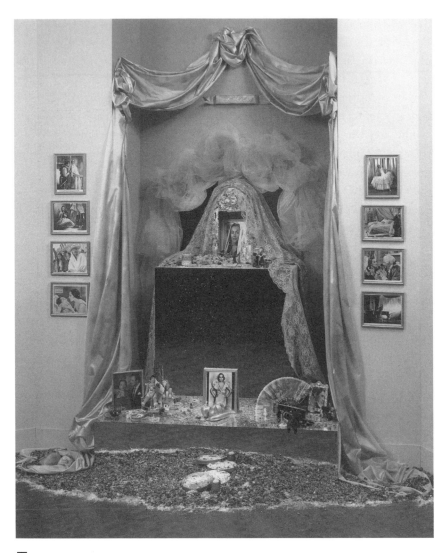

29. Amalia Mesa-Bains. *An Ofrenda for Dolores del Río*. Mixed media, 1992. (Courtesy of the artist)

Both highlight Don Pedrito Jaramillo's image as an everyday person, Chicano hero, and Chicano/Mexicano folk saint (figure 30). Santa Barraza, also from south Texas and known for her retablo paintings on tin, represents Jaramillo in *Retablo of Don Pedrito*. Barraza depicts Don Pedrito sitting before a maguey plant (a type of agave) and, as she explains, "he

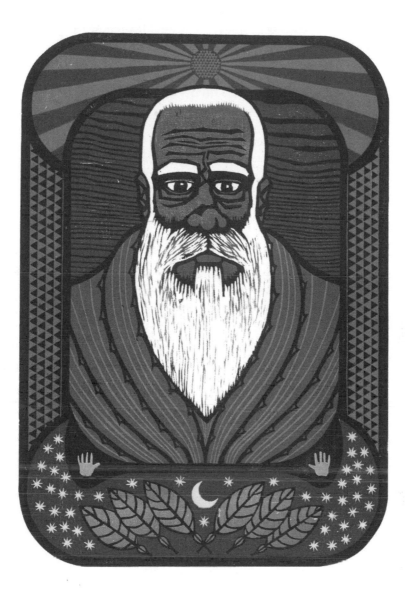

30. César Martínez. *Don Pedrito Jaramillo*. Woodcut, 1976. (Courtesy of the artist)

pops out of the maguey, as if employing the energy of the plant to heal. He is surrounded by indigenous images of water, his renowned healing element" (Herrera-Sobek 2001, 13).

■ Antiwar Activism and Third World Liberation Struggles

The Chicano movement emerged at the height of U.S. involvement in the Vietnam War. By 1968, the conflict had brought 50,000 American deaths, 250,000 wounded soldiers, and media reports of questionable American actions in Vietnam such as the My Lai massacre. The unpopular war led to the development of the largest antiwar movement in American history, with peace activists eventually playing a role in the war's end. The war affected the entire American population, but as the Chicano movement gained ground it became clear that Mexican Americans and African Americans were overrepresented amongst the casualties. As a result, Chicano activists began questioning the discriminatory application of the draft, as well as the justification for fighting a war against the Vietnamese when poverty and racism were prevalent issues at home. Tanya Luna Mount, a Chicana activist who participated in the East Los Angeles Blowouts (coordinated high school walkouts), linked unequal educational opportunities in East Los Angeles to the Vietnam War: "Do you know why they [Los Angeles Board of Education] have no money for us? Because of a war in Vietnam 10,000 miles away, that is killing Mexican-American boys—and for WHAT? We can't read, but we can die! Why?" (Ruiz 1998, 115). These powerful words describe the sentiment of many Chicano and Chicana activists, who believed that the government should focus on solving the unequal treatment of communities of color in the United States before promoting and imposing the American way of life abroad.

In 1969, Chicano activists participated in a series of nationwide moratoria calling for an end to the war in Vietnam. The following year, Chicano activists founded the National Chicano Moratorium Committee, whose goal was to organize peace activism. On August 29, 1970, the National Chicano Moratorium Committee organized its first public demonstration in East Los Angeles. Twenty to thirty thousand community members and activists attended the demonstration in an overwhelming display of solidarity. Their march through East Los Angeles culminated in orga-

nized speeches and festivities at Laguna Park. Despite the peaceful nature of the rally, Los Angeles police opened fire on activists, families, and children, using "non-lethal projectiles" and tear gas. As justification for their actions police officials alleged that a liquor store had been broken into and the thieves had fled into the crowd at Laguna Park. As families scattered, innocent community members were beaten and arrested. During the ensuing riot, police shot a tear gas projectile into the Silver Dollar Bar, where a group of people had sought refuge from the violence. *Los Angeles Times* columnist Rubén Salazar was hit in the head by the tear gas canister and killed. At day's end police had killed three people, and more than sixty had been injured. Rubén Salazar's image and the events at the Silver Dollar became emblematic of the Moratorium's tragic end. Salazar was one of the first reporters to provide in-depth coverage of the issues and demands of the Chicano movement, particularly in his seminal column, "What Is a Chicano and What Do Chicanos Want?" As Chicano activist and filmmaker Moctezuma Esparza explained, Rubén Salazar's death coincided with a loss of innocence in the Chicano movement. Speaking about the Moratorium, Esparza stated, "It was a tremendous blow. Because we lost a certain heart, we lost a certain innocence of ideals. . . . That we could engage this country . . . through the Bill of Rights, through the ideas that the country was supposedly founded on and that we could be killed" (*Chicano!* 1996). Several months later, Rupert García produced a silkscreen announcing a group exhibition in memoriam of Salazar's life to be held at the Galería de la Raza in San Francisco (figure 31). Frank Romero's 1998 silkscreen *The Death of Rubén Salazar* is a remembrance of the Chicano Moratorium and the ensuing violence (figure 32). Romero's expressionistic painterly print depicts the police shooting the tear gas into the Silver Dollar Bar. It visually elaborates on Esparza's discussion of how Chicanos witnessed for the first time the lengths to which American government and law enforcement agencies were willing to go to crush peaceful dissent and protest. Made almost thirty years after the Moratorium, the print shows the impact the incident had on Chicano collective consciousness.

Although the Chicano movement began with strong nationalist ideas, from the movement's onset activists recognized the importance of incorporating Third World perspectives and awareness into the development of Chicano political consciousness. In fact, Chicano artists created works that were in solidarity with the Vietnamese who were fighting the United

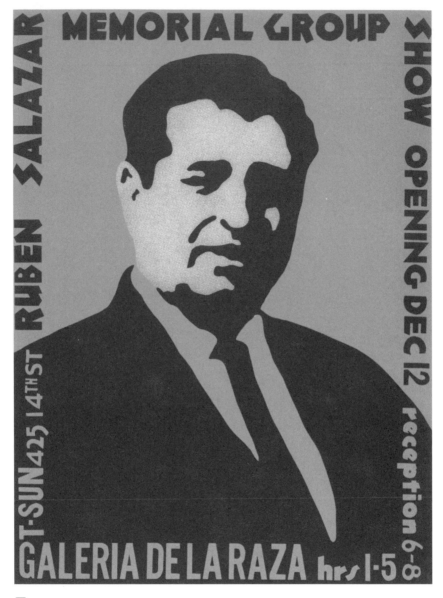

■ 31. Rupert García. *Rubén Salazar Memorial Group Show*. Silkscreen, 1970. (Courtesy of the artist; Rena Bransten Gallery, San Francisco, CA)

32. Frank Romero. *Death of Rubén Salazar*. Silkscreen, 1998. (Courtesy of the artist, Photo: Douglas Parker)

States. Malaquias Montoya's poster *Vietnam Aztlán* (figure 5) was an effort to create solidarity between the anticolonialist stance of the Chicano movement and the struggles of the Vietnamese fighting U.S. intervention. In 1970, Rupert García created a poster advocating an end to the Vietnam War, relating the North Vietnamese fight against U.S. imperialist intervention to the Chicano movement's own fight for self-determination and equality. García's *¡Fuera de Indochina!* (Get Out of Indochina!) presents a high-contrast portrait of a person demanding withdrawal of American troops. Unique about García's poster is his presentation of the demand for withdrawal in Spanish. By his use of Spanish, García reaches out specifically to the Chicano/Latino community, making it clear that it is up to the people to stop this war.

As Chicano activists sought an end to cultural and political colonialism within their own communities, they also recognized the need to stand in solidarity with international independence movements similarly seeking an end to foreign intervention. For example, Chicano artists created work in solidarity with Latin American struggles for self-determination. Chicano

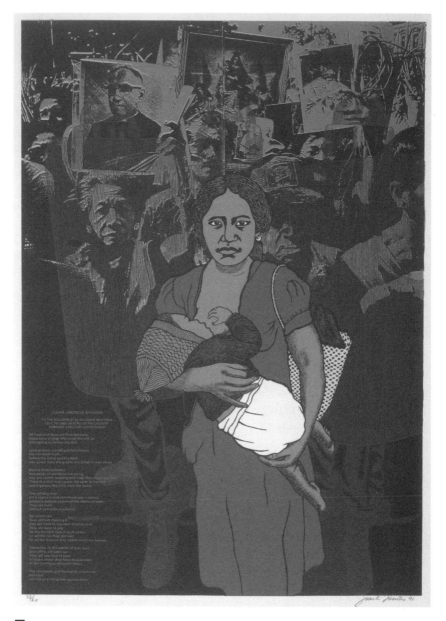

33. Juan R. Fuentes. *¡Romero Presente!* (Romero Is with Us!) Silkscreen, 1991. (Courtesy of the artist)

artworks often protested covert U.S. operations supporting antidemocratic counterrevolutionaries in countries like Nicaragua, El Salvador, and Chile. In 1979, Sandinista revolutionaries overthrew the U.S.–sponsored Somoza dictatorship and installed a democratic socialist government. Several years earlier, San Francisco–based printmaker Juan Fuentes began creating posters and prints supporting independence movements in Nicaragua and El Salvador. Fuentes's silkscreen print ¡Romero Presente! (Romero Is with Us!) creates a multi-layered image that remembers the life and contributions of Salvadoran priest and civil rights leader Archbishop Oscar Romero (figure 33). Louie "The Foot" González's 1981 poster Salvadoran People's Support Committee supported efforts in the United States to encourage democratic change and oppose U.S. intervention in Central America (figure 6). This poster is a direct and powerful representation of Chicano art expressing solidarity with Latin American social movements.

In 1978, Linda Lucero created a silkscreen print linking the Nicaraguan liberation movement with similar campaigns taking place in El Salvador. The print includes text reading "Solidarity with the Peoples of Nicaragua and El Salvador" and presents likenesses of Augusto Sandino and Farabundo Martí, a leader of Salvadoran independence during the 1920s and 1930s.

Luis Jiménez has also created works addressing U.S. intervention in Latin America. His lithograph Flirting with Death represents the danger such activity poses, not only to Latin American safety and democracy, but also to the future stability of the United States. Flirting with Death is an expressive drawing that provides a good contrast to the works of poster makers such as Fuentes, Lucero, and Sigüenza. Herbert Sigüenza created a poster in 1980 to support the Farabundo Martí National Liberation Front (FMLN) efforts to resist U.S. intervention. Sigüenza's poster resembles a comic strip and shows two characters engaged in dialogue, one character saying, "It's simple, Steve. Why don't you and your boys just get the fuck out of El Salvador?" A more subtle representation is Ester Hernández's silkscreen poster Tejido de los Desaparecidos (Textile of the Disappeared). While on the surface the image looks like a simple and colorful textile, a deeper examination reveals a pattern constructed out of helicopters and dead bodies. It references the disappearances and deaths of socialist-minded activists and revolutionaries as a result of counterrevolutionary movements in Central America.

Chicano Popular Culture

The experiences of urban Chicano youth have figured prominently in Chicano visual art. Migration from rural areas to urban centers was well under way by the 1940s. As the Mexican American community became more urbanized, it increasingly interacted with other cultures. This interaction led to the development of a Mexican American youth culture called **pachucos** (there were also a lesser number of pachucas). Shifra Goldman and Tomás Ybarra-Frausto, in their introduction to *Arte Chicano: A Comprehensive Annotated Bibliography of Chicano Art*, define pachucos as "young urban working class people of Mexican descent whose parents maintained and imposed cultural standards viable in Mexico but unworkable in the United States, according to their children who rejected these standards" (Goldman and Ybarra-Frausto 1985, 29). Pachucos developed linguistic and social behavior that was controversial to both the Anglo-American and traditional Mexican American communities. They were most notable for their zoot suits, flamboyant outfits characterized by baggy slacks and long coats. Originating in El Paso in the 1940s, pachucos were street youth often but not always associated with gang culture (Muñoz 1989, 37). They were deliberately ostentatious in an era when minorities were expected to be subservient and humble before whites.

In 1943, as large numbers of Mexican Americans battled fascism and fought for American values abroad in World War II, tensions ran high between pachuco youths and Anglo sailors who had docked in Los Angeles on shore leave. The tensions escalated into a weeklong riot known as the Zoot Suit Riots, during which Anglo sailors and marines entered predominantly Mexican American communities and systematically abused and beat pachuco youths. Newspapers owned by William Randolph Hearst further fueled the riots by publicly supporting the attacks against Mexican American youth (Muñoz 1989). The newspapers presented pachucos as subversive elements that undermined the war effort and threatened American peace and security at home (Goldman and Ybarra-Frausto 1985, 30). They went so far as to encourage servicemen to strip pachucos of their clothing.

Chicano artists have represented this experience in various media. Luis Valdez, the founder of El Teatro Campesino, created *Zoot Suit*, a prominent and successful play later developed into a Hollywood-sponsored motion picture. José Montoya, known for both his visual art and his poetry, is

credited with leading the visual representation of the pachuco experience. His work reclaimed the story of Mexican American urban youth as another example of the racism and discrimination the Chicano community faced throughout the twentieth century. Montoya created numerous silkscreen prints presenting dynamic line drawings of pachucos. Montoya's images represent another form of cultural reclamation that ties the experiences of Mexican Americans during the 1940s to the efforts of Chicanos seeking self-determination during the 1960s and beyond. Most notable are two posters from 1978, one promoting Luis Valdez's play *Zoot Suit* and another promoting the artist's prominent traveling exhibition, José Montoya's Pachuco Art: A Historical Update. Both posters present powerful images of pachucos, one as a Chicano youth and another as a **calavera** (figure 34). In a letter to the author, Jose Montoya briefly describes how the latter print came into being:

> I was fascinated with the idea of doing the first RCAF series of woodcut prints, but an RCAF mission required that we attend an important session in New Mexico or Texas. I still had some work left to do, so Rudy Cuellar and Louie "The Foot" González stayed behind to finish the project. Rudy's forte is the linoleum cut, so he cut the design on linoleum—ran one print on Japanese rice paper, did a positive of it, put it [burned a positive] on to the silkscreen and ran it as a silkscreen series! Impudent Young Pilots!!!! The court martial was held at the Reno Club and the rest is history, as they say! Oralé.

Montoya also wrote a complete essay, "Anatomy of an RCAF Poster," published in the catalogue for the Just Another Poster exhibition, which gives more detail about the creation of the *José Montoya's Pachuco Art: A Historical Update* poster. The inventiveness and collaborative nature of the RCAF are discussed further in chapter 4.

Chicano artists in the twenty-first century have continued to visually represent the Zoot Suit Riots. In 2001, Vincent Valdez, a Chicano artist from San Antonio, Texas, created a powerful painting entitled *Kill the Pachuco Bastard!* He shows pachucos being assaulted by servicemen but also fighting back—in particular, in the central image of a pachuco fending off an attacking serviceman. More than half a century later, the pachuco is depicted by Valdez as a cultural and political phenomenon where Chicano and Mexican American youth were not acted upon, but rather actors who fought for their unique place in American society.

■ 34. José Montoya, Rudy Cuellar, and Louie "The Foot" González. *José Montoya's Pachuco Art: A Historical Update*. Silkscreen, 1978. (Courtesy of José Montoya)

Texas artist César Martínez has created numerous portraits of pachucos and urban Chicanos and Chicanas, often shown only as busts. The simple and direct images specifically recall community members who populated San Antonio, Texas. Martínez collected images from his high-school yearbooks, newspapers, and other media, using them to represent each individual's uniqueness. Martínez's paintings portray contemporary manifestations of the urban Chicano experience while connecting them to earlier times. For instance, his painting *Hombre Que le Gustan las Mujeres* could be a representation of a pachuco from the 1940s or a *cholo* from the 1980s. His 1979 painting *La Parot* reflects a strong influence from pop art while still remaining specific to the Mexican American experience. Martínez shows what could be a pachuco, cholo, or vato combing La Parot hair gel into his hair.

Pachuco culture remains a prominent theme in Chicano art because the contemporary urban cholo culture is seen as its historical successor. Chicano activists and cultural critics see the present-day experiences of cholos and cholas as directly paralleling the segregation, discrimination, and police brutality pachucos endured during the 1940s. A number of cultural identifiers are applied to cholos and cholas: army surplus khakis, oversized white T-shirts or sleeveless T-shirts, extravagant makeup, jewelry, jeans, identifying tattoos, and low-rider cars (Goldman and Ybarra-Frausto 1985). Martínez's *Hombre Que le Gustan las Mujeres* is a perfect example of the tattoos, clothing, and style of the cholo subculture.

Chicano and Chicana photographers have been notable in capturing the experiences of cholos, cholas, and other urban Mexican American youth. Louis Carlos Bernal is a significant Chicano photographer whose artwork could be discussed in multiple sections of this book. He has documented families, Chicano neighborhoods, and Chicano popular culture, primarily in Arizona but also throughout California, New Mexico, and Texas. In 2003, the University of Arizona Press published a catalogue of his work, titled *Louis Carlos Bernal: Barrios* (Simmons-Myers 2003), accompanied by personal essays from colleagues. His powerful photograph titled *Cholos, Logan Heights, San Diego* (1980) captures two young cholos standing in front of a series of murals at Chicano Park in San Diego (figure 35). Speaking about his work, Bernal states that "my images speak of the religious and family ties I have experienced as a Chicano" and that "I have concerned myself with the mysticism of the Southwest and the strength of the spiritual and cultural values of the barrios" (Troy 2002, 55). *Cholos,*

■ 35. Louis Carlos Bernal. *Cholos, Logan Heights, San Diego*. Gelatin silver print. (Copyright 2002 Lisa Bernal Brethour and Katrina Bernal)

Logan Heights, San Diego is just one of many Bernal photographs that transmit the essence of Chicano barrios.

Like Bernal, Delilah Montoya is a versatile Chicana photographer whose work is mentioned earlier in the chapter. Montoya's photo collages were exhibited in the seminal CARA exhibit. Scholars have written about those works as addressing the spiritual and sociopolitical journeys that many Mexicans and Mexican Americans face in relationship to the metaphorical and physical U.S.–Mexico border. Montoya's fifteen-foot photomural titled *La Guadalupana* represents the intersection of spiritual and religious representations in popular culture (figure 36). *La Guadalupana* pictures a Chicano prisoner with a large tattoo of the Virgin of Guadalupe on his back. The prisoner is handcuffed and thus references a variety of issues that go beyond religious, spiritual, and cultural references to include the sociopolitical landscape that many Chicanos face. In discussing this piece, Montoya states

> A recent work, La Guadalupana, is a 15.5-foot photomural that was in-
> stalled at the Musee Puech Denys at Rodez, France. I was invited to create
> an installation that would source the Guadalupe. Since a 17c-easel painting

resided in the town's cathedral, they were familiar with the icon as a religious relic. I wanted to present them the Chicano vernacular concerning the Virgin. The mural depicts a "Pinta" (inmate) standing in front of metal bars, he is wearing handcuffs, and a tattoo of the Guadalupe is on his back. . . . The intention was to return an image of colonialism's dark side to Europe. Ultimately the piece resonated the sacred and profane. Once again [the] Saints and Sinners theme emerged. . . . Saints and Sinners is an investigation of Chicano spiritualism. This investigation is part of a study to define a personal and collective identity.

In discussing a different series of artworks, Montoya continues discussing central issues related to her photomural, *La Guadalupana*. "Spiritualism, a binding force of the Chicano homeland, is crucial to maintaining the mental boundaries of Aztlan. The study deals with iconography used by the Hermandad for the transmutation of sin to absolution. The exhibit expresses the universal themes of life, death and salvation" (Montoya, "Artist Statement"). Montoya's work and discussion is critical in understanding the multiple sources and meanings that permeate various aspects of Chicano culture.

Gaspar Enríquez, an artist from El Paso, Texas, and a former *trilión*, a term often assigned to rebellious barrio youth during the 1950s and 1960s, has created numerous paintings depicting the experience of contemporary urban Chicano youths (Keller et al. 2002, vol. 1). His painting *Tirando Rollo* (I Love You), a triptych that in total spans six feet by four feet, presents in a photorealistic style a young chola communicating the words "I love you" through arm gestures. "Tirando rollo" is an expression that originated in *caló*, a slang adopted by pachucos in the 1940s that often takes various forms. As Enríquez elaborates, "An especially remarkable form of *Tirando Rollo* can be spotted daily in El Paso, Texas. . . . There, along the perimeter of the county jail, wives, girlfriends, relatives, and friends of the inmates gather on the sidewalks and gaze at the narrow windows of the jail. Unable to connect through traditional means, visitor and inmate alike transcend their separateness and communicate through elaborate arm gestures, proving once again that heartfelt communication can never be denied" (Marin 2002, 61). Enríquez's description evokes the everyday defiance of Chicano and Chicana youth, who, like the pachucos before them, resist cultural and political limitations to communicate and express their culture.

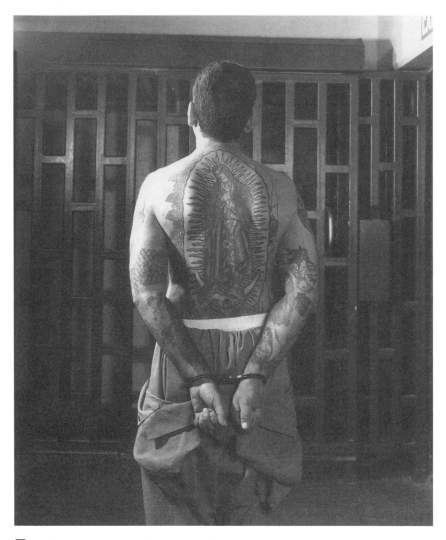

36. Delilah Montoya. *La Guadalupana.* Photo mural, 1999. (Courtesy of the artist)

■ Conclusion

This chapter gives a brief introduction to selected themes that have been addressed in Chicano visual art. One important issue to highlight in concluding this chapter is the overlapping nature of the issues and themes presented. In an effort to articulate central themes, I have devoted a separate section to each. Yet, many of the artworks discussed reference multiple

themes. For instance, Alma López's *Tattoo* is discussed in the section "Chicana Feminism," but her print also contains images of the U.S.–Mexico border and issues of immigration. This overlapping highlights the point that issues of social justice transcend borders. The causes of gender equality and a just immigration policy are both part of a larger movement towards equality and social justice.

■ Discussion Questions

1. Discuss how the border has been represented in Chicano visual art. Why would this be an important issue to represent visually? How has the border been visually represented both metaphorically and literally?

2. Why is it important for Chicanos to visually represent pre-Columbian Mesoamerican cultures? Why is the reclamation of the past important to establishing a sense of self and cultural identity? How might this mythologizing be problematic?

3. Discuss the importance of new imagery that challenges traditional women's roles in Chicano culture. How have La Malinche and La Virgen de Guadalupe been represented, both traditionally and by Chicano artists?

4. How have artists represented various forms of everyday life in Chicano culture? What is the importance of the "ritual"?

5. Discuss three different artworks from this chapter that transcend one particular issue and represent the multiplicity of Chicano culture.

■ Suggested Readings

Anzaldúa, Gloria. *Borderlands/La Frontera: The New Mestiza*. San Francisco: Aunt Lute Books, 1987.

Arceo-Frutos, Rene H., Juana Guzmán, and Amalia Mesa-Bains, comps. *Art of the Other Mexico: Sources and Meanings*. Chicago: Mexican Fine Arts Museum, 1993.

Chávez, Leo R. *Covering Immigration: Popular Images and the Politics of the Nation*. Berkeley: University of California Press, 2001.

Chicano! History of the Mexican American Civil Rights Movement. Video. Los Angeles: NLCC Educational Media, 1996.

Davalos, Karen Mary. *Exhibiting Mestizaje: Mexican (American) Museums in the Diaspora*. Albuquerque: University of New Mexico Press, 2001.

Fregoso, Rosa Linda. *meXicana Encounters: The Making of Social Identities on the Borderlands*. Berkeley: University of California Press, 2003.

Gaspar de Alba, Alicia. *Chicano Art Inside/Outside the Master's House: Cultural Politics and the CARA Exhibition*. Austin: University of Texas Press, 1998.

Goldman, Shifra M., and Tomás Ybarra-Frausto. *Arte Chicano: A Comprehensive Annotated Bibliography of Chicano Art, 1965–1981*. Berkeley, CA: Chicano Studies Library Publications Unit, University of California, 1985.

Gómez-Quiñones, Juan. *Mexican American Labor, 1790–1990*. Albuquerque: University of New Mexico Press, 1994.

Keller, Gary D. *Triumph of Our Communities: Four Decades of Mexican American Art*. Tempe, AZ: Bilingual Press, 2005.

Keller, Gary D., Joaquín Alvarado, Kaytie Johnson, and Mary Erickson. *Contemporary Chicana and Chicano Art: Artists, Works, Culture, and Education*. 2 vols. Tempe, AZ: Bilingual Press, 2002.

Keller, Gary, Mary Erickson, and Pat Villeneuve. *Chicano Art for Our Millennium: Collected Works from the Arizona State University Community*. Tempe, AZ: Bilingual Press, 2004.

León-Portilla, Miguel. *Aztec Thought and Culture*. Norman: University of Oklahoma Press, 1963.

Muñoz, Carlos Jr. *Youth, Identity, Power: The Chicano Movement*. New York: Verso, 1989.

Ruiz, Vicki L. *From out of the Shadows: Mexican Women in Twentieth-Century America*. New York: Oxford University Press, 1998.

Chicano Art Collectives

Artist collectives have been prominent in many national and international artistic movements and were especially important in developing the **Chicano art movement.** Rather than competing with one another for exhibitions, name recognition, and sales of artwork, **Chicano** artists made concerted attempts to work collectively to promote the goals of the Chicano movement. Collaborating for community benefit rather than competing for individual gain is a strong value in **Mexican American** culture. Chicano art collectives worked in a variety of media and existed for varying durations; some were short-lived while others continue to work collectively to this day. The organization and activity of Chicano art collectives deserve greater study and research. In this chapter I provide a brief description of only selected Chicano art collectives and the ideas that inspired them. (Artes Guadalupanos de **Aztlán** and Movimiento Artístico Chicanos (MARCH) are both discussed in chapter 2.)

Wherever artistic activity emerged in Chicano communities, groups of artists entered into dialogue on the role of art in the Chicano movement. Between 1968 and 1980, significant Chicano art collectives sprang up in every major city across the United States, including Chicago, Detroit, Austin, San Antonio, San Diego, Los Angeles, San Francisco, Sacramento, and Albuquerque. The group discussions and exhibitions proved to be fertile ground for developing a new visual culture; artists posed questions, developed ideas, held critique sessions, worked on large public projects, and challenged one another in their individual and common goals.

Mexican American Liberation Art Front (MALAF), 1968–1970

The Mexican American Liberation Art Front (MALAF) was organized in the San Francisco Bay Area in 1968. Its members included Manuel Hernández-Trujillo, Esteban Villa, René Yañez, and Malaquias Montoya. Although not a founding member of MALAF, José Montoya was

affiliated with their activities, exhibitions, and publications. MALAF is one of shortest-lived collectives discussed in this chapter, but it is one of the first examples of artists working together to promote Chicano art. In addition, MALAF members would individually have a large impact on the development of Chicano art in different parts of California, as well as have a national and international presence. The collective functioned for two years, holding informal meetings where the artists met, sometimes joined by community members and activists, to discuss Chicano art and activism. They addressed issues such as the Vietnam War, the **UFW** and the farmworker struggle, and educational inequity. Manuel Hernández-Trujillo states that members of MALAF "knew that art could be a significant power tool in unifying 'our people' against the ghastly impact of a system bent on maintaining Chicanos as a perpetual class of workers fragile and malleable in the presence of prejudice turned racism" (Zirker 1997, 17). Members introduced their independent views about art and art's use as a tool for social change; together these ideas, based on their own backgrounds and experiences, their respective communities, and their own creative sensibilities, created a unified but multifaceted vision for the emerging art movement. While nationalism fueled much of the Chicano movement's activism and certainly influenced the collective, MALAF was also heavily involved in addressing third world concerns and linking the Chicano movement with universal issues of justice and humanity.

MALAF organized traveling exhibitions and community workshops to produce posters and publications. As Esteban Villa explains in Jacinto Quirarte's 1973 book *Mexican American Artists*, MALAF's main objective was to "create new symbols and images for *la nueva raza*. It is an effort to present in visual form an artistic account of the Chicano movement" (134). In its promotion of a new visual culture, MALAF organized a traveling exhibition entitled New Symbols for La Nueva Raza. Independent exhibitions and publications enabled Chicano artists to have control over the way their art and culture were promoted. They also ensured that Chicano art and culture remained accessible to the Mexican American community.

Chicano scholar and professor Octavio Romano created just such an independent Chicano literary publication, *El Grito: A Journal of Contemporary Mexican-American Thought*. The spring 1969 special issue of *El Grito* was devoted exclusively to visual art and featured MALAF. Malaquias Montoya, Esteban Villa, Manuel Hernández-Trujillo, René Yañez, and José Montoya each presented a portfolio of his work accompanied by an

individual artist statement. Hernández-Trujillo included various wood-block **relief prints** representing a relationship between pre-Columbian and postcolonial cultures in the Americas (figure 37). In his artist statement, Hernández-Trujillo reflects eloquently on the efforts of not only MALAF but also subsequent Chicano artists, cultural workers, and activists:

> Para saber a donde vamos es importante preocuparnos por saber de donde venimos. En esta preocupación por conocer nuestro pasado hay oportunidad de reconocer la amarga igual que dulce historia de nuestros abuelos. La humana historia de los abuelos nos despierta al miserable momento en el cuál es encuentra nuestra cultura en este país. Es aquí en este despertar que nos encontramos y es aquí en este momento que busco por medio de la expresión artística los símbolos que más bien expresan lo que soy. Así fue el arte para el antiguo Azteca, después para el Mexicano, y ahora aquí para el Chicano.

> In order to know to where we are headed, it is important to concern ourselves in knowing from where we have come. In this concern to know our past there is opportunity to recognize the bitter as well as the sweet history of our grandparents. The human history of grandparents awakes us to the miserable situation our culture finds itself in this country. It is here in this awakening that we find ourselves and it is here in this moment that I look for, by means of artistic expression, the symbols that best express what I am. That is what art was for the Aztec of our past, later for the Mexican, and now here, for the Chicano. (Romano, Carrillo, and Vaca 1969)

Although MALAF disbanded after only two years, it would continue to have a lasting impact on the development of Chicano art through the individual members' continued work. Malaquias Montoya and Manuel Hernández-Trujillo both continued working in the Bay Area, creating community murals and establishing the first community-based Chicano **silkscreen** workshops to emerge from the Chicano movement in East Oakland. Working out of community colleges and through the East Oakland Development Centers, they remained committed to producing posters for community-based organizations, direct social justice activism, and a variety of benefits and community causes.

Malaquias Montoya began teaching silkscreen poster making in the newly established Chicano studies program at the University of California,

37. Manuel Hernández-Trujillo. *Sangrandose*. Woodblock, ca. 1965. (Courtesy of the artist)

Berkeley, and continues to this day teaching university-level classes in community mural painting and silkscreen-poster making. Montoya also established the Taller Artes Gráficas (TAG), a silkscreen poster workshop in Oakland where he made hundreds of prints and posters to support community activism and events. Esteban Villa and José Montoya eventually moved to Sacramento, where they established the Rebel Chicano Art Front, popularly known as the Royal Chicano Air Force (RCAF). René Yañez moved into San Francisco and helped establish Galería de la Raza in the Mission District. The RCAF is discussed further in this chapter; Galería de la Raza is discussed in chapter 5.

Asco, 1971–1987

Various Chicano art collectives, mural and silkscreen workshops, and community centers flourished in Los Angeles in the late 1960s and 1970s, particularly in East Los Angeles, a large, culturally vibrant Mexican American community. Garfield High School was a center of student activism and creative activity in this community, producing during this time a number of prominent Chicano artists, such as the members of the musical groups Los Lobos and The Midnighters. It was at Garfield High School that Patssi Valdez, Willie Herrón, Gronk, and Harry Gamboa Jr. first met (Benavidez 2002). Several of them participated in the East Los Angeles Blowouts in 1968. In 1971 they formed the collective Asco, Spanish for nausea. Other artists who subsequently joined the group included Daniel J. Martínez and Diane Gamboa. Asco was composed of self-taught artists who represented street youth and was known for subversive and conceptual performances and public artworks.

The members of Asco first began working together when Harry Gamboa Jr. asked Willie Herrón, Patssi Valdez, and Gronk to work with him on the Chicano literary and political journal *Regeneración*. Gamboa, in an article published in the catalogue for the CARA exhibition, states that through their work on *Regeneración*, "they discovered that they shared many experiences, enjoyed a common sense of dark humor, and were intensely committed to personal expression. At times, the nights of work gave way to group discussions of their collective influences" (Gamboa 1991, 123). These included influences from both popular Chicano and American culture, especially **pop art** and experimental **performance art** such as that of Fluxus and Andy Warhol. Willie Herrón explains that Asco sought to

represent through art the true realities of "the street, the real Chicanos who were taking it all the way. We weren't romanticizing or glorifying what the streets were like. . . . We wanted to reach inside and pull people's guts out" (Benavidez 2002, 18).

These intentions led to various and experimental forms of artistic production. These included the creation of *No Movie*, the *Instant Mural*, the *Walking Mural*, and other conceptual works (Benavidez 2007). In 1971, Asco began creating public art with their performance *Stations of the Cross*. On a prominent street corner in East Los Angeles Asco members embodied a Christ/Death figure, Pontius Pilate, and a zombie altar boy. They walked a mile along Whittier Boulevard, performing an alternative version of the Roman Catholic Stations of the Cross. Their mile-long pilgrimage ended at the U.S. Marine Recruiting Station. The humorous Chicano interpretation of a Catholic tradition tied in pre-Columbian imagery to make a statement against the increasing number of casualties in the Vietnam War. This was the first of Asco's many notable experimental "happenings" and public works.

In 1974, Asco turned a performance into a public mural when Gronk used masking tape to fasten Herb Sandoval and Patssi Valdez to an exterior wall in *Instant Mural*. Instead of painted images, this "mural" employed living figures, questioning what constituted a mural and highlighting concerns with cliché-ridden imagery (Sánchez-Tranquilino 1990, 98). Gronk and Herrón also created notable murals in East Los Angeles. *The Black and White Mural* depicts scenes from the Chicano Moratorium riots and other scenes of the Los Angeles Chicano experience. Although credited to Herrón, the 1972 mural *The Wall That Cracked Open* uses imagery representative of the social critique and visual experimentation practiced by Asco. Painted in an alley, *The Wall That Cracked Open* protested a gang beating of Herrón's brother and addressed the larger issue of alienation and violence within the Chicano community. Depicting a young man suffering, youth fighting, and a grandmother weeping, the mural's composition also incorporated existing graffiti. The incorporation of urban street graffiti is one example of the many ways Asco challenged traditional societal and artistic norms, validating various forms of cultural creation.

During Asco's sixteen years of collective activity, its membership varied along with its performances and creative output. Through the members' work on the streets of East Los Angeles, and their exhibitions and collective efforts at both Chicano community art centers such as Self Help

Graphics and mainstream art institutions such as the Los Angeles County Museum of Art, Asco left a lasting mark on the cultural production of Chicanos in Los Angeles and throughout the United States.

■ Royal Chicano Air Force (RCAF), 1972–

The Royal Chicano Air Force (RCAF) is a collective initially composed of José Montoya, Esteban Villa, Ricardo Favela, Rudy Cuellar, Juanishi Orozco, and Louie "The Foot" González. The RCAF remains active today, with a larger membership of artists and cultural workers that includes Juan Carrillo, Tere Romo, Armando Cid, Stan Padilla, Juanita Ontiveros, Max García, and Francisco "Xico" González, Celia Herrera Rodríguez, Sam Ríos Jr., Juan Cervantes, Lorraine García, and Irma Lerma Barbosa. The RCAF is and has been a fluid organization with a broad membership of cultural workers. Many of the listed artists would consider themselves part of the RCAF, while it is certain some would no longer consider themselves affiliated. As José Montoya (2001, 26) states in "The Anatomy of an RCAF Poster," the RCAF "wasn't only about painters, muralists, and commercial artists. It included in its ranks students, educators, historians, poets, *teatristas*, and community organizers, all operating within the constructs of struggle and resistance to utilize the impulse of pure creative energy in all aspects of organizing." The RCAF did whatever was necessary to further the goals of civil rights for Mexican Americans through art making and creative organizing.

Organized in 1972, the RCAF began as the Rebel Chicano Art Front, but because of constant confusion with the acronym for the Royal Canadian Air Force, the initial members began styling themselves the Royal Chicano Air Force. As Ricardo Favela states in the documentary *The Pilots of Aztlán*, "We kept on getting confused with the Royal Canadian Air Force so one day we said, 'Yeah, man, we fly adobe airplanes!'" As the myth developed, people brought RCAF members different air force regalia such as bandoliers, flight jackets, and air force pins. The references became more developed and satirical: young RCAF members who wished to become pilots earned stripes by attending "flight school," and the founders of the RCAF were self-described generals. The RCAF was an outgrowth of the discussions that took place amongst members of MALAF, but as Favela explains, the group took the notion of a collective to a different level:

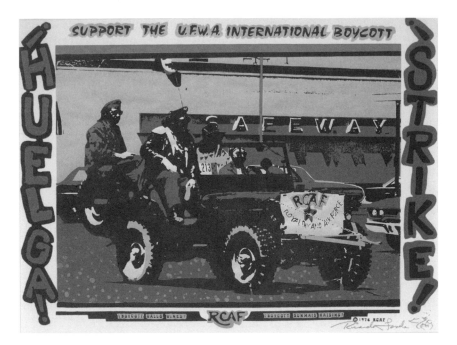

38. Ricardo Favela. *¡Huelga!* Silkscreen, 1976. (Courtesy of the artist)

> Everyone contributed to the myth of the RCAF. . . . It was very easy to do
> because it was all in fun. It is what we call in the barrio *cábula*, which means
> you play with humor and you use it as a means of resistance or defiance.
> As a means of doing something to your oppressor so that they don't know
> what you are doing to them. With that cultural awareness on our part, we
> had a field day. (*Pilots of Aztlán 1994*)

The collective used humor in oppositional ways to further its goals of
serving the Chicano community. It also brought multiple artists, cultural
workers, and scholars together under a unified cultural front. Primarily
active in the Sacramento Valley, the RCAF became a support organiza-
tion for the UFW union. Members of the RCAF were regular fixtures at
strikes, pickets, and protests for farmworkers' rights, and would often
appear dressed in flying caps and goggles.

The amusing anecdote behind Ricardo Favela's silkscreen poster
¡Huelga! (Strike!) provides an example of how the RCAF melded art,
activism, and direct action to serve the labor movement (figure 38). The
poster demands the boycott of Gallo Wines and Sun-Maid Raisins with a

notable central image of four RCAF members dressed in air force regalia riding in an army Jeep. The central photo was taken as the RCAF members took a beer break during a strike and boycott of Safeway in Woodland, California. While on their beer run, they wound up participating in the small town's parade, winning second place in the best entry category. This story exemplifies the group's use of creative activism and art making in living up to its slogan: *la locura lo cura* (the craziness that heals).

Proponents of Chicano nationalism, RCAF members were committed to integrating art and community development. In 1973, members founded El Centro de Artistas Chicanos as a community center and silkscreen workshop. The center provided a space for artists and activists in the Sacramento region to engage in artistic production and dialogue about important community issues. RCAF members also supported community activism through a prolific production of silkscreen posters and community murals. In addition, Esteban Villa and José Montoya—professors for many years at California State University, Sacramento—created a university-community art program to support area youth. The Barrio Art Program continues to conduct workshops in Sacramento's working-class communities. Centro de Artistas Chicanos no longer exists, but its successor, La Raza Galería Posada, continues to produce Chicano art exhibitions and cultural programming.

Mujeres Muralistas, 1973–1977

Mujeres Muralistas was a mural-painting collective composed of Chicana and **Latina** artists from the greater San Francisco Bay Area. Patricia Rodríguez, Graciela Carrillo, Irene Pérez, and Consuelo Méndez were the four founding members. At various times, Ruth Rodríguez, Xochitl Nevel-Guerrero, Susan Cervantes, Miriam Olivo, and Ester Hernández joined the collective in its mural projects. Mujeres Muralistas created eleven murals, mostly in the San Francisco Mission District, featuring the life, culture, and environment of Latin America (Davalos 2001). The collective came together at a time when women were grossly underrepresented in the Chicano art movement.

The group's mural production first evolved at Balmy Alley in 1973 (discussed in chapter 2), where two of the four members worked on a mural in an effort that was both independent and collective. Though the content was unified, the mural was broken up into sections for each artist

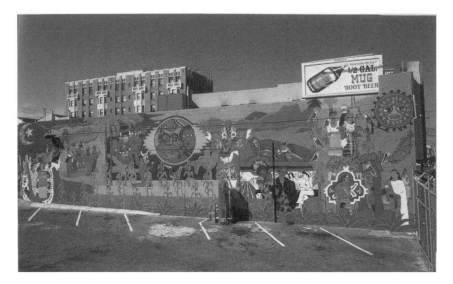

■ 39. Mujeres Muralistas (Patricia Rodríguez, Graciela Carrillo, Consuelo Méndez, Irene Pérez). *Latinoamérica*. Mural, San Francisco, 1974. (Photo by Eva Cockcroft)

to paint individually, in an attempt to fully represent each member's distinct experience and perspective. Mujeres Muralistas followed this working method in its subsequent mural projects. As María Ochoa (2003, 40) states in *Creative Collectives: Chicana Painters Working in Community*, "The processes necessary to enact a hybridized style required too much energy and time from the artists, who were always working against a deadline as they simultaneously handled the creative as well as the logistical aspects of mural work." The resulting early murals—*Latinoamérica*, *Para el Mercado*, *Rhomboidal Parallelogram*, and *Fantasy World for Children*—exhibited themes that promoted both the similarities in culture and history across Latin America, and the diversity within that experience.

Upon completion of its early mural *Latinoamérica* (figure 39), Mujeres Muralistas produced a manifesto describing the collective's activity. The members stated that their interests as artists were "to put art close to where it needs to be. Close to children; close to old people; close to everyone who has to walk or ride the buses. . . . We want our art in the streets or in places where a lot of people go each day, the hospitals, health centers, clinics, restaurants, and other places" (Ochoa 2003, 33). The manifesto related the collective's activity to the larger goals of the Chicano movement and the

Chicano art movement. Beyond serving the community, the artistic production of Mujeres Muralistas served as a powerful inspiration for Chicana activists and artists confronting patriarchal stereotypes. The collective's work broke down the idea that "women were physically not able and politically not 'meant' to create murals, to build and climb scaffolding, to be on public display and withstand the comments of passersby" (Gaspar de Alba 1998, 121). Mujeres Muralistas also challenged Chicano nationalism, questioning and defying its portrayals of Chicanas, its use of predominantly male actors, and its depiction of the pre-Columbian warrior holding a dead woman as an archetype. As Ester Hernández explains, "We were concerned with what was around us. We had the general feeling that men chose to deal with themes of social change through the portrayal of violence, heroes, and the glories of the past. In those days they were all Aztec princes and Zapatistas. As a group of women we wanted to go in another direction with our images" (Davalos 2001, 64). Rejecting these stereotypes, Mujeres Muralistas provided alternative visual representations of poor and working-class women, of Chicana and Latina activists, and of Chicano and Latin American history as seen through the eyes of women.

Con Safos and Los Quemados

Originally called Pintores de la Nueva Raza, Con Safos was an early Chicano art collective based in San Antonio, Texas. Of the original ten members, Mel Casas, Felipe Reyes, and César Martínez are the most notable. The group's original purpose was merely to provide exhibition opportunities for its members. Eventually Con Safos began to articulate a political position regarding their artistic activity and their interaction with Chicano and mainstream America. Mel Casas, an elder leader of Con Safos, issued the "Brown Paper Report," which promoted the movement ideals of self-determination and equality for Chicanos and Chicanas but was critical of "synthesizing farm workers into the mania that is middle class America" (Davalos 2001, 73). Chicano scholar and writer Tomás Rivera organized a significant exhibition of Con Safos members that traveled nationally in April 1972. Con Safos was short-lived, breaking up when members became frustrated with bureaucratic group discussions over details of exhibiting artwork. Con Safos also splintered because of disagreements over the definition of Chicano art. Various members, several of whom would eventually establish another art collective, did not believe

that Chicano art had to deal exclusively with social and political issues. Though they believed that art should reflect the social and cultural struggles of the community, they did not believe their artwork had to serve or represent any particular political ideology (Quirarte 1991).

Upon the disbandment of Con Safos in 1975, a second Chicano art collective emerged in San Antonio called Los Quemados (The Burnt Ones). Members of Los Quemados came from San Antonio and Austin, Texas, and included Santa Barraza, Carolina Flores, Carmen Lomas Garza, Amado Peña, and César Martínez. These artists came together agreeing on the common platform that they wanted to create artwork free "from dogma, political or otherwise" (Quirarte 1991, 167). César Martínez, in a catalogue of his work, states that Los Quemados wanted to be "more people and less politically oriented" (Martínez 1999, 28). Many of the artists in Con Safos and Los Quemados have been discussed throughout this book, an indication of their works' strong representation of the diverse and multiple elements constituting Mexican American traditions and ways of life.

■ Los Four, 1973–1983

Los Four was a seminal Chicano art collective composed of Carlos Almaraz, Gilbert "Magú" Sánchez Luján, Roberto "Beto" de la Rocha, and Frank Romero. John Valadez and Judithe Hernández would later be core contributors to the collective. The emergence of Los Four and the development of its artistic production sharply contrasted with that of its Los Angeles counterpart, Asco. Los Four, according to Chicano scholar Max Benavidez, represented a "cool, intellectual approach" to art making. He notes that several of the artists in Los Four were educated in the arts and held advanced degrees. Though their impetuses and artistic production differed greatly, Los Four and Asco had a similar goal of supporting the development of a visual art that represented the Chicano experience. John Valadez states, "We were so starved for any kind of positive identity that any recognition of who we were, that we were even there, caused a deep response" (Benavidez 2002, 18). Valadez's sentiment reflects the larger theme of cultural reclamation and representation of the Chicano art movement.

Los Four is credited as the first group of Chicano artists to exhibit either individually or collectively in a large, mainstream art institution. In 1974, Jane Livingston organized the exhibition Los Four: Almaraz/de la Rocha/ Luján/Romero at the Los Angeles County Museum of Art. The exhibition

was also one of the first major Chicano art exhibits reviewed in the mainstream media. Not surprisingly, although the Los Four exhibition was a breakthrough for Chicano artists in that the members' art was considered important enough to exhibit, representatives of mainstream art institutions and the media misunderstood the works' meaning and sources. *Los Angeles Times* art critic William Wilson, in reviewing the Los Four exhibit, stated that the exhibit was a decent show, but it gave him a headache. Wilson erroneously described Los Four and Chicano art's origins, stating that, "No individual invented this style, it grew naturally as an indigenous expression of thousands of Chicanos in the Southwest. It is an urban folk style. As far as I know it took shape in the 1940s among adolescent Mexican Americans" (Quirarte 1991, 170). Wilson thus equated Los Four's paintings to the 1940s gang-affiliated graffiti of **pachuco** youth in El Paso and Los Angeles. Although the mainstream art world failed to understand the cultural reclamation and political aspects of the work, Los Four opened the doors of mainstream art institutions to Chicanos and Chicanas by attempting to negotiate Chicano art's political intentions and emphasis on community with mainstream success and recognition.

▮ Co-Madres Artistas, 1992–

Co-Madres Artistas is a collective established in 1992 by six women: artists Irma Lerma Barbosa, Carmel Castillo, Laura Llano, Mareia de Socorro, and Helen Villa, and the collective's administrator, Lucy Montoya Rhodes. The artists, ranging in age from forty-four to sixty-five at the time of the organization's inception, were brought together when Irma Lerma Barbosa coordinated an exhibition coinciding with a Latina Leadership conference. Centered in northern California's Sacramento Valley, Co-Madres Artistas have played a major role in the cultural legacy of Chicano and Chicana art and art organizations in the region, including La Raza Galería Posada, the RCAF, and community businesses such as Café Luna (Ochoa 2003). Through their support and work for such organizations and institutions, the members of Co-Madres Artistas have worked together on and off dating back to 1969.

While all the members of Co-Madres Artistas produced art individually and collectively from the beginning of the Chicano movement, employment and family responsibilities left them with little time or opportunity to consistently pursue careers as artists. Many of the members taught in

public schools and ran their own art-related businesses to generate income. Although members of Co-Madres Artistas first acknowledged themselves as a collective centered around a specific art exhibit, the collective gave them a much-needed support mechanism to help them navigate the difficult path of balancing family and economic responsibilities while confronting a still very male-dominated art world. As María Ochoa (2003) explains, all the Co-Madres worked outside of the home to support their families, placed a high value on their families, and balanced their careers with other interests. Helen Villa recalled that she would regularly see other Co-Madres at art-related events in Sacramento: "I used to see Irma and Laura at different cultural events . . . usually art shows that the RCAF artists were putting on. We would always say, 'Hi! Are you painting? Are you doing any art?' We would always respond, 'Well, I haven't had a chance to, . . . the kids and everything.' One day Irma said, 'This is it. We have a chance to exhibit, and get your stuff out' " (Ochoa 2003, 60).

Co-Madres Artistas' importance as a Chicano art collective lies in its development, less as a political and social fusion of ideas and art production than as an aid to its members' efforts to persist as artists through the middle of their careers and negotiate the balance that women face between work and family, particularly in the family-oriented Mexican American culture. Members of Co-Madres have worked in a variety of media with a special emphasis on easel painting. Their imagery predominantly deals with Chicanas in empowering situations, the Chicano family, and varied representations of Mexican American spirituality.

■ Discussion Questions

1. Why were Chicano artists motivated to work collectively? How does collectivity further the ideals of creating socially and politically relevant art?

2. How did art collectives attempt to promote a vision of Chicano art that was socially relevant and anchored in the community? Discuss the variety of media that Chicano art collectives used. How did each form of visual creation promote the collective's goals?

3. Most Chicano and Chicana art collectives have been short-lived. Discuss the reasons why this might be so.

Suggested Readings

Benavidez, Max. *Gronk. A Ver: Revisioning Art History*. Los Angeles: UCLA Chicano Studies Research Center, 2007.

Davalos, Karen Mary. *Exhibiting Mestizaje: Mexican (American) Museums in the Diaspora*. Albuquerque: University of New Mexico Press, 2001.

Gaspar de Alba, Alicia. *Chicano Art Inside/Outside the Master's House: Cultural Politics and the CARA Exhibition*. Austin: University of Texas Press, 1998.

Griswold del Castillo, Richard, Teresa McKenna, and Yvonne Yarbro-Bejarano, eds. *Chicano Art: Resistance and Affirmation, 1965–1985*. Los Angeles: Wight Art Gallery, UCLA, 1991.

Noriega, Chon, ed. *Just Another Poster? Chicano Graphic Arts in California*. Santa Barbara: University Art Museum, University of California, 2001.

Ochoa, Maria. *Creative Collectives: Chicana Painters Working in Community*. Albuquerque: University of New Mexico Press, 2003.

Community Art Centers and Workshops

One of the lasting contributions of the **Chicano art movement** is the proliferation and development of community-based art centers, galleries, and **silkscreen**-poster workshops. Community art centers developed during the Chicano movement out of the need for alternative structures to support artistic creation, to use the arts as a community development tool, and to disseminate information and education about Chicano art (Goldman and Ybarra-Frausto 1985). Numerous Chicano art centers established during the height of the Chicano movement continue to exist today with the same functions that prompted their foundation.

The ideological foundations of the Chicano movement found an ideal manifestation in the development of cultural centers that used the arts as a tool to bring people together not only to share culture, but also to meet, organize, and dialogue. "El Plan Espiritual de Aztlán" provided a political platform encouraging the creation of independent, Chicano-controlled institutions. Independence as a way to ensure self-determination was a central theme of the movement. "El Plan Espiritual" states that Chicanos seek to be "autonomously free, culturally, socially, economically, and politically." Many scholars have described these words as separatist, ignoring the fact that Chicanos and Chicanas most often worked through U.S. government systems and institutions to seek their independence and autonomy. The **Mexican American** community prior to the emergence of the Chicano movement was described as an "internal colony" because people from outside the Chicano community and experience controlled many of the decision-making institutions, such as school boards and elected offices. In order to combat this lack of voice, activists decided it was essential to establish cultural, political, and economic control of their communities. Furthermore, activists sought to reconfigure the capitalist-based value system that encouraged community members to compete with one another for resources into a system of community cooperation for mutual benefit, which is more in line with Mexican American culture. According to "El Plan Espiritual," instead of viewing fellow community members as com-

petitors, Chicanos and Chicanas should draw on their "cultural background and values that ignore materialism and embrace humanism." It was believed that this would "lead to the act of co-operative buying and distribution of resources and production of resources and production to sustain an economic base for healthy growth and development." This section of the plan does not speak directly to the arts, but it does provide a context for the efforts of activists and artists to work collectively and to create institutions that fostered development of the entire community.

At the **Crusade for Justice's** Second Chicano Youth Liberation Conference in 1970, much of the rhetoric behind "El Plan Espiritual de Aztlán" was elaborated upon, including in special workshops dedicated to arts activism. The papers produced from these workshops express the sentiments that motivated Chicano artists across the United States to establish art centers and workshops in Chicano communities. At the workshop called "Los Artistas de Aztlán," attendees resolved the following:

> *Resolve:* That Chicano art is an art of our people and should be exhibited namely in those areas in which our people live; the barrios, campos, etc. Chicano art should not be aimed for the sake of selling to tourism or as an ornament to please the gringos, so we therefore, refuse to exhibit our work in gringo institutions and galleries. (Crusade for Justice 1970)

These sentiments were also proclaimed in *El Plan de Santa Barbara* in 1969. *El Plan de Santa Barbara* primarily described in detail how Chicano studies programs would be instituted in colleges and universities. One of the central goals of this document was to create a bridge or conduit between universities and the **Chicano/Latino** communities in surrounding areas. *El Plan de Santa Barbara* identified the need to develop "community cultural and social action centers" (Chicano Coordinating Committee on Higher Education 1969, 10). The drafters understood that community art centers would be more accessible to Mexican Americans if they were located in their immediate communities. While these ideas were not the immediate motivation for every community art center and workshop that developed out of the Chicano movement, they did provide the impetus for a new social structure where Chicano artists could engage in art making. This new structure would encourage community development and at the same time redefine the criteria that determined which artists and art forms were successful.

Community art centers and workshops often struggled to survive

economically, so had to creatively finance their operations through a mixture of public and private grants as well as fundraisers. Many centers and workshops did not have a business model or mission of selling their artistic production for profit. Instead, much of the work at community centers and workshops sought to "counteract the influence of the mainstream" (Davalos 2001, 60), which artists and activists saw as disempowering to the Chicano community. Many centers and workshops were initially funded by government agencies as a means to reduce poverty and promote community development. The Comprehensive Employment Training Act (CETA), a federal antipoverty program, provided funding to many early poster workshops. Even though CETA kept many early workshops and centers afloat, the organizations still struggled financially to serve their communities' cultural and creative needs.

Despite their precarious financial situation, these spaces enabled Chicanos and Chicanas to become the authorities on their own culture and how it was interpreted by society at large. Scholar Karen Mary Davalos explains that community centers and workshops "did not take the public museum as their guide; not only did they lack the money and trained staff, they focused on those subjects denied by the public museum's homogenized narrative and history of the United States" (Davalos 2001, 61). It was in this environment that **Day of the Dead** celebrations could be exhibited alongside images of **pachucos** and the **Virgin of Guadalupe.** In the spirit of self-determination, cultural workers, artists, and activists used community centers and workshops to define the lens through which Chicano culture and history would be viewed. Traditional categories and designations such as folk art, fine art, or popular art were often ignored. Instead, the entire creative expression of artists and regular community members alike was valued and promoted within this alternative structure.

The selected community art centers discussed in this chapter provide an overview of the socially and geographically diverse Chicano art centers that proliferated during the late 1960s and 1970s. The particular focus of this chapter are those centers and workshops that developed during the early phase of the Chicano movement. Chicano art centers that deserve greater attention and research include Chicago's Casa **Aztlán,** organized by Movimiento Artístico Chicano (MARCH); Guadalupe Cultural Arts Center in San Antonio, Texas; Mechicano Art Center and Plaza de la Raza in Los Angeles; and Casa de la Raza in Santa Barbara. Although many of the early Chicano art centers have closed, a significant number have man-

aged to sustain themselves for thirty or forty years and continue today. The 2000 exhibition entitled Hecho en Califas: The Last Decade 1990–1999 highlighted the ongoing cultural creation of Chicano art centers in California that emerged during the Chicano movement as well as during the 1980s and 1990s. Some of the centers that participated were Arte Américas from Fresno, Centro Cultural de la Raza from San Diego, East Bay Center for the Performing Arts from Richmond, Mexican Heritage Plaza from San Jose, La Peña Cultural Center from Berkeley, Plaza de la Raza and Self Help Graphics from Los Angeles, and La Raza Galería Posada from Sacramento. While these organizations' missions and activities vary, all continue to encourage the exhibition and creation of Chicano/Latino art.

■ Self Help Graphics and Art Inc., 1970–

Self Help Graphics and Art is a community-based art center located in East Los Angeles (see www.selfhelpgraphics.com). It has had a major impact on the development of Chicano art, serving as a premier center for silkscreen printmaking, an exhibition location, and a space for various types of civic engagement. Self Help Graphics has trained printmakers and worked with countless Chicano artists to develop prints.

The late Sister Karen Boccalero, a Catholic nun, artist, and printmaker, established Self Help Graphics in 1970. Sister Karen, as she was affectionately known, was of Italian descent and was born in Arizona in 1933. She was raised in Boyle Heights during the 1940s and 1950s. During this period, Boyle Heights, which borders East Los Angeles, was a diverse community of mainly Jewish Americans and Mexican Americans. Sister Karen gained an art education at Immaculate Heart College in Los Angeles, where a generation of women was encouraged to investigate and evaluate "the tenets of the Church, and these women, in turn, formulated critiques of the Church's patriarchal hierarchy" (Guzmán 2005, 7). At Immaculate Heart College, Sister Karen studied with Sister Corita Kent, an educator and poster maker who "had a profound effect on [her] artistic education and emerging sociopolitical consciousness" (6). Sister Karen joined the Order of the Sisters of St. Francis and set out to work in Boyle Heights, which by then had become predominantly Mexican American. Using her background as an artist, Sister Karen made it her mission to foster the potential of every individual.

Sister Karen teamed up with artists Carlos Bueno, Antonio Ibáñez, and

Frank Hernández to create an art center that would foster **Chicanismo** by nurturing young artists. Sister Karen stated that "individuals have a significant contribution to make for themselves and society. Chicano art and artists are a gift to society, mirroring a powerful and desired cultural richness" (Guzmán 2005, 7). Working out of a garage in East Los Angeles, the founding group of artists set two distinct goals for Self Help Graphics: (1) to provide training in silkscreen printmaking for local Chicano artists, and (2) to "offer the surrounding community, including families and children, cultural experiences that would instill a sense of cultural pride" (6). Sister Karen, Bueno, Ibáñez, and Hernández staged their first exhibition at El Mercado, an indoor community shopping plaza in East Los Angeles. In 1972, Sister Karen secured seed money from the Order of the Sisters of St. Francis to be used for basic operational costs and for renting a larger venue. In 1978, Self Help Graphics moved to its present nine-thousand-square-foot space on Cesar Chavez and Gage, the rent on which is underwritten by the Sisters of St. Francis.

With an established location, Self Help Graphics began offering community batik and silkscreen classes that culminated in exhibitions of work created in the workshops. In an effort to reach out to the Chicano community, Self Help Graphics created the Barrio Mobile Art Studio (BMAS), a converted van that offered mobile community art activities. When school was out of session, local artists created lesson plans in painting, photography, puppetry, and silkscreen printing for community members. It has been estimated that in its first eight months of operation, BMAS reached more than seven thousand community members of all ages. In 1972, Self Help Graphics also began its annual **Día de los Muertos** exhibition and celebration. Typically scheduled on November 2, the event included a procession that began at a local cemetery in Boyle Heights and ended at Self Help Graphics. The procession coincided with an exhibition of altars and creative artworks and installations paying homage to the deceased. Notable Chicano art collectives such as Asco and Los Four often contributed. Asco, in particular, used this public procession and celebration to create street **performance art** that pushed the interpretation of Día de los Muertos and its relevance to the contemporary Chicano community. The event would set a standard for and influence celebrations at other Chicano art centers and galleries. Chicana scholar Kristen Guzmán (2005) highlights the influence of Self Help Graphics' Día de los Muertos celebration, noting that the Mexican Museum in San Francisco dedicated a large por-

tion of its 2000 exhibit "Chicanos en Mictlán: Día de los Muertos in California" to Self Help Graphics and Sister Karen.

Self Help Graphics' silkscreen **atelier** has been a major contributor to the development of Chicano art. *Atelier* is the French word for an artist's studio, but here it refers to a program that offers artists an opportunity to work with an experienced silkscreen printer, or "master printer," to develop a limited-edition silkscreen print. The program enabled Chicano artists not proficient in the silkscreen process to access the benefits of printmaking and reach a wider audience with multiple copies of a single work and also allowed them to create artworks affordable to those within the Chicano community interested in supporting artists and purchasing art. The first atelier occurred when Sister Karen invited Gronk to create a series of silkscreen prints with master printer Steven Grace (Guzmán 2005, 16). In traditional printmaking ateliers, the artist keeps half of the prints, and the studio keeps the other half as payment for the use of its facilities and for use as a fundraising tool. Artists often exhibit their own prints or sell them to support themselves financially. Self Help Graphics used Gronk's prints to raise funds for its operation and to lay the foundation for the atelier program, which continues to this day. Many of the most prominent Chicano artists have participated in Self Help Graphics' atelier program, including Ester Hernández, Carlos Almaraz, Frank Romero, Michael Amescua, Barbara Carrasco, Yreina Cervántez, Richard Duardo, Diane Gamboa, Patssi Valdez, Gronk, Harry Gamboa, Willie Herron, Leo Limón, Malaquias Montoya, Linda Vallejo, Alex Donis, Juana Alicia, Sam Coronado, Samuel Baray, Lalo Alcaraz, Lysa Flores, Artemio Rodríguez, and Vincent Valdez. Most of these works have been archived at the University of California, Santa Barbara's, California Ethnic and Multicultural Archives (CEMA; http://cemaweb.library.ucsb.edu).

Today, local musicians, art groups, and community organizations continue to use the top floor of Self Help Graphics as a space for dialogue and unity. While Self Help Graphics is a symbol of success in supporting the development of Chicano art and encouraging cultural empowerment and community development, it has often struggled to maintain its direction and sustain itself financially. The art created at Self Help provided fodder for a fertile debate on the direction of Chicano art that surfaced in the 1980s with the emergence of more culturally based imagery that did not directly reflect the political themes common in the early period of the Chicano movement. In addition, Self Help Graphics established various

relationships with universities, foundations, and corporations in an effort to provide the necessary funding and research base to support the organization's activities. Self Help Graphics's ongoing struggle to remain afloat demonstrates that even after years of dedication and worthwhile contributions, providing alternative community-based spaces to create and exhibit culture is never easy.

■ Galería de la Raza, 1970–

Galería de la Raza is a community arts organization and center in San Francisco's Mission District (see www.galeriadelaraza.org). Founded in 1970 by Nicaraguan Rolando Castellón, Galería de la Raza brought together a wide range of artists from a number of different collectives such as MALAF, Casa Hispana de Bellas Artes, Artes 6, and Artistas Latino Americanos (Goldman 1990). The diversity of this initial group is reflective of the diverse Latino population in San Francisco's Mission District. In 1971 Galería de la Raza settled into a storefront at the corner of Bryant and 24th Streets, where it continues to provide exhibitions and art workshops for the Chicano/Latino community. From 1971 through 1974 Galería de la Raza was funded through San Francisco's Neighborhood Arts Program, which provided funding for operational costs and paid the salaries of codirectors René Yañez and Ralph Maradiaga. The Galería survived on a mixture of grants and fundraising until María Pinedo turned an adjoining room into a photocopy service and gift store that made the organization economically self-sustaining (Davalos 2001).

Galería de la Raza holds community art workshops but is mainly known for its support of San Francisco muralism. The Galería brought together many highly influential artists of the Chicano art movement. Las Mujeres Muralistas, Mike Ríos, Tony Machado, Spain Rodríguez, Chuy Camusano, Rubén Guzmán, Domingo Rivera, and Gilberto Ramírez have all worked with and at the Galería (Maradiaga 1977). The Galería printed the first edition of its *Mission Community Mural Tour Guide* guidebook in 1975. It encouraged muralism in numerous other ways as well, including by appropriating a Foster and Kleiser billboard on the side of the Galería's building (Goldman 1990). Galería-affiliated artists decided to seize the billboard and begin painting revolving community murals on it to promote exhibitions and record issues critical to the community's well-being. Since 1975, except for a brief interlude when the corporate owners tried to wrest it away, the

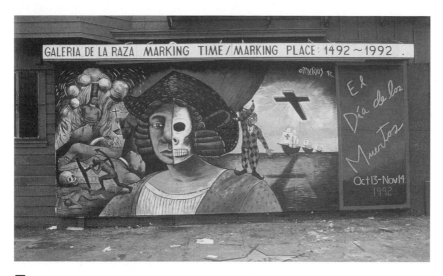

■ 40. Michael Ríos. *Día de los Muertos: Marking Time/Marking Place*. Temporary billboard mural, Galería de la Raza, San Francisco, 1992. (Courtesy of the artist)

billboard has displayed a number of highly successful murals. While many of the works created on this billboard have specifically related to the issues and culture of the Chicano/Latino community, others have moved "beyond the Chicano cultural nationalist paradigm" (Davalos 2001, 93). Xavier Viramontes created numerous murals on the Galería billboard dealing with a variety of issues and themes. In 1976, he painted *International Hotel*, a visual protest against the closure of the Chinatown hotel of that name, which was inhabited mainly by retired Filipino merchant seamen. In 1992, Michael Ríos painted *Día de los Muertos: Marking Time/Marking Place* to announce an exhibition recognizing and protesting the five hundredth anniversary celebration of Christopher Columbus's encounter with the Americas (figure 40). Ríos's image represented Columbus as both Death and Life, alluding to the disease and warfare brought upon the indigenous communities. Mexican artist Frida Kahlo has also been a prominent figure in Galería billboard murals. In 1978, Ríos painted Frida's portrait with the words "Homenaje a Frida Kahlo" scrawled across an open landscape. Again, in 1987, Rios painted *Recuerdos de Frida* (Memories of Frida), announcing an exhibition of works dedicated to her life and work. The Galería's billboard murals, as well as the concurrent exhibitions dealing with the history and culture of countries throughout Latin America, have

provided the community with alternative, informative, and educational imagery. As René Yañez stated in 1977, "the importance of the Galería de la Raza is that we have broken ground. The Galería's existence has made it possible for other groups to get started. We broke the ground and through murals, posters, and exhibitions, created an interest among the audience" (Maradiaga 1977, 31).

■ Centro Cultural de la Raza, 1970–

Centro Cultural de la Raza was established in 1970 in San Diego (see www.centroculturaldelaraza.org). Its mission is to promote Chicano culture by providing a space that encourages a variety of artistic practices. Owing to its location close to the U.S.–Mexico border, the center has often promoted cultural creations dealing with border issues. During the 1970s the Centro was crucial in fostering a new Chicano mural movement, and in the 1980s it served as a space for artists to criticize and protest the militarization of the U.S. border and the criminalization of Mexican and Latin American immigrant workers.

In the late 1960s numerous San Diego–based Mexican American artists were creating art aligned with the emerging Chicano movement. Notable among them were Guillermo Aranda; Victor Ochoa; Alurista, the poet who wrote the introduction to "El Plan Espiritual de Aztlán"; and Salvador Roberto Torres, also known as "Queso"; all of whom were working in San Diego prior to 1968. Torres had attended the California College of Arts and Crafts where he met artists José Montoya and Esteban Villa. The three artists greatly influenced one another's ideas and artistic development, especially as all went on to establish vital Chicano art organizations and community centers.

Centro Cultural de la Raza began as an informal art center in 1968 when the San Diego Parks and Recreation Department gave Torres permission to use an abandoned facility in Balboa Park as an art studio. Torres intended to make a series of large, portable murals that required a good-sized studio space. Torres began inviting other artists to join him in this building, a former Ford Motor Company display space for a 1935 international expo. Initially, painters gathered in the studio to produce paintings and murals, but the group soon expanded to include writers and performance artists who practiced theater and pre-Columbian dance. The

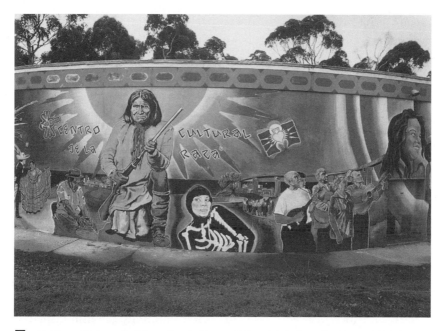

41. Victor Ochoa. *Gerónimo*. Mural, Centro Cultural de la Raza, San Diego, 1981. (Courtesy of the artist)

Centro truly had a grassroots beginning as recalled by Victor Ochoa, who used the facility for printing posters and painting murals (figure 41):

> I met Queso at San Diego State where I was studying art. I was bummed out by the classes there and he told me about what they were doing. There was a demand for posters, so we set up a table in the Ford Building and started stockpiling paints and materials for a workshop. But we primarily printed stuff from one day to another, for a picket, demonstration or some kind of activity like that. We were meeting in people's houses because there wasn't even electricity at a certain time in the Ford Building. We would bring stuff that we were working on and share poetry. This was in 1969. (Brookman and Gómez-Peña 1986, 18)

It was in this environment that artists and activists began seeking to solidify these activities and workshops into a permanent community art center.

Los Toltecas en Aztlán was the official name of the artists working at the Ford Building. Alurista came up with the organization's name, which

signified the pre-Columbian cultural heritage of the Mexican American community. In their founding mission statement Los Toltecas en Aztlán stated that their collective "shall be constituted of all those Chicano Artists dedicated to Human Truth and Chicano Beauty, which in our belief can only be lived up to through Mutual Self-Respect, Self-Determination in our endeavors, and the Self-Sacrifice of our individual differences for the sake of a Centro Cultural de la Raza, where our indigenous ancestral spirit of brotherhood, justice and peace can flourish in contemporary Chicano Art Forms" (Brookman and Gómez-Peña 1986, 18). The mission statement clearly reflects the goals of the larger Chicano movement but with a special focus on the values that would govern them in working collectively and establishing a new cultural art center. Between the creation of Los Toltecas en Aztlán and the official establishment of the Centro Cultural de la Raza, the artists and activists working at the Ford Building engaged in one of the most dynamic episodes of the Chicano movement, the struggle to establish Chicano Park. Chicano Park is discussed in chapter 2 but deserves mention here as well because the community activism displayed in its establishment was similar to the agency displayed in the development of the Centro Cultural de la Raza.

On the same day that the takeover of Chicano Park began, Los Toltecas en Aztlán approached the San Diego City Council, requesting that the city permanently turn over the Ford Building to them for the establishment of the Centro Cultural de la Raza. Salvador Torres represented Los Toltecas in negotiations. Initially, the city council had slated the Ford Building to become an aerospace museum, providing a parallel to the fight for the Coronado Bridge underpass, which was intended to house a Highway Patrol station. Salvador Torres presented three demands:

(1) that the Ford Building be turned over to the Toltecas en Aztlán board of directors to be converted into a Centro Cultural de la Raza. (2) That in the event another building is offered by the city, such a building must be of comparable size to the Ford Building and be located in Balboa Park. (3) That the city commit itself to match the funds that the Toltecas are able to raise with an equal amount. (Brookman and Gómez-Peña 1986, 21)

After fierce negotiations that included eviction notices, an agreement was eventually reached whereby Los Toltecas were given a one-dollar-per-year lease on an abandoned concrete water tank located in the same park.

In May 1971, Los Toltecas moved into its new space, and in July the members held their opening reception, attracting more than five hundred attendees.

The Centro Cultural de la Raza gave artists a base from which to execute public art projects such as the Chicano Park murals. During its first years the Centro took a multimedia and multidisciplinary approach to artistic creation and education. Workshops were conducted in painting, mural painting, pottery, jewelry, film, Aztec dance, and theater. Ballet Folklórico en Aztlán is a performing arts group active at the Centro from its inception, providing workshops in folklórico dancing in addition to performing. Alurista, Juan Felipe Herrera, and Mario Aguilar organized Los Servidores de Árbol de la Vida, another arts group that performed music combining pre-Columbian instruments with dance and poetry. A number of Centro musicians also conducted music workshops. Teatro Mestizo, a Chicano theater group, performed in the community and on the picket lines in support of the farmworkers' struggle, much like El Teatro Campesino did. These goings-on were just a small sampling of the diverse and vibrant activities conducted at the Centro Cultural de la Raza.

The Centro also served as an organizing space for the development of the Border Art Workshop (BAW), founded by Victor Ochoa, Isaac Artenstein, Jude Eberhart, Sara-Jo Berman, Guillermo Gómez-Peña, and Michael Schnorr (see www.borderartworkshop.com). The Border Art Workshop is a collective that emerged in the 1980s of artists engaged in art making on both sides of the U.S.–Mexico border. An eclectic group of cultural workers, scholars, and artists came together with the goal of addressing "the social tensions the Mexican-American border creates while asking us to imagine a world in which this international boundary has been erased" (Grynsztejn 1993, 25). Composed of Chicano, Mexican, and Anglo-American artists in many disciplines, the organization crossed cultures and borders in a common dedication to creating art that directly spoke to the issues plaguing the U.S.–Mexico borderlands. David Avalos, with administrative support from the Centro, directed this group of artists in a series of challenging performances and public artworks. BAW is one of many examples of the Centro Cultural de la Raza's continual willingness to engage the important issues facing the San Diego and national Chicano community.

La Raza Silkscreen Center (LRSC), 1970–1995, and Mission Gráfica, 1995–

La Raza Silkscreen Center (LRSC) is a community-based poster workshop founded in San Francisco's Mission District in 1971 by Al Borvice, Oscar Melara, and Pete Gallegos. Other artists who initially worked at LRSC included Eileen Starr, Jos Sances, and Mike Ríos. LRSC was affiliated with the La Raza Information Center, a nonprofit organization that ran community services such as free breakfast programs, a community newspaper, a health clinic, and defense committees for community members in need of legal services. The two organizations shared space in the Mission District, and LRSC would often produce silkscreen posters for La Raza Information Center events, organizations, and political causes. LRSC also produced hundreds of posters for prominent Chicano issues and organizations such as the **UFW** unionization struggles and La Raza Unida Party.

La Raza Silkscreen Center attracted many influential Chicano artists to the production of silkscreen prints. Herbert Sigüenza, a current member of the Chicano comedy troupe Culture Clash, and Linda Lucero both became key artists, eventually providing leadership for the LRSC. Other participating artists have included Juan Fuentes, Rupert García, Carlos Azúcar, Rosa Quintana, Antonio Chávez, Consuelo Méndez, Roberto Andress, Kike Estrada, Miriam Medina, and Rayvan Gonzales. Although LRSC's primary activity was producing silkscreen posters, they expanded their services to offer neighborhood youth silkscreen printing classes. In 1974, LRSC expanded into a larger facility and began providing offset **lithography** services and typesetting. This allowed the center greater ability to produce information, newsletters, posters, and brochures on a mass scale.

La Raza Silkscreen Center underwent numerous reorganizations in adaptations to the changing political and economic climate. In 1983, LRSC officially became part of La Raza en Acción, an umbrella organization of a variety of San Francisco–based community services, including La Raza Information Center, La Raza Tutorial Program, La Raza Centro Legal, and the Housing Development and Neighborhood Preservation Corporation. LRSC exemplifies the ways Chicano art centers have worked in conjunction with community service organizations to achieve their common goals and use art for social ends. Until 1993, LRSC continued to provide the San Francisco Mission District with art workshops in print-

making, painting, and drawing. Very respected Chicano/Latino artists, such as Juana Alicia, Emmanuel Montoya, Kate Connell, and Francisco Camplis, worked at LRSC during this period teaching workshops and creating artwork.

In 1995, La Raza Silkscreen Center merged with the Mission Cultural Center for Latino Arts (see http://missionculturalcenter.org). Many of the LRSC's poster makers and artists would help establish Mission Gráfica, a printmaking studio within the Mission Cultural Center. Established in 1977, the Mission Cultural Center still exists today, offering a variety of community-based art activities for Mission District residents. Throughout LRSC's many transformations, Linda Lucero continued to organize exhibitions and provide workshops, while creating her own posters and silkscreen prints. In 1986, Lucero organized a very important exhibition documenting and celebrating the LRSC's first fifteen years. Entitled Buscando América (Looking for America), the exhibition featured such artists as Enrique Chagoya, José Letelier, Antonio Ramírez, Domitila Domínguez, Sal García, Irene Pérez, René Castro, Ester Hernández, Juan Fuentes, Herbert Sigüenza, Linda Lucero, and Oscar Melara. These names alone document the incredible importance of LRSC in the development of Chicano printmaking. Today, Juan Fuentes continues to lead Mission Gráfica, offering silkscreen printing workshops and producing posters relevant to the political and cultural life of the Mission District's diverse community.

■ Social Public Art Resource Center (SPARC), 1976–

Chicana artist and muralist Judy Baca founded the Social Public Art Resource Center (SPARC) in 1976 in Venice, California (see www.sparcmu rals.org). SPARC was established with the goal of promoting and documenting public art that represented America's diverse communities and experiences and told the stories not well represented in mainstream media or art, especially those of women, the working poor, youth, the elderly, and immigrant communities. As discussed in chapter 2, Judy Baca has had an incredible impact on the development of the Chicano mural movement and continues through SPARC to create programming and opportunities encouraging the proliferation of community murals. Baca was influential in turning a series of mural workshops conducted with inner-city youth

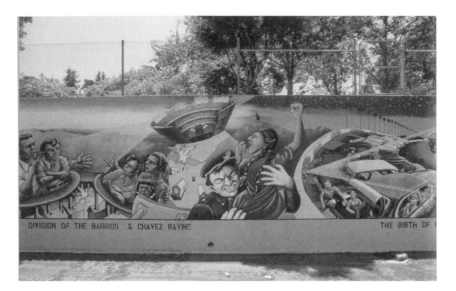

■ 42. Judith F. Baca. *Great Wall of Los Angeles: Division of the Barrios and Chávez Ravine*. Mural, Los Angeles, 1983. (Photo by Gia Roland)

into a city-sponsored public mural program. From 1974 to 1976, the City-wide Mural Program supported the development of more than forty murals in diverse communities throughout the Los Angeles metropolitan area.

SPARC's first project was organizing and executing the massive *Great Wall of Los Angeles. The Great Wall* has served as a premier example of a community art project that involved youth in creating a monumental, beautiful, and culturally important work (see figure 42). Baca explains the motivation for using muralism as a tool to create community:

> In the case of the Great Wall the metaphor really is the bridge. It's about the interrelationship between ethnic and racial groups, the development of interracial harmony. The product—there are really two products—the mural and another product which is invisible, the interracial harmony between the people who have been involved. (Mesa-Bains 1990, 81)

As Baca describes, community mural making can play a role in encouraging community development and unity, not only in the viewers, but in everyone involved in producing the murals, whether as artists, assistants, and students working together or as one of the countless passersby curious to watch the art in progress.

Most Chicano art centers, while promoting muralism, have used their spaces primarily to promote printmaking as a cultural and political tool. SPARC is unusual because its main focus, muralism, occurs outside of buildings at sites within the community. In 1988, SPARC began a program called Neighborhood Pride: Great Walls Unlimited, which commissioned artists to work with youth on mural projects. SPARC's Mural Resource Center is an archive housing thousands of slides that document community murals throughout the United States. In addition, SPARC holds rotating exhibitions in its gallery space (Baca 1990). For further discussion of a specific portion of the *Great Wall*, murals in Los Angeles generally, and the importance of muralism to the Chicano movement refer to chapter 2.

■ Discussion Questions

1. How did the ideals of the Chicano movement foster the emergence of community art centers and workshops? What purpose did these organizations serve?

2. How did community art centers and workshops offer alternatives to mainstream art institutions? Why was it important to provide alternative spaces where Chicano artists could exhibit?

3. Why, in your opinion, was it necessary to demand spaces within communities such as San Diego for the establishment and support of community art centers?

■ Suggested Readings

Arreola, Daniel D. "Mexican American Exterior Murals." *Geographical Review* 74, no. 4 (1984): 409–24.

Barnet-Sánchez, Holly, and Eva Sperling Cockcroft, eds. *Signs from the Heart: California Chicano Murals*. Venice, CA: Social Public Art Resource Center, 1990.

Chávez, Patricio, Madeleine Grynsztejn, and Kathryn Kanjo, comps. *La Frontera/The Border: Art about the Mexico/United States Border Experience*. San Diego: Centro Cultural de la Raza, Museum of Contemporary Art, 1993.

Davalos, Karen Mary. *Exhibiting Mestizaje: Mexican (American) Museums in the Diaspora*. Albuquerque: University of New Mexico Press, 2001.

Drescher, Timothy W. *San Francisco Murals: Community Creates Its Muse, 1914–1994*. St. Paul, MN: Pogo Press, 1994.

Dunitz, Robin J., and James Prigoff. *Painting the Towns: Murals of California*. Los Angeles: RJD Enterprises, 1997.

Goldman, Shifra. "A Public Voice: Fifteen Years of Chicano Posters." *Art Journal* 44, no. 1(1984): 50–57.

Griswold del Castillo, Richard, Teresa McKenna, and Yvonne Yarbro-Bejarano, eds. *Chicano Art: Resistance and Affirmation, 1965–1985*. Los Angeles: Wight Art Gallery, UCLA, 1991.

Guzmán, Kristen. *Self Help Graphics and Art: Art in the Heart of East Los Angeles*. Los Angeles: Chicano Studies Research Center, UCLA, 2005.

Maradiaga, Ralph. *The Fifth Sun: Contemporary/Traditional Chicano and Latino Art*. Berkeley: University Art Museum and Chicano Studies, University of California, 1977.

Noriega, Chon. *Just Another Poster? Chicano Graphic Arts in California*. Santa Barbara: University Art Museum, University of California, 2001.

Trends in Chicano Art

Thus far, I have attempted to give a brief introduction to the influences, organization, and cultural expression of the **Chicano art movement.** The survey in this chapter looks at Chicano art as a specific American art movement that deserves to be recognized and promoted. Chapter 3 discussed the major thematic manifestations of Chicano art, providing a window into the ways **Chicano** and **Chicana** artists have visually represented the **Mexican American** experience. Whereas chapter 2 focused on the poster and mural movements as unique components of the larger Chicano movement, this chapter is not limited to a specific time frame and provides examples of artworks spanning the last forty years of artistic creation.

In this chapter I discuss a number of issues regarding how Chicano art has been publicly represented in exhibitions, private and public collections, publications, and archives. I also briefly discuss prominent debates that have occurred among Chicano artists and cultural workers over the various directions Chicano art, as a movement, has taken and should take. The question at the heart of these debates is what ultimately determines a victory for the Chicano movement and for Chicano artists.

Exhibitions

The first decade of the Chicano art movement was characterized by the proliferation of Chicano art exhibitions in community art centers and workshops but not in mainstream art museums. Chicano artists during this period were also concerned with creating and promoting public art as a form of exhibition. Using posters and murals, Chicano artists actively exhibited their work outside of the traditional venues of galleries and museums. These exhibitions were often created with minimal financial resources, and there was very little funding for exhibition catalogues and documentation. The focus during the early years of the Chicano art movement was to empower the community using visual imagery, and as a result

many of the early exhibitions were ephemeral and lightly documented. Many notable community center and workshop exhibitions are mentioned in chapter 5; this section will cover the emergence of prominent Chicano exhibitions in mainstream art museums since 1980. A chronological list of some significant art exhibitions from 1969 to 2006 can be found in the box. This list encompasses both exhibitions at private galleries or community art centers and those at museums.

As discussed in chapter 5, community art centers and workshops were created with the goal of gaining control over the ways the Mexican American community was represented. Activists and cultural workers saw this as necessary because major U.S. museums had traditionally presented American culture from a Eurocentric point of view. Validation of the Chicano experience needed to come from within the community. Rather than look to experts or scholars from major U.S. institutions to define them and their culture, Chicano artists and cultural workers became the experts on cultural representation. Validation came through community art exhibitions and public art such as posters and murals.

Major art museums, such as the Metropolitan Museum of Art in New York, the National Museum of American Art in Washington, DC, and the Museum of Modern Art in New York, present contemporary art as a tradition that extends back to the Western classical civilizations of Greece, Rome, and Egypt. In *Exhibiting Mestizaje* Karen Mary Davalos discusses the variety of ways Chicanos have challenged traditional American forms of representing art and culture. She argues that mainstream American museums place Western civilization as the "height of perfection. Even the frenzy of the 1980s and 1990s to re-model the public art museum to include a gallery or wing for non-Western art does not challenge the European-centered collection policy or, more important, the unspoken assumption that the entire citizenry traces its heritage to Western civilization" (Davalos 2001, 38). It is no coincidence that the architecture of American cultural institutions and museums often resembles ancient European temples, churches, or palaces (Davalos 2001). This Eurocentric perspective has created a high degree of alienation amongst communities in the United States that don't share historical and cultural lineage based solely upon "the West."

In the mid-1970s museums began recognizing the emergence of Chicano art and offering spaces to exhibit it. As mentioned in chapter 4, the Los Four: Almaraz/de la Rocha/Luján/Romero exhibit at the Los Angeles County Museum of Art in 1974 was the first exhibition of Chicano art to

Timeline of Selected Chicano Art Exhibitions

- New Symbols for la Nueva Raza (Oakland, 1969)
- Arte de la Jente (California State University, Sacramento, 1970)
- Pintores de la Nueva Raza (Carleton Gallery, San Antonio, 1970)
- El Arte del Pocho (California State University, Long Beach, 1970)
- 4 Chicano Artists (California State University, Los Angeles, 1970)
- Arte del Barrio (Galería de la Raza, San Francisco, 1970)
- Con Safos, Los Quemados (traveling exhibition, 1972)
- Mexican American Artists (three exhibitions: Taos, San Antonio, Albuquerque, 1973)
- Chicano Art (Santa Ana College, 1974)
- Chicanos Gráficos (Southern Colorado State College, Pueblo, 1974)
- Mujeres Muralistas (San Francisco, openings in conjunction with mural completion, ca. 1974)
- Los Four: Almaraz/de la Rocha/Luján/Romero (Los Angeles County Museum of Art, 1974)
- Chicanarte (Los Angeles Municipal Gallery, 1975)
- Chicanismo en el Arte (East Los Angeles College, 1975)
- Chicanos and the Arts (Heard Museum, Phoenix, 1975)
- Dále Gas: Chicano Art of Texas (Contemporary Arts Museum, Houston, 1977)
- The Fifth Sun: Contemporary/Traditional Chicano and Latino Art (University Art Museum, University of California, Berkeley, 1977)
- Ancient Roots/New Visions (traveling exhibition that opened at the Tucson Museum of Art, 1977)
- Reflecciones: A Chicano-Latino Exhibition (Centro Cultural de la Raza, San Diego, 1978)
- Mexiposición and La Mujer: A Visual Dialogue (Chicago, 1975–1978)

- Califas: An Exhibition of Chicano Artists in California (Mary Porter Sesnon Gallery, University of California, Santa Cruz, 1981)

- Murals of Aztlán: Street Painters of East Los Angeles (Craft and Folk Art Museum of Los Angeles, 1981)

- Made in Aztlán (Centro Cultural de la Raza, 1985)

- Border Realities (Galería de la Raza, San Francisco, 1985)

- Chicano Expressions (four exhibitions, INTAR Latin American Gallery, New York, 1986)

- Buscando América (La Raza Silkscreen Center, San Francisco, 1986)

- Latina Art: Showcase '87 (Mexican Fine Arts Center Museum, Chicago, 1987)

- The Barrio Murals—Murales del Barrio (Mexican Fine Arts Center Museum, Chicago, 1987)

- The Latin American Spirit (traveling exhibition that opened at the Bronx Museum of Art, 1988–1990)

- Aquí Estamos y No Nos Vamos (California State University, San Bernardino, 1990)

- Chicano Art: Resistance and Affirmation (CARA), 1965–1985 (traveling exhibition that opened at the Wight Art Gallery, University of California, Los Angeles; toured September 1990–August 1993)

- The Chicano Codices: Encountering the Art of the Americas (The Mexican Museum, San Francisco, 1992)

- Ceremony of Spirit: Nature and Memory in Contemporary Latino Art (The Mexican Museum, San Francisco, 1993)

- La Frontera/The Border: Art about the Mexico/United States Border Experience (Centro Cultural de la Raza and Museum of Contemporary Art, San Diego, 1993–1994)

- Art of the Other Mexico: Sources and Meanings (Mexican Fine Arts Center Museum, 1993; toured nationally and internationally, 1993–1995)

- Xicano Progeny: Investigative Agents, Executive Council, and Other Representations from the Sovereign State of Aztlán (The Mexican Museum, San Francisco, 1995)

- From the West: Chicano Native Photography (The Mexican Museum, San Francisco, 1995)

- Across the Street: Self Help Graphics and Chicano Art in Los Angeles (Laguna Art Museum and Self Help Graphics, 1995–1996)

- East of the River: Chicano Art Collectors Anonymous (CACA) (Santa Monica Museum of Art, 2000)

- Road to Aztlán: Art from a Mythic Homeland (traveling exhibition opening at the Los Angeles County Museum of Art, 2001)

- Just Another Poster? Chicano Graphic Arts in California (opened Jack S. Blanton Museum of Art, University of Texas, Austin, 2000; traveled nationally, 2001–2003)

- Chicano Visions: American Painters on the Verge (traveling exhibition, 2002–2007)

- The African Presence in México: From Yanga to the Present (Mexican Fine Arts Center Museum, 2006)

- Caras Vemos, Corazones No Sabemos: The Human Landscape of Mexican Migration (Snite Museum of Art, University of Notre Dame, 2006)

- The Women of the Taller de Gráfica Popular (Snite Museum of Art, University of Notre Dame, 2007)

- Phantom Sightings: Art after the Chicano Movement (Los Angeles County Museum of Art, 2008)

Sources: Quirarte (1991); Gaspar de Alba (2001) ■

occur at a major public museum. But, in a 1991 article that provides a timeline of significant Chicano art exhibitions, Jacinto Quirarte, a leading scholar of Chicano art, cited Chicanarte, a 1975 exhibit at the Los Angeles Municipal Gallery, as the most important Chicano exhibit within a mainstream art institution. To develop the show and corresponding catalogue (see Al Frente Communications 1975), Chicano artists and cultural workers formed Al Frente Communications Inc. and collaborated with the Chicano Studies Research Center and the Department of Fine Arts at the University of California, Los Angeles (UCLA). Artists from the RCAF, Self Help Graphics, Centro Cultural de la Raza, Asco, and Los Toltecas en **Aztlán** curated the exhibition, which included more than one hundred artworks by twelve men and three women (Quirarte 1984).

In the decade following Chicanarte, university museums began incorporating Chicano art exhibits into their schedules. Often these exhibitions were held in conjunction with conferences or educational programming to encourage dialogue about the meaning and direction of the Chicano art movement. An exhibition of Chicana Art, called Expresión Chicana, was held in 1976 at Mills College in Oakland. Although not as publicized or well documented as the other exhibitions in this chapter, it should be acknowledged as an early example of Chicana artists organizing to demonstrate their central position within the Chicano art movement. Linda Lucero's poster publicizing this exhibition is not only a powerful representation of the Chicana experience but also serves as a historical document for the efforts of Chicanas who sought to organize against their exclusion from emerging Chicano art exhibitions (figure 43).

Califas: An Exhibition of Chicano Artists in California, organized in 1981 by Eduardo Carrillo, artist and professor at the University of California, Santa Cruz, was held at the UCSC Mary Porter Sesnon Gallery in conjunction with a roundtable artist discussion. The Fifth Sun: Contemporary/Traditional Chicano and Latino Art was held at the University of California, Berkeley, in 1977, and traveled to the University of California, Santa Barbara (UCSB), in 1978. Ralph Maradiaga, artist and cofounder of San Francisco's Galería de la Raza, curated The Fifth Sun to present the historical development of art and culture in the Americas. A valuable exhibition catalogue was produced in conjunction with the exhibit that gave an overview of the **Mexican mural renaissance,** Chicano muralism, Chicano poster art, and the development of community art centers (see Maradiaga 1977).

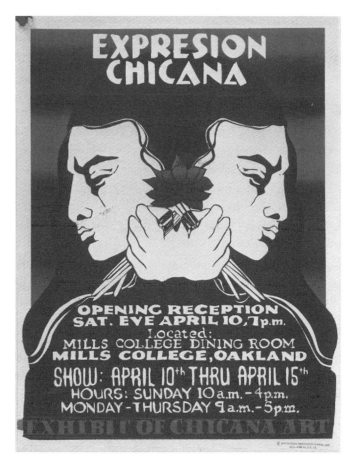

43. Linda Lucero. *Expresión Chicana*. Silkscreen, 1976. (Courtesy of the artist)

The establishment of Chicago's Mexican Fine Arts Center Museum (MFACM) in the early 1980s was an important development in providing institutional support for the promotion and exhibition of Mexican American art (see www.nationalmuseumofmexicanart.org). Educators Carlos Tortolero and Helen Valdez established MFACM in 1982 with a mission to "awaken the City of Chicago to the wealth and breadth of the Mexican culture, as well as to stimulate and preserve the appreciation of the arts of Mexico in the city's largest Mexican community" (Davalos 2001, 113). During its first five years of operation MFACM did not have a permanent home, so exhibitions were staged at a variety of venues. In 1986, MFACM and the Chicago Park District turned a former boat shop in Harrison Park

into a home for the museum. MFACM exhibitions and educational programming have promoted a borderless vision of Mexican culture, presenting the development of Mexican and Mexican American art and culture as indistinguishable from each other.

Since its inception, MFACM has hosted exhibitions of contemporary Chicano art alongside exhibits of traditional Mexican cultural expressions. In 1987, MFACM organized The Barrio Murals—Murales del Barrio, an exhibit of nineteen portable murals by nineteen muralists who had participated in the Chicago mural movement (see Mexican Fine Arts Center Museum 1987). This significant exhibition highlighted the relationship between Chicago's Chicano art movement and concurrent movements in the Southwest and elsewhere in the Midwest. The MFACM currently has one of the most prominent public collections of contemporary Chicano art, which was displayed in a 1993 exhibit Art of the Other Mexico: Sources and Meanings (see Arceo-Frutos, Guzmán, and Mesa-Bains 1993). The exhibit traveled throughout the United States and internationally for two years. The MFACM has also used its venue to promote the historical development of culture in Mexico. A recent exhibit, The African Presence in México: From Yanga to the Present, described the varied ways that Africans have been present in Mexican culture since the beginning of Spanish colonization (see Mexican Fine Arts Center Museum 2006). Exhibitions such as these continue to highlight aspects of the Mexican American experience yet to be explored or recognized by mainstream public art institutions.

The Chicano Art: Resistance and Affirmation (CARA) exhibit was a seminal event in the development of Chicano art (see Griswold del Castillo, McKenna, and Yarbro-Bejarano 1991). CARA represented a significant nationwide effort to place Chicano art in the forefront of major public museums and university galleries. Chicano artists and cultural workers wanted CARA to publicly present Chicano art as a unique and important American art movement. While no one exhibition could be comprehensive, CARA was a large exhibition, both thematically and in terms of artists represented. In total, more than 180 artists and three artist collectives participated, contributing almost 130 artworks and fifty-four documented murals. The exhibition was organized into four thematic areas: Feminist Visions, Reclaiming the Past, Regional Expressions, and Redefining American Art. Asco, Los Four, and the RCAF were assigned separate rooms to present their collective's work. The ambitious exhibition was

instigated by a group of Chicano art professors at UCLA, including Cecelia Klein and Shifra Goldman, as well as graduate students María de Herrera, Holly Barnet-Sánchez, and Marcos Sánchez-Tranquilino. In 1983, this group of scholars approached UCLA's Wight Art Gallery with the idea of presenting an exhibition of Chicano art in a nontraditional format. Planning and fundraising began the following year, culminating with the opening reception at the Wight Art Gallery in 1990. From 1990 until 1993, CARA toured the United States, making stops at the Denver Art Museum, the Albuquerque Museum, the San Francisco Museum of Modern Art, the Fresno Art Museum, the Tucson Art Museum, the National Museum of American Art, El Paso Museum of Art, the Bronx Museum of Art, and the San Antonio Museum of Art.

In addition to its scale, CARA is unique for its extensive planning and advisory committee, brought together with the goal of organizing a comprehensive exhibition authentically reflecting the sources and meanings of Chicano art. The CARA executive committee, composed of scholars Alicia González, Teresa McKenna, Victor Alejandro Sorell, and Tomás Ybarra-Frausto, defined the mission of CARA in a thoughtful manner as an attempt to present the first twenty years (1965–1985) of the Chicano art movement, showing in the most "inclusive manner possible, the roots, and complexities of the most current, significant, and unified development of Mexican art and culture that is indigenous to the United States—Chicano art" (Griswold del Castillo, McKenna, and Yarbro-Bejarano 1991, 27). The committee wanted to portray Chicano art as an art movement indigenous to the United States, not a foreign form or something artificially created for tourist consumption. According to the exhibition catalogue, Chicano art is "a distinct art that arose from the dynamic interdependent relationship between the Movimiento (Chicano movement) and a significant segment of the artistic community of Americans of Mexican descent, and . . . this art has been identified by its creators and participants as 'Chicano' " (27). In the same spirit that created community art centers and workshops, Chicano artists sought to define their cultural production and history from within the community, serving as the foremost authorities on its interpretation and meaning.

CARA established a standard for how Chicano art should be interpreted and viewed within public museums. Artists and Chicano scholars from across the United States helped organize the structure and content of the exhibition. Along with the national executive committee, an organizational

structure was developed consisting of a national selection committee, an editorial board, and regional committees from Arizona, northern California, southern California, Colorado, the Eastern Seaboard, the Midwest, New Mexico, the Northwest, and Texas. Task forces were also assigned to organize the "interpretive components" of the exhibition as well as conduct fundraising, design, and outreach. Many of Chicano art's most notable artists, scholars, and critics participated in these task forces and regional committees. CARA's structure and collaborative development made it an important contribution to the history of Chicano and Chicana art exhibitions. As Alicia Gaspar de Alba states in *Chicano Art Inside/Outside the Master's House: Cultural Politics and the CARA Exhibition*, the exhibition's significance "is not just its presence in public museums across the country, but rather . . . its resistance to traditional museum practices, its complex organizational structure, its politics of self-representation, and its reception by the different communities that it addressed or confronted" (Gaspar de Alba 1998, 8).

Gaspar de Alba's study is a seminal piece of scholarship that both praises and critiques the exhibition for what was represented and what was excluded. She thoughtfully discusses the various ways patriarchy is manifested in the exhibition's works, as well as pointing out the unequal representation of women. While many scholars and activists praised the inclusion of the Feminist Visions thematic section, a quantitative analysis of the works exhibited still reveals a disparity in the recognition of women's cultural participation. Historically patriarchal, Mexican American culture still often undervalues the agency and contributions of women despite the ongoing efforts of the Chicana feminist movement.

CARA's groundbreaking achievements did not come without struggle. Scholars Shifra Goldman, Victor Sorrell, Marcos Sánchez-Tranquilino, and Holly Barnet-Sánchez began the organizing process by applying for a planning grant from the National Endowment for the Humanities (NEH). Their first grant application was denied because the NEH felt the word *Chicano* was inappropriate and too politically charged an identifier. The NEH rejection exemplified the difficulty CARA faced in confronting the mainstream public, which did not understand the importance of the Chicano art movement or its sources and meanings. NEH viewed "Chicano art" as a threatening form of cultural creation incompatible with the selection committee criteria. In 1985, another proposal was sent

to the NEH that more thoroughly explained the significance of the word *Chicano* in defining the cultural and visual production of the Mexican American community. The second proposal was funded only after a series of debates over the validity of the sources and meanings of the "Chicano experience." Despite this initial funding, the NEH would turn down three separate requests for implementation funds for CARA. Eventually, the Rockefeller Foundation stepped in as a primary sponsor of the planning and implementation, and it is credited with keeping the project alive. Other corporate and private foundations gave CARA financial support, including the Anheuser-Busch Companies and the Andy Warhol Foundation for the Visual Arts. Despite these funding struggles that could have killed the project, CARA was an incredible success, setting the stage for a number of notable Chicano art exhibitions organized nationally and internationally.

In 2001, the Los Angeles County Museum of Art produced a major exhibit entitled Road to Aztlán: Art from a Mythic Homeland (see Fields and Zamudio-Taylor 2001), which later traveled to the Austin Museum of Art and the Albuquerque Museum. The exhibition contained 250 artworks made in the Americas, specifically in the Mesoamerican region of the present U.S. Southwest and Northwest Mexico, from the years 1325 through 2000. Its objective was to present artworks created long before an international border separated the region and to present a variety of different perspectives on the origination and use of the term *Aztlán*. Unlike CARA's involvement of Chicano artists and scholars throughout the United States, Art from a Mythic Homeland used a more traditional curatorial approach. A team of curators solicited artworks for the exhibition and essays for the accompanying catalogue. Virginia M. Fields, the museum's curator of pre-Columbian art, and Victor Zamudio-Taylor, an independent scholar and advisor to the Televisa Cultural Foundation, were the chief organizers. They produced a massive exhibition and catalogue with eighteen essays from various scholars of pre-Columbian, colonial Mexican, modern Mexican, and Chicano art. The exhibition's corporate sponsorship demonstrates the increasing validity of Mexican and Chicano art to corporate sponsors. AT&T and Univisión, a large Spanish-language media company, both contributed introductions to the exhibition catalogue expressing their support for Mexican and Mexican American culture and art.

◼ Archives, Collections, and Publications

The institution of public archives specifically collecting Chicano art and a variety of supporting items such as papers, photos, and other documentation began during the Chicano movement and continues to this day. Public research libraries gather primary source material in order to provide researchers access to important records of cultural contributions. Prior to the late 1960s, historians and archivists paid scant attention to the contributions of Mexican Americans in the southwestern United States. Archivists and librarians naturally set their own criteria for what is of importance to collect, and the historic lack of Chicano research programs resulted in a serious dearth of primary source material on Mexican American contributions and experiences.

The emergence of the field of Chicano studies has stimulated the creation of research archives that collect primary documents relating to the Chicano experience. In 1971, Stanford University began collecting Chicano manuscripts with the acquisition of the Ernesto Galarza papers. This led to a larger collection of manuscripts and papers dealing with farm labor in the United States, especially in California. In 1974, the University of Texas developed the Mexican American Library Program, collecting valuable materials from the League of United Latin American Citizens and most recently acquiring the Julián Samora papers (see www.lib.utexas.edu/ad min/cird/policies/subjects/mexam.html). Established in 1969, the Chicano Studies Library at the University of California, Berkeley, has been at the forefront of collecting Chicano publications and a variety of early documentation of Mexican American and Chicano artists (see http://eslibrary .berkeley.edu/csc.htm). Currently, the UCLA Chicano Studies Research Center has developed archival projects such as the Frontier Digitization Project, digitizing the largest collection of Mexican American vernacular music, and the Chicano Cinema Recovery Project, an effort to archive and make available Chicano-produced films (see www.chicano.ucla.edu). The Chicano Studies Research Center has also initiated a partnership with Self Help Graphics, helping to document and preserve the center's vast collection of art (Guerena n.d.).

The California Ethnic and Multicultural Archives (CEMA) at UCSB, is the most notable archive of Chicano art (http://cemaweb.library.ucsb.edu). In 1968, the staff of the Center for Chicano Studies and United Mexican American Students (UMAS) at UCSB established a Chicano archive/

collection called Colección Tloque Nahuaque, which developed out of a collection of papers from MEChA. (Movimiento Estudiantil Chicano de Aztlán). In 1984, the Chicano studies librarian was charged with acquiring important manuscripts and collections, and in 1985 acquired the papers from El Teatro Campesino and Luis Valdez. The UCSB library also acquired the entire collection of institutional papers and prints from Self Help Graphics and Art, consisting of hundreds of posters created by Chicano artists. In 1986, UCSB also acquired the archives of Galería de la Raza in San Francisco, and an archive of videos on Chicano art and artists. Between 1984 and 1993, the UCSB collection expanded beyond Chicano art and culture to encompass the four major ethnic groups of color in California—African Americans, Asian Americans, Native Americans, and Mexican Americans. These collections were then organized and merged into CEMA. CEMA now holds the archives and papers of the RCAF, Alurista, Centro Cultural de la Raza, Yolanda López, and the Linda Lucero Collection of La Raza Silkscreen Center (Guerena n.d.).

CEMA's collection and that of the Center for the Study of Political Graphics were central in the development of a 2000 exhibition of Chicano Posters entitled Just Another Poster? Chicano Graphic Arts in California. The Center for the Study of Political Graphics houses more than 60,000 posters and multiples, actively promotes educational programming, and exhibits its holdings throughout the United States and internationally (see www.politicalgraphics.org/home.html).

The collection and archiving of Chicano cultural productions in universities and other institutions is essential to ensuring that the contributions of Chicano artists are recorded and made available to researchers and scholars. Public libraries and research centers began acquiring Chicano art in the 1980s, only a few decades after the Chicano art movement began. Though institutions are in the process of caring for and archiving the artwork, this by no means signifies an end to the Chicano art movement. To this day Chicano artists are actively involved in creating and exhibiting a variety of art forms, much of it portraying the same themes that emerged during the late 1960s. Moreover, artwork and ephemeral material from Chicano artists can still be found in community centers and workshops, which continue to promote the creation of Chicano culture, even as these materials are making their way into major research centers.

In addition to public archives, important private art collections have developed as well. During the late 1970s and 1980s, when Chicano artists

began exhibiting their artwork in commercial galleries, various private collectors began focusing on Chicano art. In 2000, the Santa Monica Museum of Art held an exhibition entitled East of the River: Chicano Art Collectors Anonymous (CACA), highlighting various private collections of Chicano art. Chicano Art Collectors Anonymous, or CACA (Spanish slang for poop), is an irreverent group of Chicano art collectors who describe their group as a support group for those addicted to collecting art. The exhibition catalogue notes that CACA was established after a group of Chicano art collectors continued running into each other at galleries across Los Angeles. Chicano scholar Chon Noriega describes the group as "sharing a similar history as participants and/or beneficiaries of the civil rights struggles of the 1960s and 1970s. Most were first generation college-educated professionals who still maintained a working class and community based ethos. Few had studied art or art history; instead they started from scratch. But at some point in the 1980s, each had moved from the occasional art purchase to the act of collecting, in the process attending some fifty shows per year. They had become addicted" (Noriega 2000, 8). The collections of CACA members represent a commitment to supporting Chicano artists' cultural creations. The collectors value the development of Chicano art, beginning with the early works of the Chicano movement, as part of the unique quality, character, and intention of the artwork they collect.

Dr. Gilberto Cárdenas is credited as the largest private collector of Chicano art. In 2006, the Snite Museum of Art at the University of Notre Dame held an exhibition entitled Caras Vemos: Corazones No Sabemos, exhibiting works from Dr. Cárdenas's collection that deal with immigration. Dr. Cárdenas is the assistant provost and holds the Julián Samora Chair in Latino Studies at the University of Notre Dame; previously he served as a professor of sociology and the director of the Center for Mexican American Studies at the University of Texas, Austin. During his time at UT Austin Dr. Cárdenas started the National Public Radio Program "Latino USA." He also managed a private Chicano art gallery, Galería Sin Fronteras. Through his work, Dr. Cárdenas has had a significant impact on the development of Chicano art. Here he explains his initial motivations:

My collecting of Chicano visual arts began during the 1960s with poster art and prints, and later incorporated drawings, watercolors, and paint-

ings. Yet it was not until the early 1980s and my first acquisitions of the serigraphs produced at Self Help Graphics, Inc., an important art center in East Los Angeles, that I seriously assumed my identity as a collector. My conversations with Ramon Favela also contributed to the formation of this identity. Shortly thereafter, Sister Karen Boccalero, founder and director of SHG, and I began a close working relationship that lasted until her untimely death in 1997. (Cárdenas 2006, 107)

Dr. Cárdenas has also been involved in promoting exhibitions and conferences that continue dialogue on the nature of Chicano art and its relevance in addressing prominent issues affecting the Mexican American community. The Caras Vemos exhibition is one example of this effort, in that it highlights artworks directly representing immigration from the Chicano community's perspective and experience. Dr. Cárdenas's support of Chicano art deserves recognition as he continues to work with artist groups nationwide, creating exhibition opportunities and developing support structures for artists, community centers, and workshops.

Chicano Visions: American Painters on the Verge was a prominent exhibition of paintings from the collection of comedian and actor Cheech Marin. Chicano Visions and Chicano Now (an interactive exhibit for families) toured more than fifteen prominent museums (see www.chicano art -life.com/visions.html. Cheech Marin's collection is impressive for its significant number of paintings from many of Chicano art's most prominent artists: Carlos Almaraz, Charles Bojórquez, David Botello, Mel Casas, Gaspar Enríquez, Diane Gamboa, Margaret García, Rupert García, Carmen Lomas Garza, Gronk, Raúl Guerrero, Adán Hernández, Ester Hernández, Wayne Healy, Leo Limón, Gilbert "Magú" Luján, César Martínez, Frank Romero, Alex Rubio, Marta Sánchez, Eloy Torrez, Jesse Treviño, John Valadez, Pattsi Valdez, Vincent Valdez, and George Yepes. While buying art is an investment for the collector, Cheech Marin, like Dr. Cárdenas, has been an important supporter of Chicano artists and has promoted the continued development of a uniquely American art movement. As Marin explains, Chicano artists continue to experience nominal commercial success and to create for personal reasons:

With little commercial encouragement, these artists have struggled to gain acceptance in the gallery world. Many painters show their works in restaurants, coffeehouses, or wherever there is a wall and an audience. What matters most is that they continue to create. . . . Going into its

fourth generation of artists, the school [of Chicano Art] continues to grow without losing its essential characteristic—the visual interpretation of the Chicano experience. Whatever the means—historical, political, spiritual, emotional, humorous—these painters each find a unique way to express their singular point of view. (Marin 2002, 8)

Marin's words exhibit true respect for the legacy of the Chicano movement and the cultural work of artists and activists who have sought self-determination for the Chicano community.

Chicano Now, the multimedia interpretive and interactive exhibit accompanying Chicano Visions, was produced with the intention of educating viewers about the Chicano experience, which was seen as essential for a full appreciation of the background and significance of the artwork presented in Chicano Visions. Chicano Now features prominent Chicano and Mexican American performers and filmmakers such as Culture Clash, Guillermo Gómez-Peña, George López, Cheech Marin, Lourdes Portillo, Paul Rodríguez, Robert Rodríguez, and Gustavo Vazquez. The interactive exhibition also reflects the shift, beginning with CARA, toward exhibiting Chicano art outside of community centers, meaning many of the viewers are not from the Mexican American community. Because of the continuing absence of authentic representation of the Chicano experience in traditional American education, educative programming has always been considered necessary in order to appropriately exhibit Chicano art in mainstream public museums and galleries.

Bilingual Press, housed at Arizona State University, has recently published four large volumes on Chicano art that serve as source material for collectors and researchers interested in investigating the variety of artists working today. *Contemporary Chicana and Chicano Art* (Keller et al. 2002) is a two-volume set containing more than six hundred pages with five hundred color images of artwork by almost two hundred Chicano artists. The volumes mainly present artist profiles with a selection of images and a short commentary on the sources and meanings of their visual production. Bilingual Press subsequently published *Chicano Art for Our Millennium* (Keller, Erickson, and Villeneuve 2004), which is organized thematically and represents a variety of Chicano artistic productions. This book is intended as an introductory text for students in primary and secondary levels as well as the general public. Finally (at least as of this writing), Bilingual Press has produced *Triumph of Our Communities: Four Decades of*

Mexican American Art (Keller 2005), which highlights the contributions of community art organizations in the development of Chicano art over the past forty years. All of these books are quality artistic publications that honor the vibrancy of the actual works.

The Future of Chicano Art

The first decade of the Chicano art movement was characterized by a community-oriented focus. Rather than seeking validation from institutions and individuals outside the community, Chicano artists and cultural workers sought to create independent institutions to support Chicano artistic production. During the mid 1970s Chicano artists began exhibiting in prominent mainstream public museums as well as commercial galleries. Many artists continued to work in a "noncommercial community–oriented" way, but others became "more assimilationist in relation to the dominant society and its values, and more commercial in the content and dissemination of their art" (Goldman and Ybarra-Frausto 1985, 32). At this time a fervent debate surfaced amongst Chicano artists regarding the direction the Chicano art movement should take. They questioned how Chicano art should be framed: was it a political art movement, a cultural one, or could it be both? Where would Chicano artists seek validation? Did Chicano art's increased commercialization and exhibition in mainstream institutions contradict its original purpose of culturally empowering the Chicano community? Could Chicano artists successfully negotiate the mainstream and gain acceptance from traditional institutions, and if they did, what did they win or lose in the process?

In 1980, a series of articles published in the Chicano journal *Metamorfosis: Northwest Chicano Magazine of Art and Literature*, published by the Centro de Estudios Chicanos at the University of Washington, sparked serious discussion. Two articles in particular, the article by Malaquias Montoya and Lezlie Salkowitz-Montoya entitled "A Critical Perspective on the State of Chicano Art" (1980), and the response written by Shifra Goldman (1980–81), have been central to the literature on Chicano art and continue to be discussed and cited in scholarly journals and publications relating not only to art but to the entire Chicano movement.

Malaquias Montoya and Lezlie Salkowitz-Montoya called upon Chicano artists to reevaluate the growing trend of artists seeking validation from mainstream art institutions. Their article begins with a brief

introduction on the origins of the Chicano art movement, bringing to light its initial intention of "working in the barrios and the importance of using art as a social tool, as a weapon to combat the circumstances that up to this point in time had made Chicanos feel so alienated from mainstream society" (Montoya and Salkowitz-Montoya 1980). They note that in the first years of the movement, artists decided not to create a fixed definition of Chicano art because to do so would limit artistic freedom and impede creativity. Yet, lacking a fixed definition, Chicano art came to be defined as any art created by people with Spanish surnames. Even though there was a strong decline in the political orientation of Chicano art, artists were still presenting their works in the name of **"Chicanismo."** Montoya and Salkowitz-Montoya recognized the difficulties of carving out a new system and structure to support community-based art activities and creative output. Acknowledging that serving the Chicano movement through art was an activity difficult to maintain financially, they explain a shift in Chicano artists' intentions:

> Artists worked hard for long hours within the community with little or no glory. Since they received little or no pay as well, the ever-existing reality of subsistence for all artists in this country became increasingly hard to bear. The already diminishing Romanticism of the earlier years began to fade. After two or three years of protesting against institutions that controlled art—museums and galleries, colleges, government agencies and publishers—because they perpetuated a philosophy that Chicano artists were struggling against, these same artists agreed to become involved with them. When the doors of museums and galleries opened and invitations were extended, artists went running, despite the fact that Raza communities, which had been the original emphasis for the Chicano art movement, rarely frequented museums. (Montoya and Salkowitz-Montoya 1980)

This article questions why Chicano artists worked to develop new structures to support self-determination for the Chicano community, only to turn and seek validation and inclusion from the very institutions that had previously denied them access.

Shifra Goldman's "Response: Another Opinion on the State of Chicano Art" describes the Montoyas' article as a separatist statement. The majority of her article defines the various reasons that separatism is impossible and undesirable for Chicano artists. Goldman argues that separatism is an

illusion and claims that Chicano activists and artists had made enough gains to be able to negotiate the mainstream while not losing their drive for self-determination: "by 1980, the Chicano movement has attained many of these objectives, and can confront the mainstream from a position of strength and self-awareness. Its vanguard—political militants, artists, intellectuals, self-education workers, students—now have the twin obligation of disseminating and testing constantly evolving new ideas within the U.S. Mexican community, and among potential allies outside that community" (Goldman 1980–81). Goldman seeks to delineate how artists can participate in the mainstream while continuing to demand that mainstream culture and Chicano culture fully embody justice and equality.

Both articles remain relevant to this day, especially considering the ongoing vast inequalities and struggles that the Mexican American community experiences. How does one remedy these inequalities while living within the very society that perpetuates them? What compromises are necessary? And what is lost or gained in the process? These are questions that deserve our attention.

Many scholars have cited the Montoyas' essay as in line with the rhetoric of "El Plan Espiritual de Aztlán," which called for the establishment of a "Mestizo nation." Separatism, as a scholarly idea, denotes complete separation from the dominant, or mainstream, culture. Shifra Goldman and subsequent scholars, however, dispute that separatism is possible or valuable in creating independent institutions and scholarly disciplines. Outside of the actions of Reies López Tijerina and La Alianza to regain control of lands taken from Mexican land-grant holders, the vast majority of the Chicano movement was an attempt to gain autonomy for the Mexican American community while still living within the American structure, government, and economy. For example, La Raza Unida began as a new political party representing the needs of the Chicano community, but it still operated within the American political system. Similarly, Chicano studies programs were created as independent disciplines to serve the Chicano community's efforts for equal representation in education but have largely been housed within established academia. Both Chicano studies programs and La Raza Unida Party sought autonomy and self-determination while remaining dependent on the very structures they were seeking to change. Although they were forced to make compromises to achieve their objectives, their intentions remained intact.

Just as the movement's goal of self-determination didn't imply separatism,

neither did the Montoyas' call for Chicano artists to remain accountable to their communities imply complete disavowal of mainstream structures. The Montoyas approached the debate from the perspective of artists, or creators of culture, not as critics or scholars, and thus they were free to imagine a different reality and to remind Chicano artists of their idealistic beginnings. They believed that by continuing to struggle together, Chicano artists could use their creative abilities to invent alternative structures supporting cultural creation without having to negotiate mainstream art institutions. Of course, Chicano artists would have to make compromises along the way—negotiation was and is necessary for all—but the belief that a new direction was possible, that the arts could serve as a tool for empowering the Chicano community and for achieving justice and equality, would remain.

At the heart of the debate is what ultimately constitutes "victory" for the Chicano movement, and in particular, the Chicano art movement. Does inclusion in mainstream museums constitute victory or a sellout of Chicano artists to the commercial art establishment? The Montoyas argue that "it will be a victory when Chicano communities find Chicano artists a success because they are viewed as spokespersons, citizens of humanity, and their visual expressions viewed as an extension of themselves" (Montoya and Salkowitz-Montoya 1980). From the perspective of art history scholarship, Shifra Goldman provides a thorough critique of the Montoyas' article, but she does not offer an alternative future for Chicano cultural production, other than to list a set of criteria for identifying artworks that have been co-opted, including "slickness, emptiness, static ideas and forms" (Goldman 1980–81).

Today the *Metamorfosis* debate continues to resonate amongst Chicano artists. In January 2005, the *Los Angeles Times Magazine* published a front-page article by Josh Kun entitled "The New Chicano Movement." The front cover of the magazine was headlined "This Is Chicano Art? A Signature L.A. genre is being transformed by a new generation of artists who want to be known for their work, not their identity." Accompanying the headline was Solomon Huerta's photorealist painting of the back of a person's head. The article chronicled a growing segment of Mexican American artists in Los Angeles who no longer want to be known for their identity and are creating artwork that does not directly address or represent the Chicano experience. Many of the artists cited in the article are university educated with advanced degrees in studio art, and exhibit in

very prominent Los Angeles and New York commercial galleries. While they identify with the Mexican American experience, the new generation does not see the need to continue to promote the iconography and political message that was such a vital part of the Chicano art movement. In the article Solomon Huerta asks, "Why just because of my name should I be put in a show based on color, when all the white students I graduated with from Art Center and UCLA are being put in shows based on their work? It is very important to me that I be recognized as an artist who is part of the world like everyone else" (Kun 2005, 15). Huerta represents a new generation of Mexican Americans and Chicanos who seek to live in a color-blind society based on meritocracy, where the injustices of the past become irrelevant. His perspective, echoed by other artists featured in the article, does not see a connection between the disparities in Mexican American representation in areas such as education, politics, and the prison system and the historical injustices the community has faced.

To answer Josh Kun's question in the *Los Angeles Times Magazine* about whether Solomon Huerta's painting is Chicano art, I turn to Chicano studies scholar Rosa Linda Fregoso's definition of what constitutes Chicano cinema. In her book *The Bronze Screen: Chicana and Chicano Film Culture* (1993) Fregoso describes the trinity of "by, for and about." At one time this rubric of "by Chicanos, for Chicanos, and about Chicanos" helped define what constituted Chicano art. The "for" and "about" criteria describe artwork or cultural production that emerged during the Chicano movement, created to authentically represent the community's experiences and culture. Fregoso describes the growing shift of artists, critics, and scholars towards defining Chicano art based solely upon race. She states that "if the 'for' and in some cases the 'about' are no longer fashionable for defining Chicano cinema, then what has in fact dropped out of the equation is the cultural politics that inspired a whole generation in the struggle for human rights and social justice" (Fregoso 1993, xvii). Fregoso argues that if Chicano cinema (and by extension, art) developed out of the Chicano movement's efforts to achieve equality and self-determination, then it must somehow be held to those ideals. If the politics of the Chicano movement are removed, then "the definition [of Chicano cinema/art] becomes too banal, too all-inclusive, too pluralistic, equating cultural forms engaged in antiracism and empowerment struggles with those informed by fascist, racist, or sexist tendencies" (xix). Thus, she argues, if the "for" and "about" are stripped from the definition of Chicano art, and all that is left is "by,"

then *Chicano art* becomes simply a race-based term, effectively removing its relevance.

Although the Chicano Visions exhibit has been critically praised in the mainstream press, it has also served to exemplify the issues still actively debated within the Chicano community. One ongoing debate concerns how Chicano art is represented in prominent collections and exhibitions. At question is whether the current presentation of Chicano art authentically represents the historical trajectory of this art movement. Chicano Visions is an exhibition of one Chicano art patron's collection, yet Armando Durón, a fellow collector and member of CACA, presents an important critique in his review of the exhibition for the journal *Aztlán*. A potent statement from Durón addressed the very title of the exhibition:

> Another limitation suggested by the title is the seemingly forward-looking phrase: "on the verge." It begs the question: "on the verge of what?" Fame, fortune, acceptance? Sadly, some of these artists will tell you that they have been "on the verge" for twenty or more years. The circumstance of suspension could have been explored. Questions of long-standing exclusion from mainstream galleries and museum exhibitions, the lack of a secondary market to speak of, the failure of an established institutional backbone to support these artists, the scarcity of collectors within the community, and the experience of being permanently "on the verge" are a few over-ripened topics that are yet to be openly explored in this exhibit. (Durón 2004, 234)

In his review, Durón acknowledges the importance of this exhibition but he also brings to light the many issues which still exist in relationship to the full representation of the Chicano art movement.

Another perspective on Chicano Visions is presented by Barbara Renaud González in her article "Targeting Chicano." González argues that the term *Chicano* was distorted by Chicano Visions, and in her article she critiques not only the exhibition but also the politics of representing Chicano art in the twenty-first century. She argues that the presentation actually disempowered the sources and meanings of Chicano art. The sponsorship by Target, Hewlett-Packard Company, Daimler-Chrysler, and Clear Channel Entertainment allowed these corporations to brand their images on Chicano art, and thereby Chicano Visions "sold the only property we have left—our word for struggle, justice, and hope. I think we sold our-

selves too cheaply. I think the price we will pay is too high" (González 2002, 28). According to González, Chicano art is distorted when exhibitions place Chicano cultural production within mainstream venues backed by major corporate sponsors whose interests are often oppositional to those of Chicano self-determination. González expresses sentiments not often sounded by art reviewers and cultural critics. For some, the use of the word *Chicano* to identify the exhibited artworks was a victory in itself, representing continued opposition to melting pot and assimilationist identifiers. For others, inclusion into the mainstream was the goal from the beginning.

In her conclusion González quotes artist Adán Hernández, who after hearing her critique of the exhibit stated, "The other alternative is nothing. . . . I want my share of the American Dream" (30).

González counters that the Chicano art movement presented an opportunity to redefine the American dream. She ends with, "Maybe that's the nightmare in all of this. After all the marching and shouting and rejections, did we just want to be included in a dream that someone else dreamed for us? Or is it possible that we have forgotten how to dream at all?" (30).

■ Discussion Questions

1. Discuss the CARA exhibit. In what ways was the extensive organizational structure established to stage CARA important to creating a national exhibit?

2. Why did the location and structure of exhibitions change between the early period of the Chicano art movement and the 1980s? How was this a departure from early ideals of Chicano activism?

3. Discuss the debates about the future of Chicano art that occurred during the 1980s and their relevance to recent mainstream exhibitions of Chicano art.

4. Does inclusion in mainstream art galleries and museums mean that Chicano art has abandoned its original ideals? Does mainstream Chicano art continue to remain relevant to the Chicano community? Do you feel this evolution reflects a change in the position of the Mexican American community within society as a whole?

5. What is your personal definition of what constitutes Chicano and Chicana art?

■ Suggested Readings

Al Frente Communications. *Chicanarte*. Los Angeles: UCLA Chicano Studies Center, 1975.

Arceo-Frutos, René H., Juana Guzmán, and Amalia Mesa-Bains, comps. *Art of the Other Mexico: Sources and Meanings*. Chicago: Mexican Fine Arts Museum, 1993.

Castellón, Rolando, comp. *Mano a Mano: Abstraction/Figuration*. Santa Cruz: Art Museum of Santa Cruz County, University of California, Santa Cruz, 1988.

Davalos, Karen Mary. *Exhibiting Mestizaje: Mexican (American) Museums in the Diaspora*. Albuquerque: University of New Mexico Press, 2001.

Fields, Virginia M., and Victor Zamudio-Taylor, comps. *The Road to Aztlán: Art from a Mythic Homeland*. Los Angeles: Los Angeles County Museum of Art, 2001.

Gaspar de Alba, Alicia. *Chicano Art Inside/Outside the Master's House: Cultural Politics and the CARA Exhibition*. Austin: University of Texas Press, 1998.

Goldman, Shifra. "Response: Another Opinion on the State of Chicano Art." *Metamorfosis* 3, no. 2–4, no. 1 (1980–81): 2–7.

Keller, Gary D. *Triumph of Our Communities: Four Decades of Mexican American Art*. Tempe, AZ: Bilingual Press, 2005.

Keller, Gary D., Joaquín Alvarado, Kaytie Johnson, and Mary Erickson. *Contemporary Chicana and Chicano Art: Artists, Works, Culture, and Education*. 2 vols. Tempe, AZ: Bilingual Press, 2002.

Keller, Gary, Mary Erickson, and Pat Villeneuve. *Chicano Art for Our Millennium: Collected Works from the Arizona State University Community*. Tempe, AZ: Bilingual Press, 2004.

Marin, Cheech, comp. *Chicano Visions: American Painters on the Verge*. New York: Bulfinch Press, 2002.

Mexican Fine Arts Center Museum. *The African Presence in México: From Yanga to the Present*. Chicago: Mexican Fine Arts Center Museum, 2006.

Montoya, Malaquias, and Lezlie Salkowitz-Montoya. "A Critical Perspective on the State of Chicano Art." *Metamorfosis* 3, no. 1 (1980): 3–7.

Conclusion

In this book I argue that the Chicano art movement is not a relic of history but rather is an artistic movement that continues to this day. Chicano art is a vital artistic movement that deserves greater attention and scholarship, and the intention of this book is to encourage further discussion, scholarship, and interest in the field of Chicano art. Furthermore, I have sought to provide a cohesive presentation of how Chicano art constitutes a unique and valid American art movement. This task is not easy in an introductory book. And while encouraging scholarship is my primary goal, I have sought to present the information in a manner that is accessible to the community and can serve as a source of inspiration for artists and cultural workers who wish to contribute to this artistic movement.

The University of Arizona Press Mexican American Experience series, of which this book is a part, is an important collection of introductory surveys of various aspects of the Chicano community. I am pleased to add to this series with *Chicana and Chicano Art: ProtestArte*. The Chicano art community is vibrant and alive. Chicano artists continue to create significant works, and so debate continues on the legitimate directions and intentions of Chicano artistic production. Many community art centers, such as Galería de la Raza and Self Help Graphics, continue to serve local Mexican American/Latino communities as cultural centers and places for artistic creation. In striving for self-determination, equality, and social justice for the Chicano community, artists have made significant contributions towards representing a new culture that embraces these goals. Their work has been and continues to be inspiring.

■ GLOSSARY

atelier: A French word describing a studio or workshop. An atelier can specifically refer to an artist's studio or to a method of artistic instruction where a few selected students apprentice with an artist. A printmaking atelier describes a working relationship between a fine art printer and a visual artist, whereby the printmaker works closely in helping the artist to produce a limited-edition print.

Aztlán: Refers to the original homeland of the Aztecs somewhere to the north of the Valley of Mexico, from where legend says the Chichimecas migrated south. Scholars have debated whether Aztlán is fact or fiction, but it is recognized in Mexico as a part of its indigenous history. Today Aztlán is represented on the Mexican national flag as "the sign that Huitzilopochitli gave the Chichimec to mark the place where they should stop migrating—an eagle perched upon a cactus sprouting from a rock" (Menchaca 2001, 22). In the 1960s the poet and activist Alurista brought the notion of Aztlán to the forefront of the Chicano movement with his "Epic Poem of Aztlán," which identified the location of Aztlán as the U.S. Southwest. This poem tied the idea of Aztlán to the Mexican American experience in the U.S. Southwest and provided a homeland in the southwestern United States for Mexican Americans.

calavera: Spanish for "skull." The depiction of calaveras, or skeleton caricatures, was popularized by José Guadalupe Posada and other printmakers of broadside ballads in early twentieth-century Mexico. Calaveras symbolize the vanity of those who forget that death spares no one.

Chicanismo: The act of living as a Chicano or Chicana. Chicanismo can also be described as the political philosophy behind Chicano as an identity. As described in 1969 in "El Plan de Santa Barbara," "Chicanismo draws its faith and strength from two main sources: from the just struggle of our people and from an objective analysis of our community's strategic needs."

Chicano/Chicana: An identity term that has many different meanings to different people. Mexican American civil rights activists appropriated the term in the late 1960s to embody a new cultural and political identity that "transformed a pejorative barrio term 'Chicano' into a symbol of pride. 'Chicana/o' implies a commitment to social justice and social change" (Ruiz 1998, 98). A Chicano or Chicana is also described as "a

'new' Mexican American, one who understood his or her roots and shunned assimilation or integration" (García 1997, 35). *Chicano/Chicana* has since become widely used to refer to any Mexican American. In this book, I use it in the senses of Ruiz and García to refer to someone who retains a commitment to social justice for the Mexican American community and pride in their mestizo heritage.

Chicano art movement: An artistic movement that emerged out of the Mexican American civil rights movement in the mid- to late 1960s. The Chicano art movement initially described the way that artists used their art to serve the Chicano movement's goals of social justice and self-determination for the Mexican American community. Just as the meaning of *Chicano* is hotly debated, so is which works should and should not be considered as belonging to the Chicano art movement. In this book I consider those Mexican-origin artists who address themes of social justice and cultural pride in their work as belonging to the Chicano art movement, whether or not they were active during the peak years of the Chicano movement.

collage: A method of visual art whereby the artist assembles an artwork using a variety of usually two-dimensional objects.

corrido: Traditionally refers to a folk song or ballad from Mexico. Corridos have been sung and composed throughout the southwestern United States and along the U.S.–Mexican border. Scholars have looked at the corrido as a form of oral history representing stories of the Mexican American experience not represented in official documents or mainstream historical texts.

Crusade for Justice: Mexican American civil rights organization based out of Denver, Colorado, established by Chicano leader Rodolfo "Corky" Gonzales in the late 1960s. The Crusade for Justice organized and hosted the first Chicano Youth Liberation Conference where "El Plan Espiritual de Aztlán" was drafted.

cultural democracy: Specifically refers to the ideas of cultural workers during the Depression era who advocated for the U.S. government's New Deal to include programs that would popularize the arts, making visual arts and theater more accessible to the masses. This ideal of making art for and as part of a community was embraced by artists of the Chicano art movement.

cultural imperialism/cultural colonialism: The practice of imposing and enforcing the culture or language of one nation onto another. Cul-

tural imperialism can manifest itself as an official policy or as a general approach.

Day of the Dead/El Día de los Muertos: Holiday celebrated primarily in Mexico where people remember family members and friends who have died. Día de los Muertos has origins that connect indigenous celebrations of the dead with All Saints' Day, a Catholic holy day.

fresco: A method of painting pigment directly into wet plaster. Fresco was the painting technique of Michelangelo in the Sistine Chapel and a favored technique for Diego Rivera's and Jose Clemente Orozco's murals.

Latino/Latina: A person of Latin American descent living in the United States. The term is often used to distinguish between Mexican Americans and people whose roots are in other countries of Latin America.

linocut: Relief printmaking method whereby an image is cut out in linoleum. The process involves inking the linoleum and transferring the printed image to paper. Linocut involves a process similar to woodblock printing.

lithograph: Printmaking method where an image is created on a limestone block and transferred to paper by inking the stone. Technological advances in lithography have developed techniques whereby large limestone blocks are no longer the only process available for transferring an image to paper.

magical realism: An artistic genre where magical or illogical scenarios appear in realistic circumstances. Often associated with Latin America, magical realism intentionally blurs the line between reality and fantasy.

mestizaje: Most directly describes racial intermarriage or mixing. *Mestizaje* is most often used to describe the process of European and Indian mixing in the Americas, thus creating mestizos/mestizas, people of mixed racial and cultural heritage. As used by Chicanos, mestizaje implies embracing the indigenous, or nonwestern component of one's Mexican heritage.

Mexican American: An identity first widely used in the 1940s to describe Americans of Mexican descent. *Mexican American* does not necessarily entail the political activism inherent in *Chicano*.

Mexicanidad: "Mexican-ness," a sentiment that emerged amongst artists in Mexico following the Mexican Revolution. Mexicanidad initially sought to represent a view of Mexico that emphasized its indigenous history, rather than its Spanish colonial legacy.

Mexican mural movement/Mexican mural renaissance: Artistic movement that emerged after the Mexican Revolution in which the central government commissioned public murals with an emphasis on representing an anticolonial perspective on the history and culture of Mexico. The ideals of the Mexican mural movement later inspired the Chicano art movement in the United States. Los Tres Grandes, the three most prominent Mexican artists of the movement, were José Clemente Orozco, Diego Rivera, and David Siqueiros.

modernism: A trend of thought that affirms the belief in humans' ability to invent, advance, and redesign their surroundings through experimentation and scientific knowledge. Modernist art flourished between World Wars I and II. Modernism has often been associated with the emergence of abstract visual art in the United States.

pachuco: Flamboyant Mexican American youth who, during the 1930s and 1940s, were associated with wearing zoot suits and using a dialect called caló. They were often connected in the public mind with gang culture.

performance art: An art form whereby the actions of a particular person or group can constitute a complete art piece. Performance art can be manifested in various public or private locations for varied lengths of time.

pop art: A visual art form depicting objects or scenes from everyday life, often appropriating techniques of commercial art or popular illustration.

rasquachismo: A Chicano sensibility utilized by artists. Rasquache art, or the act of rasquachismo, describes using what is at hand to create art or beauty. Rasquachismo emerges from the daily lives of Mexican Americans and Chicanos who, despite poverty, create art with limited means.

relief printing: Printmaking process, such as woodblock or linocut, where a negative image is created by cutting away at a piece of wood or linoleum. Applying ink to the woodblock or linocut then pressing it on paper creates a positive image.

retablo: A painting on metal or tin, often depicting a miracle or a religious event.

silkscreen: A printmaking method using a piece of silk stretched to a screen and a squeegee to transfer an image to paper. Today synthetic material is used in place of silk and many refer to silkscreen printing as *serigraphy* or *screen-printing*, which both move beyond the reference to silk fabric.

taller: Spanish for "workshop." Artistic talleres were important components of the Mexican artistic renaissance in the early twentieth century and of the Chicano art movement.

United Farm Workers of America (UFW): A labor union representing primarily farmworkers, cofounded by César Chávez and Dolores Huerta. One of the catalysts of the Chicano movement, the UFW actively recruited artists to support their political goals.

Virgin of Guadalupe: Patron saint of Mexico (Nuestra Señora de Guadalupe). The Virgin of Guadalupe is a New World manifestation of the Virgin Mary whose image is and has been used widely by Chicano and Mexican American communities.

■ SUGGESTED WEB SITES

The Internet is a very convenient and rapid source of information. However, Web sites vary widely in their accuracy and stability. The following are some reliable and relatively stable Web sites that may prove useful sources for further study.

Bilingual Review Press
www.asu.edu/clas/hrc/bilingual.press/brp.html

California Ethnic and Multicultural Archives
http://cemaweb.library.ucsb.edu/cema_index.html

California Ethnic and Multicultural Archives: Proyecto CARIDAD Chicano Visual Arts Kit: A Guide
http://cemaweb.library.ucsb.edu/visual_arts_kit.html

Centro Cultural de la Raza
www.centroculturaldelaraza.org

Coronado Studio
www.coronadostudio.com

Galería de la Raza
www.galeriadelaraza.org

Institute for Latino Studies, University of Notre Dame, Caras Vemos, Corazones No Sabemos (Faces Seen, Hearts Unknown: The Human Landscape of Mexican Migration)
www.carasvemos.org

Institute for Latino Studies, University of Notre Dame, Midwest Latino Arts Documentary Heritage Project
www.midlad.org

La Raza Galería Posada
www.larazagaleriaposada.org

Mexic-Arte Museum
www.mexic-artemuseum.org

Mission Cultural Center
www.missionculturalcenter.org

Mural Conservancy of Los Angeles
www.lamurals.org

National Museum of Mexican Art (Formerly: Mexican Fine Arts Center Museum)
www.nationalmuseumofmexicanart.org

Serie Print Project
www.serieproject.org

Social Public Art Resource Center
www.sparcmurals.org

UCLA Chicano Studies Research Center
A Ver: Revisioning Art History
www.chicano.ucla.edu/research/ArtHistory.html

United Farm Workers of America
www.ufw.org

University of California Digital Archive: Calisphere
www.calisphere.universityofcalifornia.edu

WORKS CONSULTED

Acuña, Rodolfo. 1988. *Occupied America: A History of Chicanos*. 3rd ed. New York: HarperCollins.

Ades, Dawn, Renato González Mello, and Diane Miliotes, eds. 2002. *José Clemente Orozco in the United States, 1927–1934*. Hanover, NH: Hood Museum of Art, Dartmouth College; New York: W. W. Norton.

Al Frente Communications. 1975. *Chicanarte*. Los Angeles: UCLA Chicano Studies Center.

Almaguer, Tomás. 1994. *Racial Fault Lines: The Historical Origins of White Supremacy in California*. Berkeley: University of California Press.

Anaya, Rudolfo A., and Francisco A. Lomelí. 1989. *Aztlán: Essays on the Chicano Homeland*. Albuquerque: University of New Mexico Press.

Anderson, Gary Clayton. 2005. *The Conquest of Texas: Ethnic Cleansing in the Promised Land 1820–1875*. Norman: University of Oklahoma Press.

Anreus, Alejandro. 2001. *Orozco in Gringoland: The Years in New York*. Albuquerque: University of New Mexico Press.

Anzaldúa, Gloria. 1987. *Borderlands/La Frontera: The New Mestiza*. San Francisco: Aunt Lute Books.

Applebaum, Stanley, and Roberto Berdecio. 1972. *Posada's Popular Mexican Prints*. New York: Dover.

Arceo-Frutos, René H., Juana Guzmán, and Amalia Mesa-Bains, comps. 1993. *Art of the Other Mexico: Sources and Meanings*. Chicago: Mexican Fine Arts Museum.

Arreola, Daniel D. 1984. "Mexican American Exterior Murals." *Geographical Review* 74(4): 409–24.

Baca, Judith F. 1990. Preface to *Signs from the Heart: California Chicano Murals*, edited by Eva Sperling Cockcroft and Holly Barnet-Sánchez. Venice, CA: Social Public Art Resource Center.

Bailey, Joyce Waddell. 1980. "Jose Clemente Orozco (1883–1949): Formative Years in the Narrative Graphic Tradition." *Latin American Research Review* 15(3): 73–93.

Barnet-Sánchez, Holly, and Eva Sperling Cockcroft, eds. 1990. *Signs from the Heart: California Chicano Murals*. Venice, CA: Social Public Art Resource Center.

Barrio, Raymond. 1975. *Mexico's Art and Chicano Artists*. Guerneville, CA: Ventura Press.

Bechler, Wendy, and Chon A. Noriega. 2004. *I Am Aztlán: The Personal Essay in Chicano Studies*. Los Angeles: UCLA Chicano Studies Research Center.

Benavidez, Max. 2002. "Chicano Art: Culture, Myth, and Sensibility." In *Chicano Visions: American Painters on the Verge*, compiled by Cheech Marin. New York: Bulfinch Press.

———. 2007. *Gronk. A Ver: Revisioning Art History*. Los Angeles: UCLA Chicano Studies Research Center.

Bennett, Scott H. 2002. "Workers/Draftees of the World Unite!: Carlos A. Cortez Redcloud Koyokuikatl: Soapbox Rebel, WWII CO, and IWW Artist/Bard." In *Carlos Cortez Koyokuikatl: Soapbox Rebel and Artist*, edited by Victor A. Sorell, 12–56. Chicago: Mexican Fine Arts Center Museum.

Berkowitz, Ellie Patricia. 2006. "Innovation through Appropriation as an Alternative to Separatism: The Use of Commercial Imagery by Chicano Artists, 1960–1990." PhD diss., University of Texas, Austin.

Bernal, Louis Carlos, Morrie Camhi, Abigail Heyman, Roger Minick, and Neal Slavin, comps. 1978. *Espejo: Reflections of the Mexican American*. Oakland: Oakland Museum.

Bishop, Joyce M., Karana Hattersley-Drayton, and Tomás Ybarra-Frausto. 1987. *From the Inside Out: Perspectives on Mexican and Mexican-American Folk Art*. San Francisco: Mexican Museum.

Bond, Evagene H. 1982. *La Comunidad: Design, Development, and Self-Determination in Hispanic Communities*. Washington, DC: Partners for Livable Places.

Brenner, Anita. 1929. *Idols behind Altars*. New York: Payson and Clarke.

Brookman, Philip, and Guillermo Gómez-Peña, eds. 1986. *Made in Aztlán*. San Diego: Centro Cultural de la Raza.

Broyles-González, Yolanda. 1994. *El Teatro Campesino: Theater in the Chicano Movement*. Austin: University of Texas Press.

Cárdenas, Gilberto. 1976. "Los Desarraigados: Chicanos in the Midwestern Region of the United States." *Aztlán: A Journal of Chicano Studies* 7(2): 153–85.

———. 2006. "Art and Migration: Collector's View." In *Caras Vemos, Corazones No Sabemos: Faces Seen, Hearts Unknown*, edited by Amelia Malagamba-Ansótegui. South Bend, IN: Snite Museum of Art, University of Notre Dame.

Carrera, Magali M. 2003. *Imagining Identity in New Spain: Race, Lineage, and the Colonial Body in Portraiture and Casta Paintings*. Austin: University of Texas Press.

Castellón, Rolando, comp. 1988. *Mano a Mano: Abstraction/Figuration*. Santa Cruz: Art Museum of Santa Cruz County, University of California, Santa Cruz.

Chabram-Dernersesian, Angie, ed. 2006. *The Chicana/o Cultural Studies Reader*. New York: Routledge.

Charlot, Jean. 1962. *Mexican Art and the Academy of San Carlos, 1785–1915*. Austin: University of Texas Press.

———. 1963. *The Mexican Mural Renaissance, 1920–1925*. New Haven: Yale University Press.

———. 1972. *An Artist on Art: Collected Essays of Jean Charlot*. Honolulu: University Press of Hawaii.

Chávez, César. 1965. "César Chávez Talks about Organizing and the History of the NFWA." Presentation to the California statewide meeting of the Student Nonviolent Coordinating Committee of California, Fresno, CA, December.

Chávez, Ernesto. 2002. *¡Mi Raza Primero! (My People First!): Nationalism, Identity, and*

Insurgency in the Chicano Movement in Los Angeles 1966–1978. Berkeley: University of California Press.

Chávez, Leo R. 2001. *Covering Immigration: Popular Images and the Politics of the Nation*. Berkeley: University of California Press.

Chávez, Patricio, Madeleine Grynsztejn, and Kathryn Kanjo, comps. 1993. *La Frontera/The Border: Art about the Mexico/United States Border Experience*. San Diego: Centro Cultural de la Raza, Museum of Contemporary Art.

Chicano Coordinating Committee on Higher Education. 1969. *El Plan de Santa Barbara: A Chicano Plan for Higher Education*. Oakland, CA: La Causa Publications.

Chicano! History of the Mexican American Civil Rights Movement. 1996. Video. Los Angeles: NLCC Educational Media.

Cockcroft, Eva Sperling, and Holly Barnet-Sánchez, eds. 1990. *Signs from the Heart: California Chicano Murals*. Venice, CA: Social Public Art Resource Center.

Cockcroft, Eva, John Weber, and Jim Cockcroft. 1977. *Toward a People's Art: The Contemporary Mural Movement*. New York: E. P. Dutton.

Cohn, Diana. 2002. *¡Sí, Se Puede! Yes We Can! Janitor Strike in L.A.* El Paso: Cinco Puntos Press.

Consejo Nacional para la Cultura y las Artes. 1997. *60 Años TGP: Taller de Gráfica Popular*. Mexico City: Instituto Nacional de Bellas Artes.

Cortez, Constance. 2001. "The New Aztlán: Nepantla (and Other Sites of Transmogrification)." In *The Road to Aztlán: Art from a Mythic Homeland*, edited by Virginia Fields and Victor Zamudio-Taylor, 358–73. Los Angeles: Los Angeles County Museum of Art.

Costa, Gina. 2007. *Women of the Taller de Gráfica Popular*. South Bend, IN: Snite Museum of Art.

Craven, David. 2002. *Art and Revolution in Latin America, 1910–1990*. New Haven: Yale University Press.

Crusade for Justice. 1970. "El Plan Espiritual de Aztlán: Papers from the Second Annual Chicano Youth Liberation Conference." Denver, March 25–27.

Cushing, Lincoln. 2003. *Revolution! Cuban Poster Art*. San Francisco: Chronicle Books.

Davalos, Karen Mary. 2001. *Exhibiting Mestizaje: Mexican (American) Museums in the Diaspora*. Albuquerque: University of New Mexico Press.

Davidson, Russ, ed. 2006. *Latin American Posters: Public Aesthetics and Mass Politics*. Santa Fe: Museum of New Mexico Press.

de la Mora, Sergio. 2006. *Cinemachismo: Masculinities and Sexuality in Mexican Film*. Austin: University of Texas Press.

de la Torre, Adela, and Beatríz M. Pesquera, eds. 1993. *Building with Our Hands: New Directions in Chicana Studies*. Berkeley: University of California Press.

Downs, Linda Banks. 1999. *Diego Rivera: The Detroit Industry Murals*. New York: W. W. Norton.

Drescher, Timothy W. 1994. *San Francisco Murals: Community Creates Its Muse, 1914–1994*. St. Paul, MN: Pogo Press.

Dunitz, Robin J., and James Prigoff. 1997. *Painting the Towns: Murals of California*. Los Angeles: RJD Enterprises.

Durant, Sam. 2007. *Black Panther: The Revolutionary Art of Emory Douglas*. New York: Rizzoli.

Durón, Armando. 2004. "Cheech Marin's Chicano Visions: American Painters on the Verge." *Aztlán* 29: 233–37.

Edwards, Emily. *Painted Walls of Mexico: From Prehistoric Times until Today*. Austin: University of Texas Press, 1966.

Fields, Virginia M., and Victor Zamudio-Taylor, comps. 2001. *The Road to Aztlán: Art from a Mythic Homeland*. Los Angeles: Los Angeles County Museum of Art.

Flores-Turney, Camille. 1997. *Howl: The Artwork of Luis Jiménez*. Santa Fe: New Mexico Magazine.

Folgarait, Leonard. 1987. *So Far from Heaven: David Alfaro Siqueiros' The March of Humanity and Mexican Revolutionary Politics*. Cambridge: Cambridge University Press.

——. 1998. *Mural Painting and Social Revolution in Mexico, 1920–1940: Art of the New Order*. New York: Cambridge University Press.

Fondo de Cultura Económica. 1967. *Mural Painting of the Mexican Revolution*. Mexico City: Atria.

Frank, Patrick. 1998. *Posada's Broadsheets: Mexican Popular Imagery, 1890–1910*. Albuquerque: University of New Mexico Press.

Fregoso, Rosa Linda. 1993. *The Bronze Screen: Chicana and Chicano Film Culture*. Minneapolis: University of Minnesota Press.

——. 2003. *meXicana Encounters: The Making of Social Identities on the Borderlands*. Berkeley: University of California Press.

Gallo, Rubén. 2004. *New Tendencies in Mexican Art*. New York: Palgrave Macmillan.

——. 2005. *Mexican Modernity: The Avant-Garde and the Technological Revolution*. Cambridge, MA: MIT Press.

Gamboa, Harry Jr. 1991. "In the City of Angels, Chameleons, and Phantoms: Asco, A Case Study of Chicano Art in Urban Tones (or Asco Was a Four-Member Word)." In *Chicano Art: Resistance and Affirmation, 1965–1985*, edited by Richard Griswold del Castillo, Teresa McKenna, and Yvonne Yarbro-Bejarano. Los Angeles: Wight Art Gallery, UCLA.

García, Ignacio M. 1997. *Chicanismo: The Forging of a Militant Ethos among Mexican Americans*. Tucson: University of Arizona Press.

García, John A. 2003. *Latino Politics in America: Community, Culture, and Interests*. New York: Rowman and Littlefield.

Gaspar de Alba, Alicia. 1998. *Chicano Art Inside/Outside the Master's House: Cultural Politics and the CARA Exhibition*. Austin: University of Texas Press.

——. 2001. "From CARA to CACA: The Multiple Anatomies of Chicano/a Art at the Turn of the New Century." *Aztlán* 26: 205–31.

Goldman, Shifra M. 1980–81. "Response: Another Opinion on the State of Chicano Art." *Metamorfosis* 3(2)–4(1): 2–7.

——. 1981. *Contemporary Mexican Painting in a Time of Change.* Albuquerque: University of New Mexico Press.

——. 1984. "A Public Voice: Fifteen Years of Chicano Posters." *Art Journal* 44(1): 50–57.

——. 1990. "How, Why, and When It All Happened: Chicano Murals of California." In *Signs from the Heart: California Chicano Murals*, edited by Holly Barnet-Sánchez and Eva Sperling Cockcroft. Venice, CA: Social Public Art Resource Center.

——. 1994a. *Dimensions of the Americas: Art and Social Change in Latin America and the United States.* Chicago: University of Chicago Press.

——. 1994b. "Luis Jiménez: Recycling the Ordinary into the Extraordinary." In *Man on Fire: Luis Jiménez.* Albuquerque: The Albuquerque Museum.

Goldman, Shifra M., and Tomás Ybarra-Frausto. 1985. *Arte Chicano: A Comprehensive Annotated Bibliography of Chicano Art, 1965–1981.* Berkeley: Chicano Studies Library Publications Unit, University of California.

Gómez, Laura E. 2007. *Manifest Destinies: The Making of the Mexican American Race.* New York: New York University Press.

Gómez-Peña, Guillermo. 1996. *The New World Border: Prophecies, Poems and Loqueras for the End of the Century.* San Francisco: City Lights.

Gómez-Quiñones, Juan. 1990. *Chicano Politics: Reality and Promise, 1940–1990.* Albuquerque: University of New Mexico Press

——. 1994. *Mexican American Labor, 1790–1990.* Albuquerque: University of New Mexico Press.

Gonzales, Michael J. 2002. *The Mexican Revolution: 1910–1940.* Albuquerque: University of New Mexico Press.

Gonzales, Rodolfo. 2001. *Message to Aztlán: Selected Writings.* Houston: Arte Público Press.

González, Barbara Renaud. 2002. "Targeting Chicano." *The Progressive* July 1, 27–30.

González Mello, Renato, and Diane Miliotes, eds. 2002. *José Clemente Orozco in the United States, 1927–1934.* New York: W. W. Norton.

Gordon, Robert. 1999. "Poisons in the Fields: The United Farm Workers, Pesticides, and Environmental Politics." *Pacific Historical Review* 68(1): 51–77.

Gorodezky, Sylvia M. 1993. *Arte Chicano: Como cultura de protesta.* Mexico City: Universidad Nacional Autónoma de México.

Griswold del Castillo, Richard, Teresa McKenna, and Yvonne Yarbro-Bejarano, eds. 1991. *Chicano Art: Resistance and Affirmation, 1965–1985.* Los Angeles: Wight Art Gallery, UCLA.

Grynsztejn, Madeleine. 1993. "La Frontera/The Border: Art about the Mexico/

United States Border Experience." In *La Frontera/The Border: Art about the Mexico/United States Border Experience*, edited by Patricio Chávez and Madeleine Grynstejn. San Diego: Centro Cultural de la Raza.

Guerena, Salvador. n.d. "Archives and Manuscripts: Historical Antecedents to Contemporary Chicano Collections." Available online at the California Ethnic and Multicultural Archives: http://cemaweb.library.ucsb.edu/archives_manuscripts.html (accessed May 14, 2008).

Guzmán, Kristen. 2005. *Self Help Graphics and Art: Art in the Heart of East Los Angeles*. Los Angeles: Chicano Studies Research Center, UCLA.

Hammerback, John C., and Richard J. Jensen. 2002. *The Words of César Chávez*. College Station: Texas A&M University Press.

Haney López, Ian F. 1996. *White by Law: The Legal Construction of Race*. New York: New York University Press.

———. 2003. *Racism on Trial: The Chicano Fight for Justice*. Cambridge, MA: Harvard University Press.

Helm, MacKinley. 1953. *Man of Fire: An Interpretive Memoir*. New York: Harcourt, Brace.

Helms, Cynthia Newman, ed. 1986. *Diego Rivera: A Retrospective*. New York: W. W. Norton.

Hernández, Guillermo E. 1991. *Chicano Satire: A Study in Literary Culture*. Austin: University of Texas Press.

Herrera, Hayden. 2002. *Frida Kahlo: The Paintings*. New York: HarperCollins.

Herrera-Sobek, María, ed. 2001. *Santa Barraza: Artist of the Borderlands*. College Station: Texas A&M University Press.

Huntington, Samuel P. 2004. *Who Are We?: The Challenges to America's National Identity*. New York: Simon and Schuster.

Hurlburt, Laurance P. 1976. "The Siqueiros Experimental Workshop: New York, 1936." *Art Journal* 35(3): 237–46.

———. 1989. *The Mexican Muralists in the United States*. Albuquerque: University of New Mexico Press.

Ittmann, John. 2006. *Mexico and Modern Printmaking: A Revolution in the Graphic Arts, 1920–1950*. New Haven: Yale University Press.

Johnson, Benjamin Heber. 2003. *Revolution in Texas: How a Forgotten Rebellion and Its Bloody Suppression Turned Mexicans into Americans*. New Haven: Yale University Press.

Juárez, Miguel. 1997. *Colors on Desert Walls: The Murals of El Paso*. El Paso: Texas Western Press.

Katzew, Ilona. 2004. *Casta Painting: Images of Race in Eighteenth-Century Mexico*. New Haven: Yale University Press.

Keller, Gary D. 2005. *Triumph of Our Communities: Four Decades of Mexican American Art*. Tempe, AZ: Bilingual Press.

Keller, Gary D., Joaquín Alvarado, Kaytie Johnson, and Mary Erickson. 2002. *Contemporary Chicana and Chicano Art: Artists, Works, Culture, and Education.* 2 vols. Tempe, AZ: Bilingual Press.

Keller, Gary D., Mary Erickson, and Pat Villeneuve. 2004. *Chicano Art for Our Millennium: Collected Works from the Arizona State University Community.* Tempe, AZ: Bilingual Press.

Kun, Josh. 2005. "The New Chicano Movement." *Los Angeles Times Magazine*, July 9.

Kunzle, David. 1995. *The Murals of Revolutionary Nicaragua, 1979–1992.* Berkeley: University of California Press.

———. 1997. *Che Guevara: Icon, Myth, and Message.* Los Angeles: Fowler Museum of Cultural History, University of California, Los Angeles.

Lee, Anthony W. 1999. *Painting on the Left: Diego Rivera, Radical Politics, and San Francisco's Public Murals.* Berkeley: University of California Press.

León-Portilla, Miguel. 1963. *Aztec Thought and Culture.* Norman: University of Oklahoma Press.

Lipsitz, George. 2001. "Not Just Another Social Movement: Poster Art and the Movimiento Chicano." In *Just Another Poster: Chicano Graphic Arts in California*, edited by Chon A. Noriega. Santa Barbara: University Art Museum, University of California.

Lockpez, Inverna. 1986. *Chicano Expressions: A New View in American Art.* New York: INTAR Latin American Gallery.

López, Alma. 2000. "Mermaids, Butterflies, and Princesses." *Aztlán: A Journal of Chicano Studies* 25(1): 189–91.

Lou, Richard Alexander. 2000. *Hecho en Califas: The Last Decade, 1990–1999.* Los Angeles: Plaza de la Raza.

Malagamba-Ansótegui, Amelia. 2006. *Caras Vemos, Corazones No Sabemos: Faces Seen, Hearts Unknown.* South Bend, IN: Snite Museum, University of Notre Dame.

Mann, Charles C. 2005. *1491: New Revelations of the Americas before Columbus.* New York: Knopf.

Maradiaga, Ralph. 1977. *The Fifth Sun: Contemporary/Traditional Chicano and Latino Art.* Berkeley: University Art Museum and Chicano Studies, University of California.

Marin, Cheech, comp. 2002. *Chicano Visions: American Painters on the Verge.* New York: Bulfinch Press.

Martínez, César A. 1999. "An Interview with César Martínez." By Jacinto Quirarte. In *César Martínez: A Retrospective*, edited by Jacinto Quirarte and Carey Clements Rote. San Antonio, TX: Mario Koogler McNay Art Museum.

Mathews, Jane De Hart. 1975. "Arts and the People: The New Deal Quest for Cultural Democracy." *Journal of American History* 62(2): 316–39.

McClean-Cameron, Alison. 2000. "El Taller de Gráfica Popular: Printmaking and Politics in Mexico and Beyond, from the Popular Front to the Cuban Revolution." PhD diss., Essex University.

Menchaca, Martha. 2001. *Recovering History, Constructing Race: The Indian, Black, and White Roots of Mexican Americans*. Austin: University of Texas Press.

Mesa-Bains, Amalia. 1990. "Quest for Identity: Profile of Two Chicana Muralists, Based on Interviews with Judith F. Baca and Patricia Rodríguez." In *Signs from the Heart: California Chicano Murals*, edited by Eva Sperling Cockcroft and Holly Barnet-Sánchez. Venice, CA: Social Public Art Resource Center.

———. 1993. "Art of the Other Mexico: Sources and Meanings." In *Art of the Other Mexico: Sources and Meanings*, edited by René H. Arceo-Frutos, Juana Guzmán and Amalia Mesa-Bains. Chicago: Mexican Fine Arts Museum.

Metropolitan Museum of Art. 1990. *Mexico: Splendors of Thirty Centuries*. New York: Bulfinch Press and Metropolitan Museum of Art.

Mexican Fine Arts Center Museum. 1987. *The Barrio Murals*. Chicago: Mexican Fine Arts Center Museum.

———. 2006. *The African Presence in México: From Yanga to the Present*. Chicago: Mexican Fine Arts Center Museum.

Miliotes, Diane. 2006. *José Guadalupe Posada and the Mexican Broadside*. New Haven: Yale University Press.

Miller, Arthur G. 1973. *The Mural Painting of Teotihuacan*. Washington, DC: Dumbarton Oaks Research Library and Collection.

Mock, Melody. 1996. "Hojas Volantes: José Guadalupe Posada, the Corrido, and the Mexican Revolution." M.A. thesis, University of North Texas, Denton.

Monasterio, Pablo Ortiz, ed. 2003. *Mexico, the Revolution and Beyond: Photographs by Agustín Víctor Casasola, 1900–1940*. New York: Aperature Foundation Inc.

Montoya, Delilah. "Artist Statement." www.delilahmontoya.com/ArtistStatement .html (accessed January 5, 2008).

Montoya, José. 1980a. "Russian Cowboys, Early Berkeley and Sunstruck Critics/On Being a Chicano Writer." *Metamorfosis* 3(1): 48–53.

———. 1980b. "Thoughts on La Cultura, the Media, Con Safos and Survival." *Metamorfosis* 3(1): 28–31.

———. 1992. *Information: 20 Years of Joda*. Aztlán: Chusma House Press.

———. 2001. "The Anatomy of an RCAF Poster." In *Just Another Poster?: Chicano Graphic Arts in California*, edited by Chon Noriega. Santa Barbara: University Art Museum, University of California.

Montoya, Malaquias, and Lezlie Salkowitz-Montoya. 1980. "A Critical Perspective on the State of Chicano Art." *Metamorfosis* 3(1): 3–7.

Moreno, José F., ed. 2003. *The Elusive Quest for Equality: 150 Years of Chicano/Chicana Education*. Cambridge, MA: Harvard Educational Review.

Muñoz, Carlos Jr. 1989. *Youth, Identity, Power: The Chicano Movement*. New York: Verso.

Noriega, Chon. 2000. *East of the River: Chicano Art Collectors Anonymous*. Santa Monica: Santa Monica Museum of Art.

———, ed. 2001. *Just Another Poster? Chicano Graphic Arts in California*. Santa Barbara: University Art Museum, University of California.

Noriega, Chon, Eric R. Avila, Karen Mary Davalos, Chela Sandoval, and Rafael Pérez-Torres, eds. 2001. *The Chicano Studies Reader: An Anthology of Aztlán, 1970–2000*. Los Angeles: UCLA Chicano Studies Research Center.

O'Connor, Francis V., ed. 1973. *WPA: Art for the Millions. Essays from the 1930s by Artists and Administrators of the WPA Federal Art Project*. Boston: New York Graphic Society.

Ochoa, María. 2003. *Creative Collectives: Chicana Painters Working in Community*. Albuquerque: University of New Mexico Press.

Oropeza, Lorena. 2005. *¡Raza Sí! ¡Guerra No! Chicano Protest and Patriotism During the Viet Nam War Era*. Berkeley: University of California Press.

Orozco, José Clemente. 1962. *José Clemente Orozco: An Autobiography*. Austin: University of Texas Press.

———. 2004. *José Clemente Orozco: Graphic Work*. Austin: University of Texas Press.

Paredes, Américo. 1958. *"With His Pistol in His Hand:" A Border Ballad and Its Hero*. Austin: University of Texas Press.

Pérez, Laura E. 2007. *Chicana Art: The Politics of Spiritual and Aesthetic Altarities*. Durham, NC: Duke University Press.

Pérez-Torres, Rafael. 2001. "Remapping Chicano Expressive Culture." In *Just Another Poster: Chicano Graphic Arts in California*, edited by Chon A. Noriega. Santa Barbara: University Art Museum, University of California.

Pilots of Aztlán: Flights of the Royal Chicano Air Force. 1994. Produced by Steve LaRosa, 60 min., KVIE, Videorecording.

Prignitz-Poda, Helga. 1992. *El Taller de Gráfica Popular en México, 1937–1977*. Mexico City: Instituto Nacional de Bellas Artes.

Quirarte, Jacinto. 1973. *Mexican American Artists*. Austin: University of Texas Press.

———., ed. 1984. *Chicano Art History: A Book of Selected Readings*. San Antonio: Research Center for the Arts and Humanities, University of Texas, San Antonio.

———. 1988. "Mexican and Mexican American Artists: 1920–1970." In *The Latin American Spirit: Art and Artists in the United States, 1920–1970*, edited by Luis R. Cancel, 14–71. New York: Abrams.

———. 1991. "Exhibitions of Chicano Art: 1965–Present." In *Chicano Art: Resistance and Affirmation, 1965–1985*, edited by Richard Griswold del Castillo, Teresa McKenna, and Yvonne Yarbro-Bejarano. Los Angeles: Wight Art Gallery, UCLA.

Quirarte, Jacinto, and Carey Clemente Rote. 1999. *César Martínez: A Retrospective*. Austin: University of Texas Press.

Rascón, Armando. 1995. *Xicano Progeny: Investigative Agents, Executive Council, and Other Representatives from the Sovereign State of Aztlán*. San Francisco: Mexican Museum.

Reed, Alma M. 1960. *The Mexican Muralists*. New York: Crown.

Richards, Susan Valerie. 2001. "Imagining the Political: El Taller de Gráfica Popular in Mexico, 1937–1949." PhD diss., University of New Mexico.

Rochfort, Desmond. 1993. *Mexican Muralists: Orozco, Rivera, Siqueiros*. London: Laurence King.

Rodríguez, Luis J. 1982–83. "Yet Another Response on the State of Chicano Art." *Metamorfosis* 4(2)–5(1): 4–7.

Romano, Octavio I., John M. Carrillo, and Nick C. Vaca, eds. 1969. Special issue, *El Grito: A Journal of Mexican-American Thought* 2 (Spring).

Romo, Tere. 2001. "Points of Convergence: The Iconography of the Chicano Poster." In *Just Another Poster? Chicano Graphic Arts in California*, edited by Chon A. Noriega. Santa Barbara: University Art Museum, University of California.

———. 2006. "¡Presente! Chicano Posters and Latin American Politics." In *Latin American Posters: Public Aesthetics and Mass Politics*, edited by Russ Davidson. Santa Fe: Museum of New Mexico Press.

Rosales, F. Arturo. 1997. *Chicano: The History of the Mexican American Civil Rights Movement*. Houston: Arte Público Press.

Rosen, Martin D., and James Fisher. 2001. "Chicano Park and the Chicano Park Murals: Barrio Logan, City of San Diego, California." *Public Historian* 23(4): 91–111.

Ruiz, Vicki L. 1998. *From out of the Shadows: Mexican Women in Twentieth-Century America*. New York: Oxford University Press.

Ruiz, Vicki L., and Virginia Sánchez Korrol. 2005. *Latina Legacies: Identity, Biography, and Community*. New York: Oxford University Press.

Sánchez-Tranquilino, Marcos. 1990. "Murales del Movimiento: Chicano Murals and the Discourses of Art and Americanization." In *Songs from the Heart: California Chicano Murals*, edited by Eva Sperling Cockcroft and Holly Barnet-Sánchez. Venice, CA: Social Public Art Resource Center.

Simmons-Myers, Ann. 2003. *Louis Carlos Bernal: Barrios*. Tucson: University of Arizona Press.

Siqueiros, David Alfaro. 1975. *Art and Revolution*. London: Lawrence and Wishart.

Sorell, Victor A. *Carlos Cortez Koyokuikatl: Soapbox Rebel and Artist*. Chicago: Mexican Fine Arts Center Museum.

Street, Richard Steven. 2004. *Photographing Farmworkers in California*. Stanford: Stanford University Press.

Troy, Timothy. 2002. "Louis Carlos Bernal." In *Original Sources: Art and Archives at the Center for Creative Photography*. Tucson: Center for Creative Photography, University of Arizona.

Valdés, Dionicio Nodín. 1982. *El Pueblo Mexicano en Detroit y Michigan: A Social History*. Detroit: Wayne State University.

———. 1991. *Al Norte: Agricultural Workers in the Great Lakes Region, 1917–1970*. Austin: University of Texas Press.

———. 2000. *Barrios Norteños: St. Paul and Midwestern Mexican Communities in the Twentieth Century*. Austin: University of Texas Press.

Valenzuela, Angela. 1999. *Subtractive Schooling: U.S.–Mexican Youth and the Politics of Caring*. Albany: State University of New York Press.

Vargas, George. 1988. "Contemporary Latino Art in Michigan, the Midwest, and the Southwest." PhD diss., University of Michigan, Ann Arbor.

Vargas, Zaragosa, ed. 1999. *Major Problems in Mexican American History: Documents and Essays*. New York: Houghton Mifflin.

———. 2005. *Labor Rights Are Civil Rights: Mexican American Workers in Twentieth-Century America*. Princeton: Princeton University Press.

Vargas Llosa, Mario. 2005. "Extemporaneities: Sleeping with the Enemy?" *Salmagundi* [Skidmore College] 148–49: 23–35.

Visions of Peace and Justice. 2007. Berkeley: Inkworks Press.

Weber, David J., ed. 2003. *Foreigners in Their Native Land: Historical Roots of the Mexican Americans*. Albuquerque: University of New Mexico Press.

Wechsler, James M. 2006. "Propaganda Gráfica: Printmaking and the Radical Left in Mexico, 1920–1950." In *Mexico and Modern Printmaking: A Revolution in the Graphic Arts, 1920–1950*, edited by John Ittmann. New Haven: Yale University Press.

Wells, Carol A. 2001. "La Lucha Sigue: From East Los Angeles to the Middle East." In *Just Another Poster: Chicano Graphic Arts in California*, edited by Chon A. Noriega. Santa Barbara: University Art Museum, University of California.

Williams, Lyle W. 2006. "Evolution of a Revolution: A Brief History of Printmaking in Mexico." In *Mexico and Modern Printmaking: A Revolution in the Graphic Arts, 1920–1950*, edited by John Ittmann. New Haven: Yale University Press.

Ybarra-Frausto, Tomás. 1994. "The Chicano Cultural Project, 1965 to 1994." In *Mesoamerican and Chicano Art, Culture, and Identity*, edited by Robert C. Dash, 123–45. Salem, OR: Willamette University.

Zamudio-Taylor, Victor. 2001. "Inventing Tradition, Negotiating Modernism: Chicano/a Art and the Pre-Columbian Past." In *The Road to Aztlán: Art from a Mythic Homeland*, edited by Virginia Fields and Victor Zamudio-Taylor. Los Angeles: Los Angeles County Museum of Art.

Zirker, Joseph. 1997. *Malaquias Montoya: Adaline Kent Award Exhibition*. San Francisco: San Francisco Art Institute.

■ INDEX

■ ABOUT THE AUTHOR

CARLOS FRANCISCO JACKSON was born and raised in Los Angeles, California. He is currently an assistant professor in the Chicana and Chicano Studies Program at the University of California, Davis. Carlos is an artist and writer who has exhibited his artwork throughout the United States. He is currently the first director of a community-based art workshop operated by Chicana/o Studies at UC Davis called Taller Arte del Nuevo Amanecer (TANA). TANA is a newly established silkscreen workshop that exhibits artists who work both locally and nationally and offers art workshops to members of the community surrounding UC Davis. He is the recipient of the Margarita Robinson Award and the Robert Arneson Fellowship from UC Davis and he attended, with a full fellowship, the Skowhegan School of Painting and Sculpture in Maine in 2002. In 2003–2004 he held the David Shainberg Endowed Fellowship at the Fine Arts Work Center in Provincetown, Massachusetts.

Chicana and Chicano Art: ProtestArte is a volume in the series The Mexican American Experience, a cluster of modular texts designed to provide greater flexibility in undergraduate education. Each book deals with a single topic concerning the Mexican American population. Instructors can create a semester-length course from any combination of volumes, or may choose to use one or two volumes to complement other texts.

Additional volumes deal with the following subjects:

Mexican Americans and Health
Adela de la Torre and Antonio Estrada

Chicano Popular Culture
Charles M. Tatum

Mexican Americans and the U.S. Economy
Arturo González

Mexican Americans and the Law
Reynaldo Anaya Valencia, Sonia R. García, Henry Flores, and José Roberto Juárez Jr.

Chicana/o Identity in a Changing U.S. Society
Aída Hurtado and Patricia Gurin

Mexican Americans and the Environment
Devon G. Peña

Mexican Americans and the Politics of Diversity
Lisa Magaña

Mexican Americans and Language
Glenn A. Martínez

Chicano and Chicana Literature
Charles M. Tatum

For more information, please visit
www.uapress.arizona.edu/textbooks/latino.htm